ris

, MD 21701

WILDLIFE PHOTOGRAPHER of the YEAR

PORTFOLIO NINE

Designed by
GRANT BRADFORD

Competition Manager
LOUISE GROVE-WHITE

FOUNTAIN PRESS

Published by
FOUNTAIN PRESS LIMITED
Fountain House
2 Gladstone Road
Kingston-upon-Thames
Surrey KT1 3HD
England

Design & Layout by
GRANT BRADFORD
Design Consultants
Tunbridge Wells
Kent

Competition Manager
LOUISE GROVE-WHITE

Captions Editor
RACHEL ASHTON

Colour Origination
Setrite Digital Graphics
Hong Kong

Printing & Binding
Die Keure n.v.
Belgium

ISBN 0 86343 338 3

FOREWORD

The camera is an eye that captures in an instant the external
world and holds it for an eternity. But the speed of the shutter
belies the long hours watching and waiting for that
exceptional moment. It is this quiet patience observing
and communing with nature that breathes such soul into
the compelling images in this portfolio.

What strikes me most is the empathy that the photographers
have with their subjects. The images are more than just
beautiful, they capture the spirit of the natural world, the very
essence of their animal subjects. The light, the textures,
the forms are so vivid that all the senses seem to be
awakened – one can almost feel the softness of fur,
the ethereal lightness of clouds or smell the hot dusty air
of the African savannah.

Especially impressive are the young photographers who
reveal a remarkable instinct for the perfect shot. The calibre
of these pictures assures us that as the technical side of
photography advances, allowing us an ever more intimate
view of nature, so their artistry will conjure an ever deeper
sense of wonder.

Every page is a tribute to the extraordinary diversity
and stunning beauty of our world.

Charlotte Uhlenbroek

Charlotte Uhlenbroek

INTRODUCTION

Welcome to a celebration of the beauty and wonder found in the natural world – the winning and highly commended images from the 1999 BG Wildlife Photographer of the Year Competition.

This year's Competition, which has been organised for the sixteenth year by *BBC Wildlife* Magazine and The Natural History Museum, London, marks the tenth year of sponsorship from BG plc. It exists to encourage amateur and professional photographers around the world to record and document the diversity and beauty of nature. Each year the number of entries grows – this year over 21,000 slides from photographers in 66 countries were received.

Pictures were entered in 12 different categories, and there were two special Awards: the Eric Hosking Award for the best portfolio of pictures by a photographer aged 26 years or under, and the Gerald Durrell Award for Endangered Wildlife. This year the BG Young Wildlife Photographer of the Year Competition – for photographers aged 17 years and under – consisted of three age categories and two special Awards: the YOC Award and the meg@ Award.

In October, the winning photographers were brought to The Natural History Museum for the presentation of the main awards and the official opening of the Exhibition of winning and commended images. Four sets of the Exhibition toured the UK, displayed at some 35 different galleries, museums and nature centres. These stunning images were also enjoyed around the world during an international tour that visited countries including Australia, Germany, Holland, Japan and the USA.

THE JUDGES

Bruce Pearson
Wildlife artist

Heather Angel
Wildlife photographer

Dr Giles Clarke
Head of Exhibitions and Education, The Natural History Museum, London

Rosamund Kidman Cox
Editor, *BBC Wildlife* Magazine

Simon King
Wildlife film maker

Thomas D Mangelsen
Overall Competition winner, 1994

Matti Torkkomäki
Wildlife photographer

WILDLIFE PHOTOGRAPHER OF THE YEAR 1990-1998

Wendy Shattil
United States of America
1990

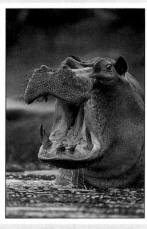

PORTFOLIO ONE
Frans Lanting
Netherlands
1991

PORTFOLIO TWO
André Bärtschi
Liechtenstein
1992

PORTFOLIO THREE
Martyn Colbeck
United Kingdom
1993

PORTFOLIO FOUR
Thomas D Mangelsen
United States of America
1994

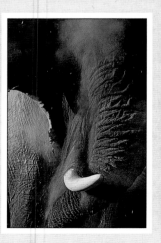

4

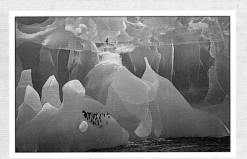

BG plc

WILDLIFE PHOTOGRAPHER
of the YEAR 1999

This is the tenth year BG has sponsored the Wildlife Photographer of the Year Competition. We are proud of our continuing association and to see the Competition develop into the leading international event of its kind.

BG often works in ecologically sensitive areas around the world and we take our environmental responsibilities extremely seriously. We regard the Competition not only as a valuable exercise in documenting the world's wildlife, but also as a demonstration of our commitment to the global environment. I believe these wonderful photographs are a reminder to us all of the importance of preserving our natural surroundings.

At BG, we aim to play a full role in society, both in the UK and around the world. Each year we send the Competition's remarkable photographs on tour to countries where we operate, as a way of making a contribution to the cultural life of the people we serve. Those same images are collected in the book you now hold and I hope you enjoy the rich diversity of wildlife represented by these stunning images.

David Varney
Chief Executive
BG plc

PORTFOLIO SIX
Jason Venus
United Kingdom
1996

PORTFOLIO FIVE
Cherry Alexander
United Kingdom
1995

PORTFOLIO SEVEN
Tapani Räsänen
Finland
1997

PORTFOLIO EIGHT
Manfred Danegger
Germany
1998

CONTENTS

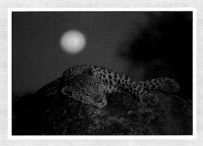

WILDLIFE PHOTOGRAPHER *of the* YEAR
8

The 'Wildlife Photographer of the Year' title is awarded for the single image judged to be the most striking and memorable of all the photographs entered in the competition.

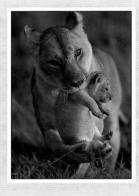

ANIMAL BEHAVIOUR
- MAMMALS -
38

Mammals pictured actively doing something. These images illustrate moments that have both interest value and aesthetic appeal.

The ERIC HOSKING AWARD
10

This Award was introduced in 1991 in memory of Eric Hosking – Britain's most famous bird photographer – and goes to the best portfolio of six images taken by a photographer aged 26 or under.

ANIMAL BEHAVIOUR
- BIRDS -
50

Birds photographed actively doing something. These images capture moments that have interest value as well as aesthetic appeal.

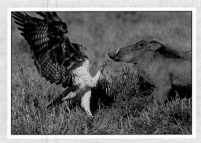

The GERALD DURRELL AWARD FOR ENDANGERED WILDLIFE
16

This Award highlights rare species officially listed in the 1996 IUCN Red List of Threatened Species as critically endangered, endangered, vulnerable or lower risk at an international or national level.

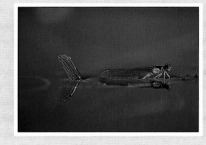

ANIMAL BEHAVIOUR
- ALL OTHER ANIMALS -
64

Subjects photographed actively doing something. From insects to reptiles, these images reveal moments that have interest value as well as aesthetic appeal.

ANIMAL PORTRAITS
26

Wildlife up close – intimate images from nature.

BRITISH WILDLIFE
72

Wild plants or animals in rural or urban settings within the UK.

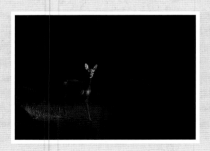

CONTENTS

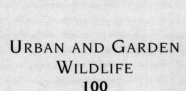
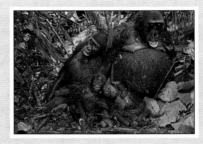
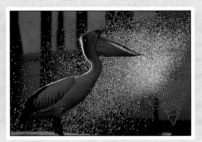

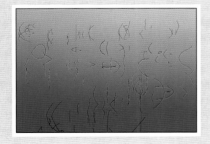
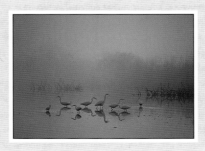

WILDLIFE PHOTOGRAPHER *of the* YEAR

The BG *Wildlife Photographer of the Year* title is awarded for the single image judged to be the most striking and memorable of all the photographs entered for the Competition. The 1999 winner, Jamie Thom, is no stranger to success in the Competition, having won the Eric Hosking Award last year. He builds on his impressive portfolio with this stunning image of a leopard.

Jamie Thom

As a game ranger at the Mala Mala Game Reserve in South Africa, Jamie has found his working environment to be a rich source of opportunities for superb photography. He comments: "It has been a real pleasure spending many hours in the pristine bush of Mala Mala monitoring the lives and behaviour of lion prides, leopards and all the other animals that inhabit this tract of land. Above all, living and working at Mala Mala has enabled me to fulfil my passion for wildlife photography."

Jamie is heavily involved with the conservation and expansion of wildlife sanctuaries in Africa and would like to devote more energy to alleviating the plight of the continent's endangered species.

Jamie Thom
South Africa
BG WILDLIFE PHOTOGRAPHER
OF THE YEAR 1999

Leopard with rising moon

"*I first met this two-year-old leopard when he was only three months old and still with his mother in the Mala Mala Game Reserve, South Africa. It usually takes a while for leopards to become accustomed to vehicles, but he showed little fear from the outset.*
He was particularly curious and adventurous, practising his stalking on adult rhinos and giraffes and giving them the fright of their lives. I had been photographing for 15 minutes before I noticed the moon rising behind him. The effect was a backdrop that most stage-set designers would die for."

Nikon F90x with 300mm lens; 1/30 sec at f4; Ektachrome E200; beanbag and spotlight

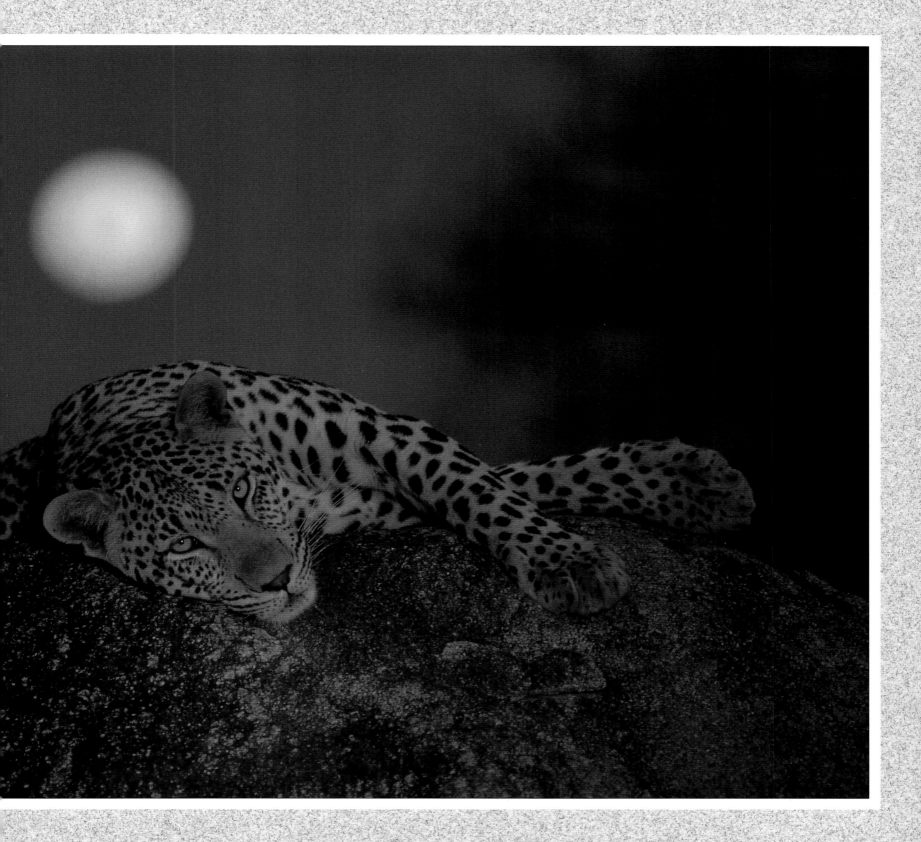

The ERIC HOSKING AWARD

This Award was introduced in 1991 in memory of Eric Hosking –
Britain's most famous bird photographer – and goes to the best portfolio
of six images taken by a photographer aged 26 or under.
This year's winner, Jamie Thom from South Africa, is also the winner
of the BG Wildlife Photographer of the Year 1999.

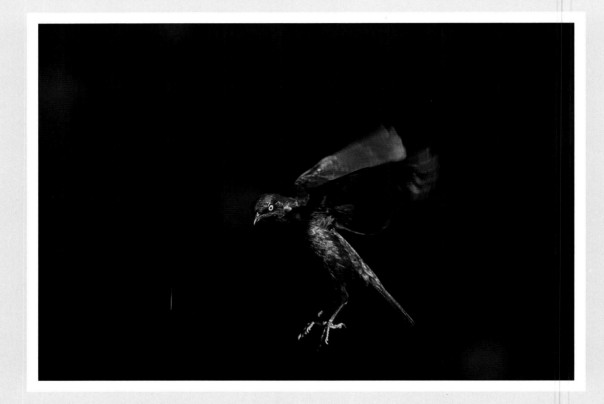

Jamie Thom
South Africa

Cape glossy starling landing

"These Cape glossy starlings are fairly common in some parts of South Africa. They home in on picnic spots, waiting for leftovers or to be fed by tourists. In the Kruger National Park, one picnic spot was seething with these birds and gave me the opportunity to photograph this striking individual. I chose a dark background and waited until the bird was about to swoop for scraps."

Nikon F90x with 300mm lens; 1/250 sec at f4; Fujichrome Sensia 100

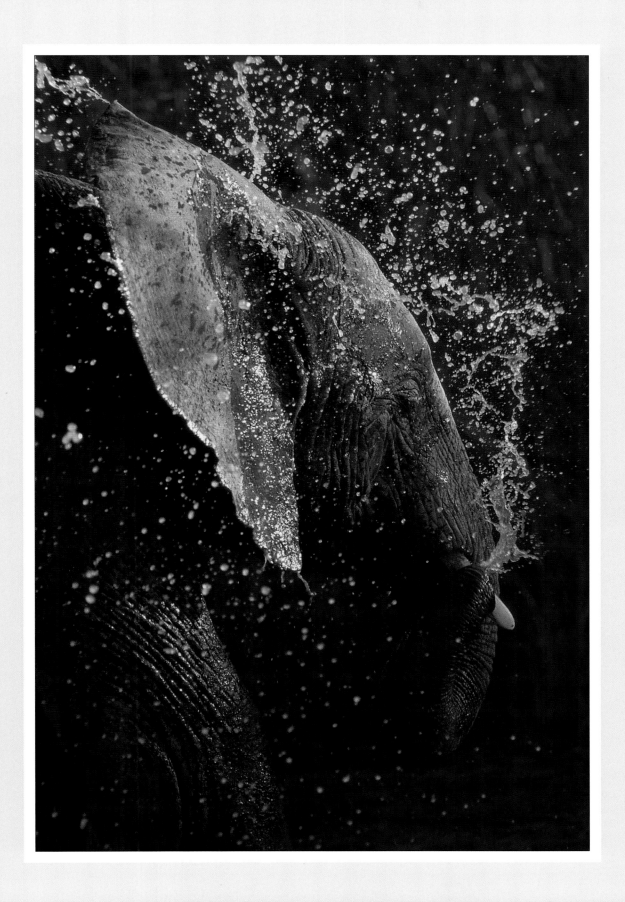

Jamie Thom
South Africa

Elephant spraying water

"In the dry, winter months of June to September, Sand River in Mala Mala Game Reserve attracts crowds of elephants and buffalo, which in mid-morning move into the water to drink and eat the lush vegetation. This was one of a herd of about 25 elephants. After quenching his thirst, he felt a shower was in order."

Nikon F90x with 300mm lens; 1/250 sec at f5.6; Ektachrome E200

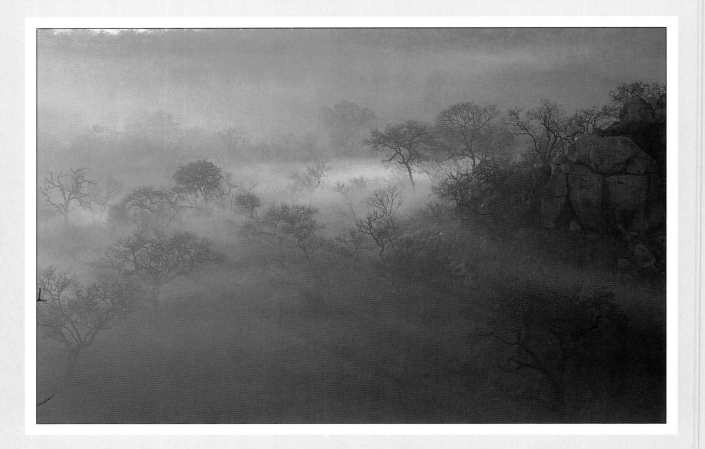

Jamie Thom
South Africa

Misty sunrise

"Winter mornings in the Mala Mala are
cold and sometimes misty. On one such
morning, I climbed one of the koppies
(hills) before sunrise until I was above
mist-level. As the sun came up, the mist
began to dissolve, and a strong side-light,
together with trees and the koppies,
provided a stunning scene."

Nikon F90x with 80-200mm lens; 1/125 sec at f4;
Fujichrome Sensia 100

Jamie Thom
South Africa

Lion roaring

"To experience a full-grown lion roaring
straight at you at close quarters
is unforgettable. This male, though,
was in fact not roaring at me,
but at some adversaries in the distance,
either to maintain his territory or to
confirm the spacing between the groups.
This gave me the perfect opportunity
to photograph him."

Nikon F90x with 300mm lens; 1/200 sec at f4;
Fujichrome Sensia 100; beanbag

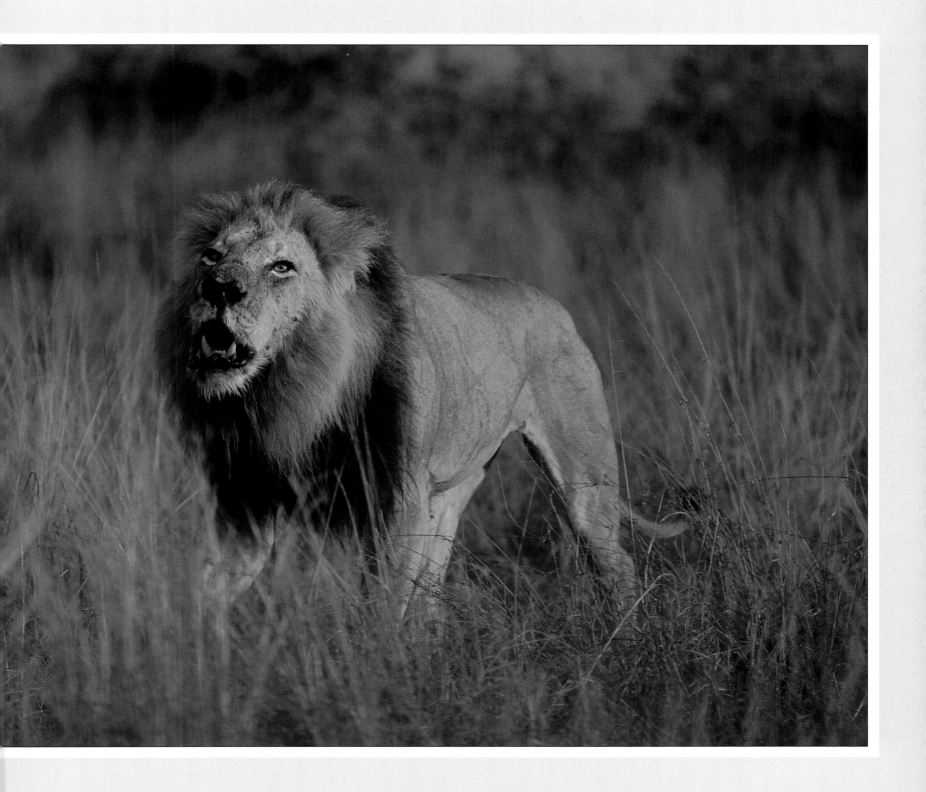

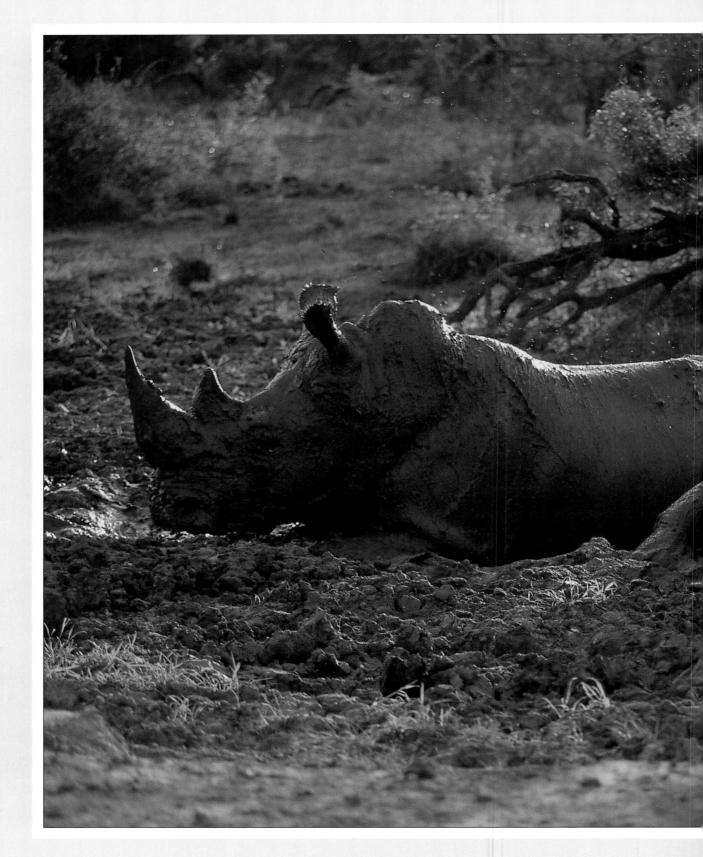

Jamie Thom
South Africa

White rhinos in mud wallow

"Animals such as rhinos, elephants and warthogs have sparse hair covering and will use a coating of mud to protect themselves from the sun and external parasites. A hot summer's day drew these two subadult male white rhinos to the mud to cool themselves and to rest."

Nikon F90x with 80-200mm lens;
1/60 sec at f4; Fujichrome Sensia 100

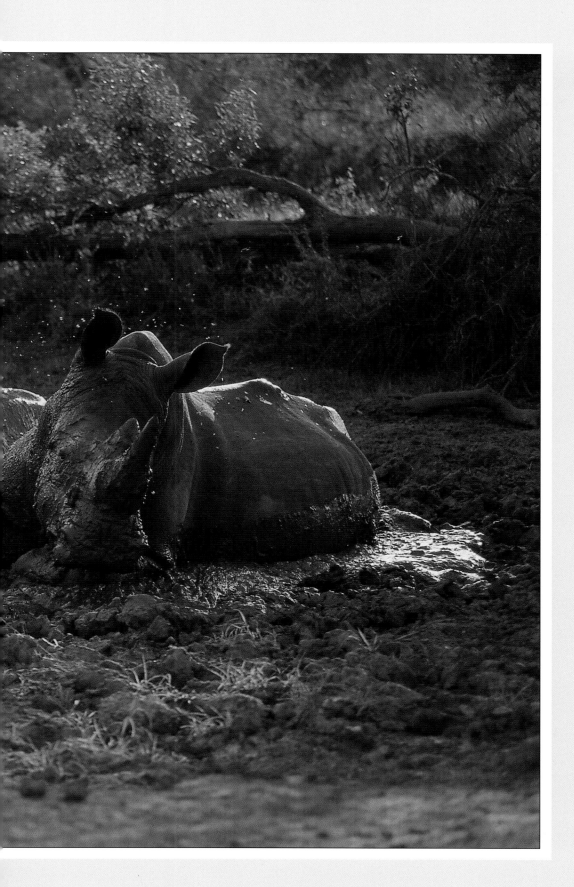

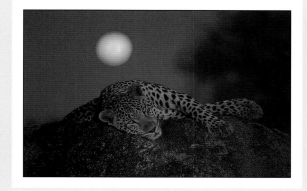

Jamie Thom
South Africa

Leopard with rising moon
"*Mala Mala Game Reserve probably
has the finest leopard viewing in Africa.
This individual was one of many
I have photographed over the past few
years. Over time, most leopards become
totally relaxed in the presence of vehicles,
allowing us to see them raising their
cubs, courting and, in this
case, relaxing.*"

Nikon F90x with 300mm lens; 1/30 sec at f4;
Ektachrome E200; beanbag and spotlight

The GERALD DURRELL AWARD FOR ENDANGERED WILDLIFE

This Award highlights rare species officially listed in the 1996 IUCN Red List of Threatened Species as critically endangered, endangered, vulnerable or lower risk at an international or national level. The Award was introduced in 1995 to commemorate the late Gerald Durrell's work with endangered species and his long-standing involvement with the BG Wildlife Photographer of the Year Competition.

This year's Award winner is Anup Shah. Born of Indian parentage, raised in Kenya and educated in England, Anup currently lectures on Environmental Economics at Newcastle University. He became interested in wildlife photography at an early age and this interest has encouraged him to spend more time in the wild in recent years. As Anup says: "Observing animals going about their daily business in the wild has enabled me to glimpse natural phenomena that are still beyond human understanding and out of reach of bio-technology."

Anup Shah
United Kingdom
WINNER

Infant orang-utan

"This wild baby in Gunung Leuser National Park, Indonesia, is only a few weeks old. An infant orang-utan never intentionally loses physical contact with its mother for the first few months and continues to be looked after for its first six years or so. The recent forest fires in South-east Asia left many babies orphaned."

Canon EOS 1N with 200mm lens; Fujichrome Provia 100

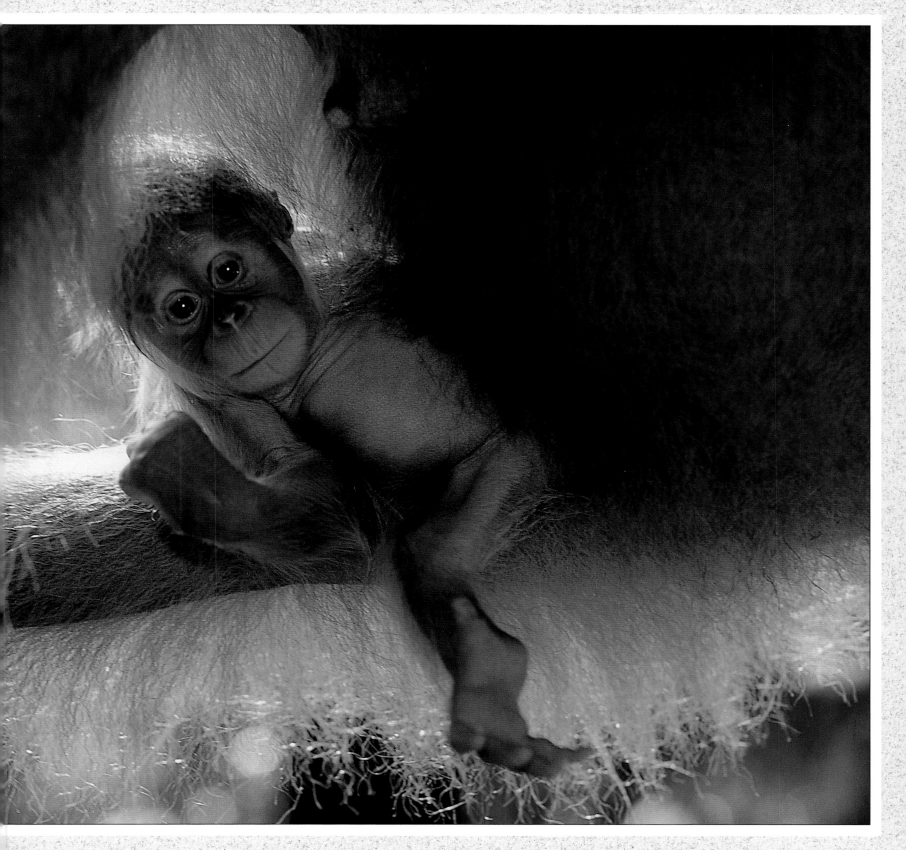

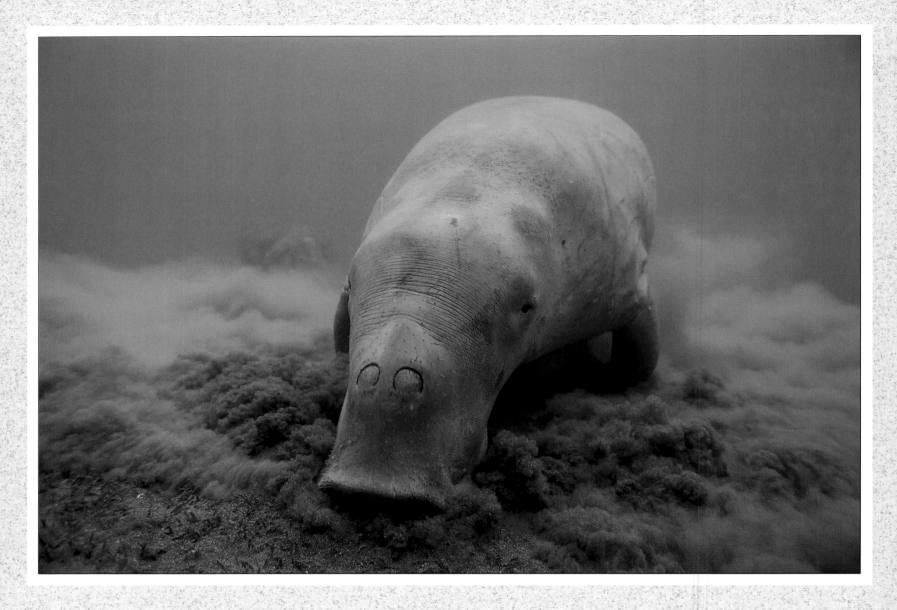

Pete Atkinson
United Kingdom
RUNNER-UP

Dugong feeding on sea grass

"This male dugong at the island of Épi, Vanuatu in the South Pacific, didn't mind human company in the evenings when there was barely enough light for photography. During the day, though, while feeding on sea grass it remained aloof. On this occasion it was completely relaxed, and I could creep silently across the sea grass carpet to photograph it feeding."

Nikon F4 with 18mm lens; 1/125 sec at f5.6; Fujichrome Velvia; underwater housing

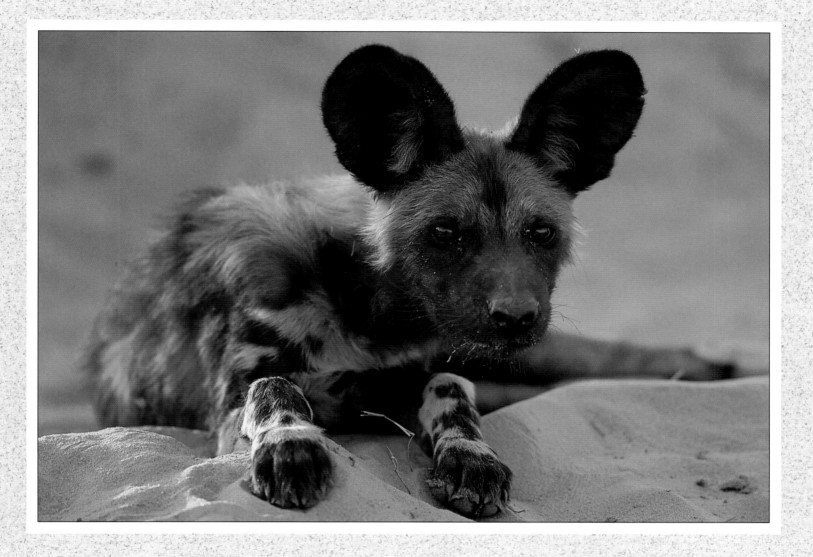

Petra Muck-Dunkel
Germany
HIGHLY COMMENDED

Wild dog at sunset

"We had spent the whole afternoon in the Moremi
Wildlife Reserve, Botswana, looking for wild dogs,
but we didn't encounter a pack until sunset.
There were five older animals and four sub-adults.
I was particularly impressed with their
beautifully coloured coats."

Nikon F90x with 40-800mm lens; 1/125 sec at f4;
Fujichrome Sensia 100

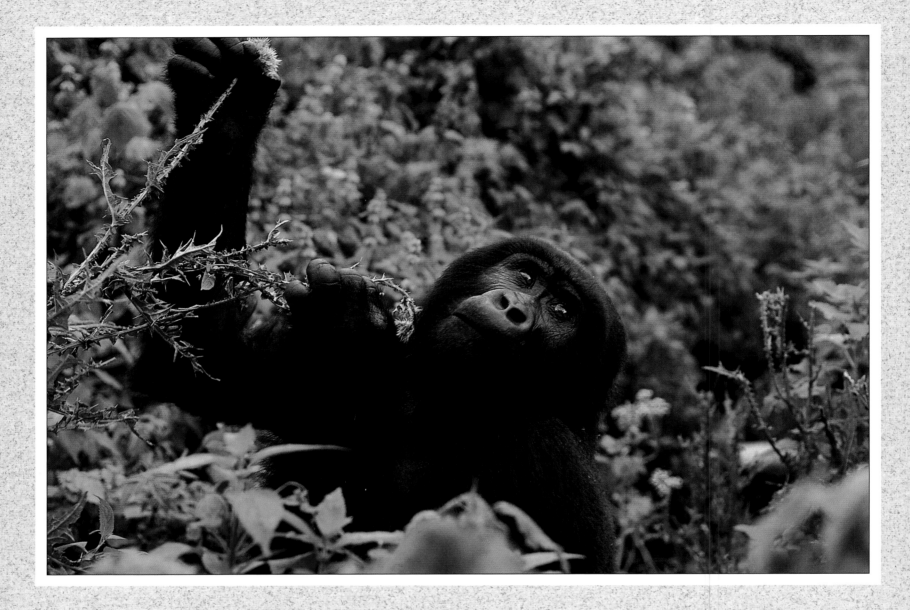

Konrad Wothe
Germany
HIGHLY COMMENDED

Mountain gorilla investigating thistle

"After a two-hour search under guidance of
a local ranger in the Virunga National Park,
Zaire, we found a group of mountain gorillas
feeding in the dark forest. The apes moved into
a clearing before our limited visiting time was
up, and I was able to photograph this male
as he carefully picked at a spiny thistle."

Canon EOS 1N with 70-200mm lens; 1/200 sec at f2.8;
Fujichrome Sensia 100 rated at 200

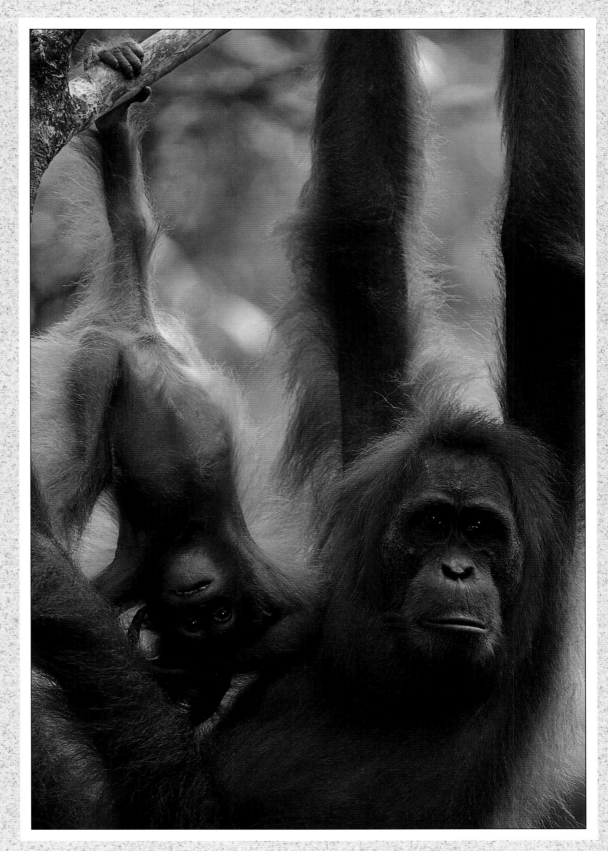

Manoj Shah
United Kingdom
HIGHLY COMMENDED

Orang-utan with acrobatic infant

"This wild female sometimes came to a feeding station for rehabilitated orang-utans in Gunung Leuser National Park, Indonesia. She watched the goings-on with undisguised fascination, but her baby quickly got bored and amused itself by putting on a virtuoso acrobatic performance."

Canon EOS 1N with 300mm lens; Fujichrome Sensia 100

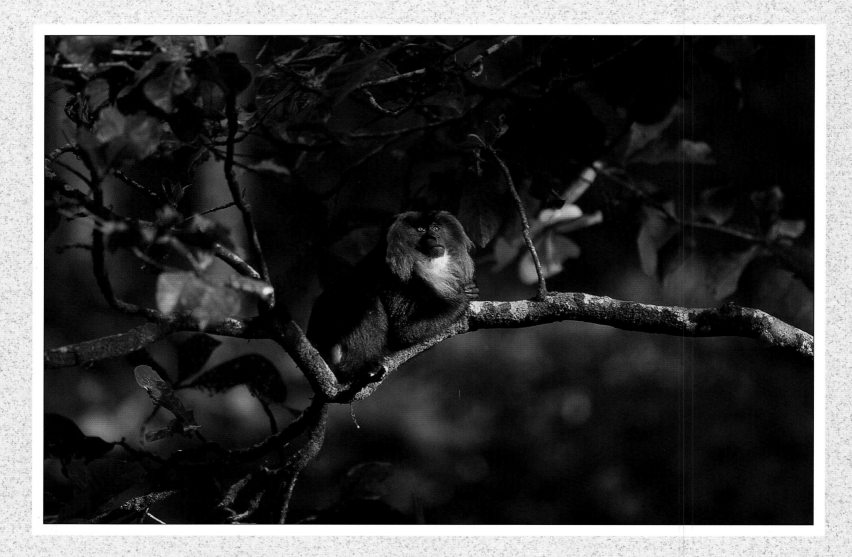

Elio Della Ferrera
Italy
HIGHLY COMMENDED

Lion-tailed macaque

*"This alpha male lion-tailed macaque
(the top male in his group) was taking an
evening rest in an evergreen forest in the
Anamalai Mountains, southern India.
The thick, wet leaves blocked out much of
the light, making it very hard to take
decent photographs. All the time I was in
the forest, I could hear the noise of
trees being illegally felled."*

Canon EOS 1N with 300mm lens; 1/30 sec at f2.8;
Fujichrome Astia rated at 200

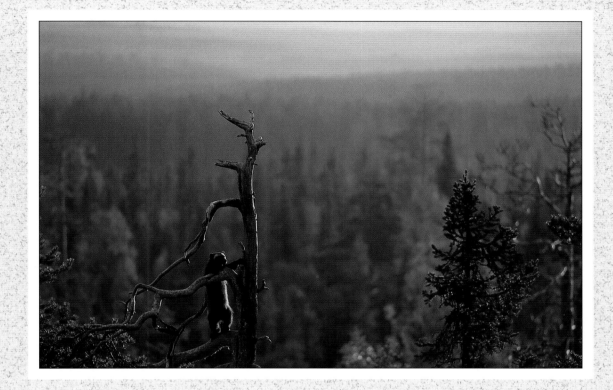

Antti Leinonen
Finland
HIGHLY COMMENDED

Wolverine

"Earlier in the year, I had seen a
wolverine climb a tree and was impressed
with its silhouette against the vast
landscape. I tried to re-create the scene
by putting baits in the trees. One August
evening, all the factors came together.
The light was right, the wolverine found
the bait and I was in my hide."

Canon EOS 100 with 200mm lens; 1/60 sec f2.8;
Fujichrome Astia

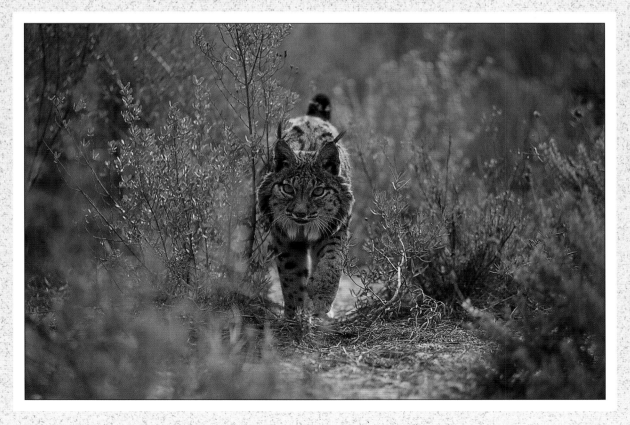

Juan Tébar Carrera
Spain
HIGHLY COMMENDED

Iberian lynx

"I took this photograph in Doñana
National Park, southwest Spain.
There are only about 1,000 Iberian
lynxes left in the wild, and about 60
of these live in the Doñana region.
I was transfixed with this individual as it
sauntered towards me, staring at me
disdainfully and making deep,
low grunts."

Nikon F90x with 400mm lens; 1/250 sec at f4;
Fujichrome Provia 100

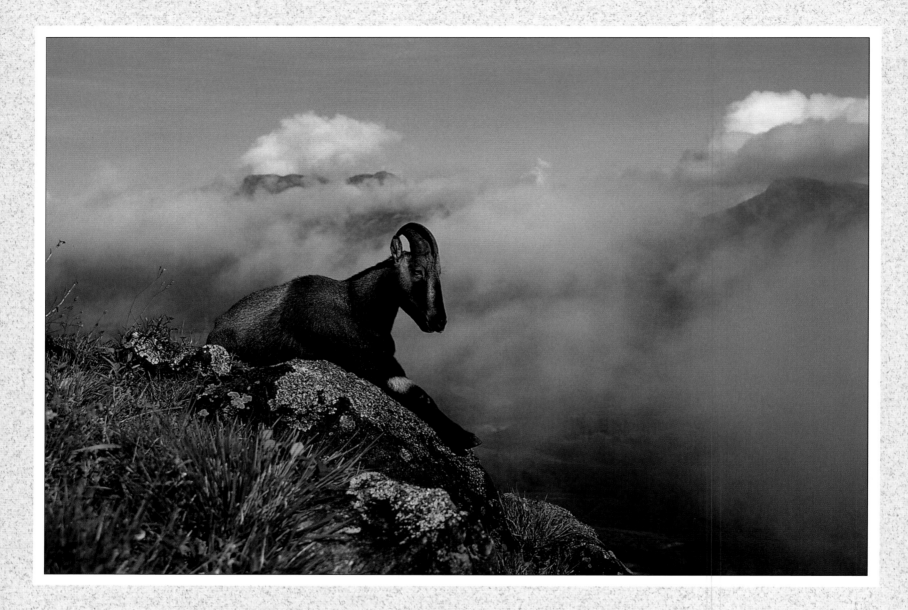

T A Jayakumar
India
HIGHLY COMMENDED

Nilgiri tahr resting

"The Rajamalai area of Eravikulam National Park
in Munnar, Kerala, India is the only place where
Nilgiri tahr can still be seen. I first saw this saddle-
back tahr male with a group of females. He soon left
the herd to climb the mountain, and I stalked him on
foot to this ledge. Here he settled down for a rest, legs
sticking out in typical tahr fashion. The whole scene
was visually elevating and quite enchanting."

Nikon F4 with 24-120mm lens; 1/125 sec at f8; Fujichrome Provia

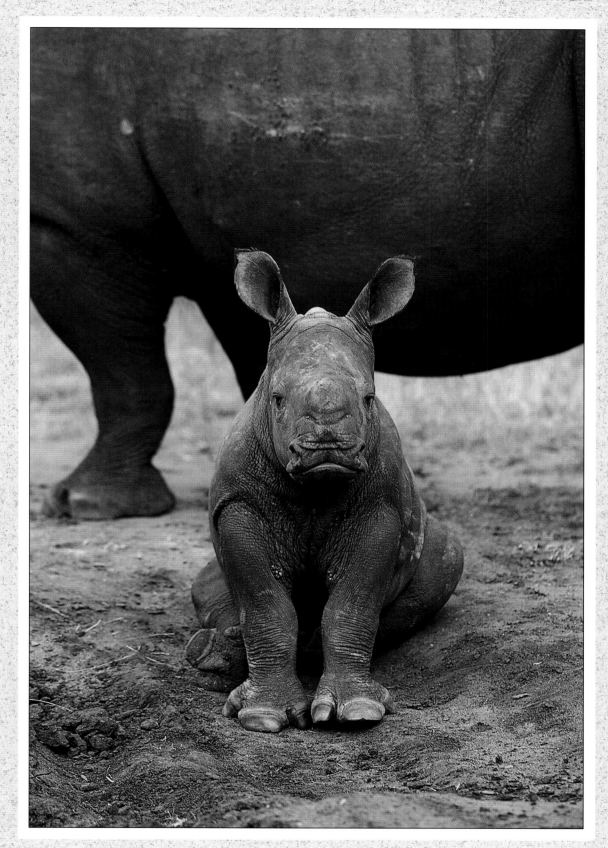

Martin Harvey
South Africa
HIGHLY COMMENDED

White rhino calf

"This young white rhino, in Mkhaya Nature Reserve, Swaziland, seemed bored with his mother's inactivity. Like a restless toddler, he fidgeted around for some time before settling into this rather unusual, dog-like posture, staring directly into my lens."

Canon EOS 3 with 300mm lens; Fujichrome Velvia; beanbag

ANIMAL PORTRAITS

Wildlife up close – intimate images from nature.

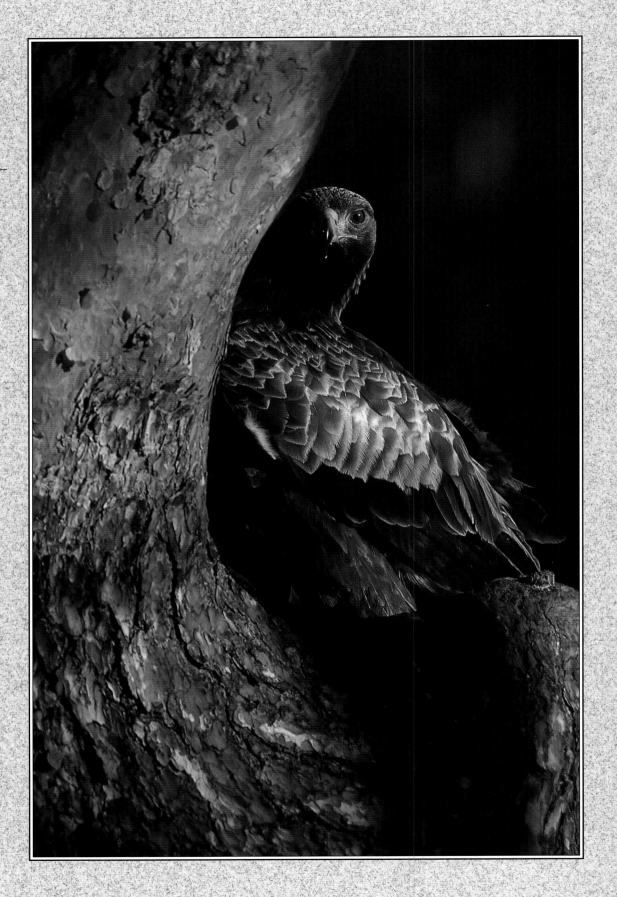

Conny Lundström
Sweden
WINNER

Golden eagle

"Winter in northern Sweden can be tough for young eagles, and so I put out meat once a week for them. Close to one of my hides was a crooked pine tree where the eagles sometimes perched. It took me two months to get the perfect portrait of a golden eagle in this special tree."

Canon F1 with 300mm lens and x2 extender;
Fujichrome Provia 100; tripod

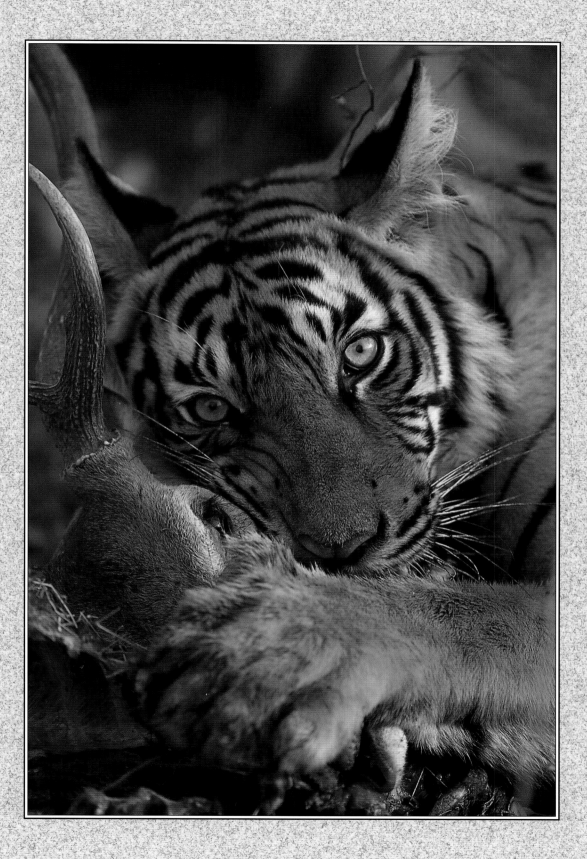

Patricio Robles Gil
Mexico
RUNNER-UP

Tiger

"In late May, midday temperatures in Ranthambore National Park, India, soar to 45°C. The water holes shrink, and animals crowd in to drink, providing sitting targets for tigers. One of the guides told me that a mother tiger with three large cubs had killed a chital deer near the road. When we arrived, only the head was left. It was thrilling to make eye contact with this cub clinging to the deer head as her mother made moves to steal it away."

Nikon F5 with 500mm lens; Fujichrome Provia 800; tripod

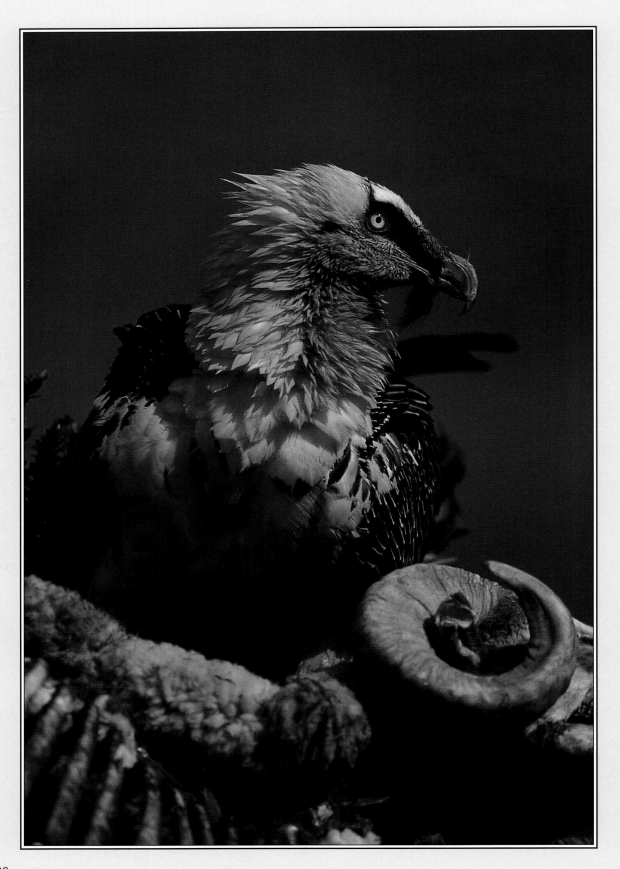

John Cancalosi
United States of America
HIGHLY COMMENDED

Lammergeier

"At certain times of the year, carrion is set out at several sites in the Spanish Pyrénées to help these bone-feeding specialists survive lean times. I set up my hide near to one of the feeding stations and after many days of waiting, several birds visited the site for a few days consecutively. I got my photos, together with a permanent impression on my buttocks of the board I was sitting on."

Nikon F5 with 500mm lens; 1/500 sec at f4; Fujichrome Velvia rated at 40; tripod

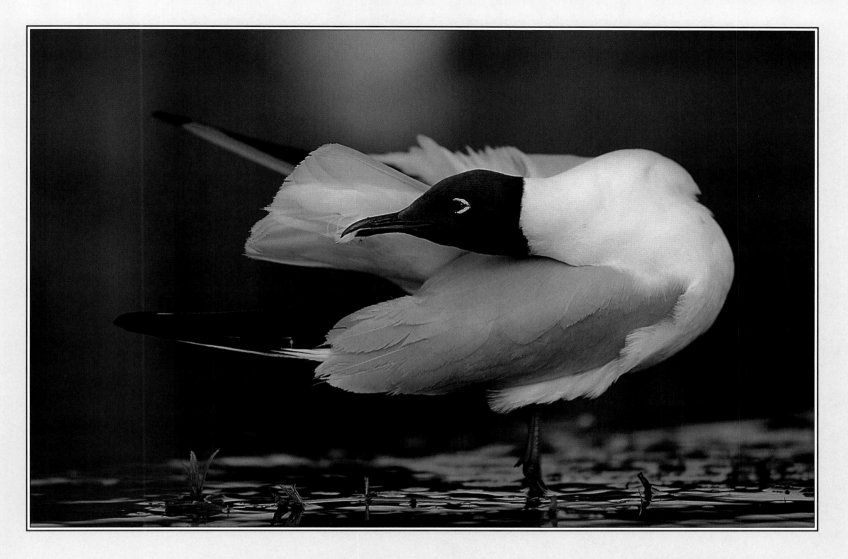

Pascal Bourguignon
France
HIGHLY COMMENDED

Black-headed gull

"I took this photograph from a hide one April evening, trying to get as level with the water-surface as possible. There were lots of black-headed gulls in breeding plumage squabbling right in front of my hide, but they were much too close for me to photograph them. This individual was calmly preening himself, allowing me to home in on him before he joined the mob."

Canon EOS 5 with 300mm lens and x1.4 teleconverter; 1/250 sec at f5.6; Fujichrome Velvia

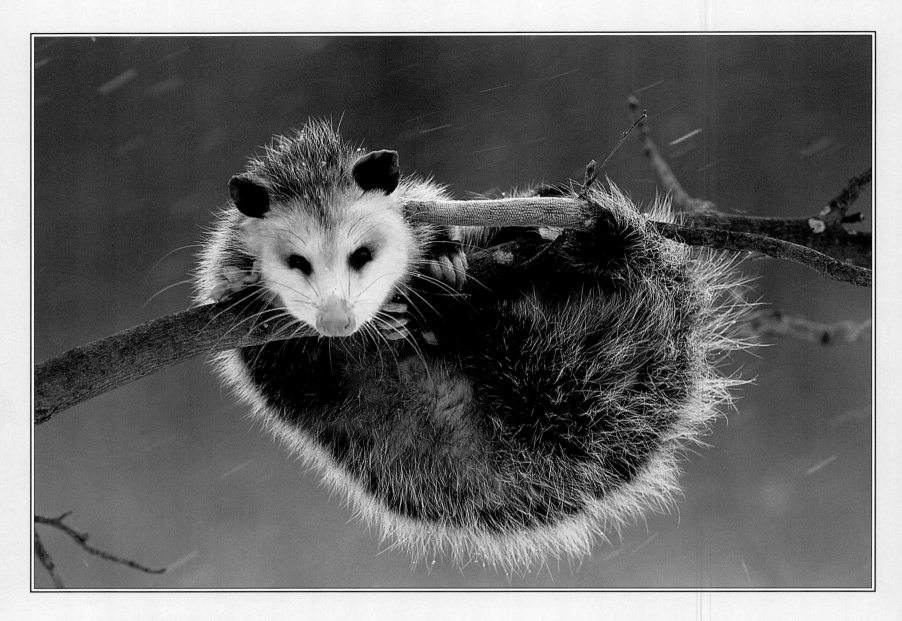

Stephen J Gettle
United States of America
HIGHLY COMMENDED

Opossum

"I was amazed to see this opossum out and about one
February day – with the wind chill factor, it was nearly
-30°C. These marsupials usually spend the coldest days
of the year curled up, especially here in Michigan, USA,
which is the northern limit of their range; perhaps this
individual had been disturbed. He had lost 4 centimetres
of his tail to frostbite. When threatened, opossums 'play
dead'. Fortunately, this one didn't try that trick."

Nikon N90s with 300mm lens; 1/60 sec at f2.8; Fujichrome Velvia; tripod

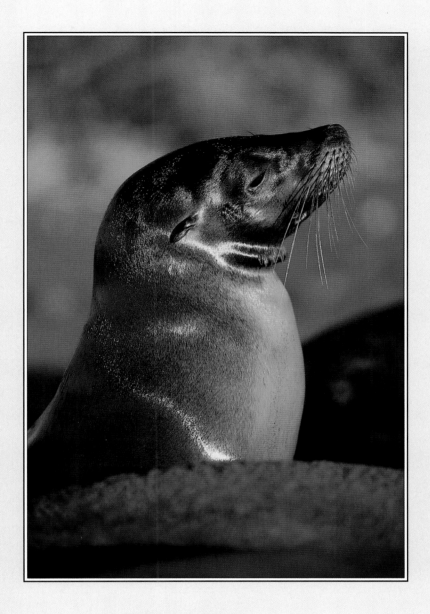

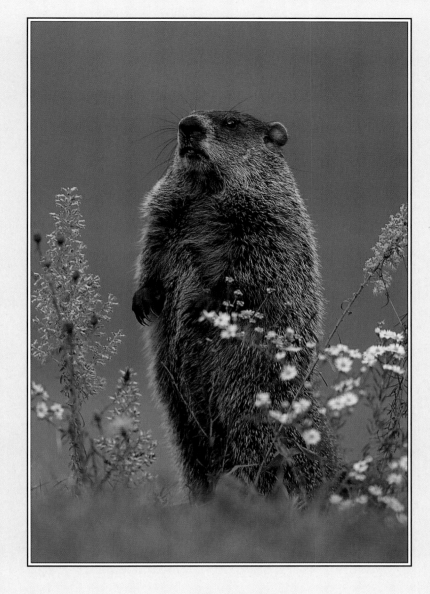

Jonathan R Green
United Kingdom
HIGHLY COMMENDED

Galapagos sea lion

"The beach at Rabida Island, in the Galapagos Islands, contains a high iron content from the breakdown of basaltic lava. The iron was reflecting the sunset onto the sea lions' wet coats, which gave them a golden glow as they returned up the beach for the night. This individual was a young male who was posing in this position as a form of display while the dominant male, or 'beach master', was not around. When the beach master reappeared, the juvenile sidled off, glancing backwards to check he wasn't being pursued."

Nikon with 80-200mm lens; 1/125 sec at F8; Fujichrome Sensia II 100

Mark Hamblin
United Kingdom
HIGHLY COMMENDED

Woodchuck among flowers

"Woodchucks are found throughout Michigan, USA, where they inhabit meadows. This individual was photographed at a rehabilitation centre in Michigan, where it was released into a large meadow full of wild flowers. It is standing on its back legs to survey its surroundings."

Canon EOS 1N with 500mm lens; 1/250 sec at f8;
Fujichrome Sensia 100; tripod

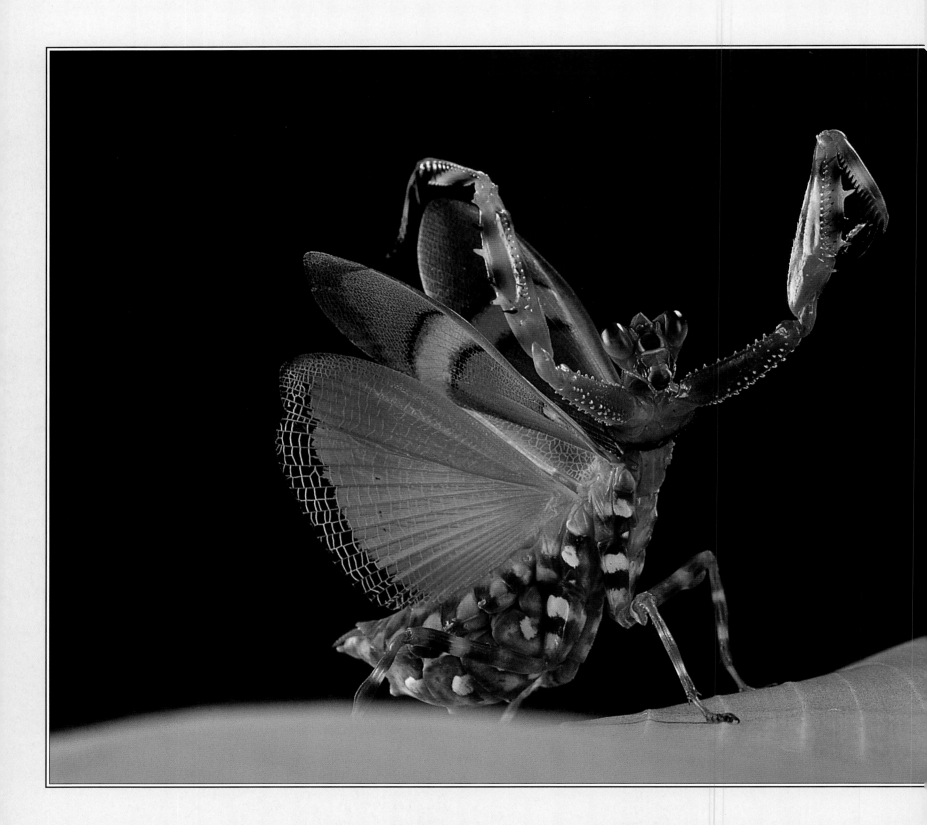

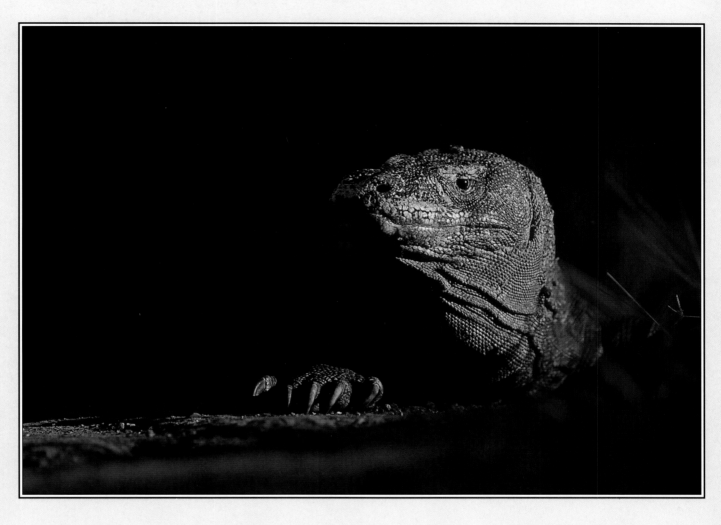

Dan Bool
United Kingdom
HIGHLY COMMENDED

Chalk-Seng Hong
Malaysia
HIGHLY COMMENDED

Komodo dragon

"Having lived with the dragons on Komodo for nearly a year, I felt fairly confident in predicting their moods. First thing in the morning, when this shot was taken, the dragons like to lie around keeping an eye out for carrion. This full-grown male lay sprawled in a shaft of light, seemingly lethargic, and so I had no problem getting on the ground to shoot him at eye level. Almost as soon as I had snapped off this shot, he lunged out and tried to snap me, but not quite quickly enough."

Spotted mantis

"This species is very rare and found only in cool places in mountain areas. I found this individual, which measured 4cm in length, in the Cameron Highlands, Malaysia. When confronted with my camera, it reared up like this to protect itself. Their amazing colours last only a few weeks — when they are ready to breed, they turn green."

Leica R5 with 100mm macro lens; 1/60 sec at f22;
Fujichrome Velvia

Canon EOS 1N with 70-200mm lens; 1/250 sec at f4;
Fujichrome Provia

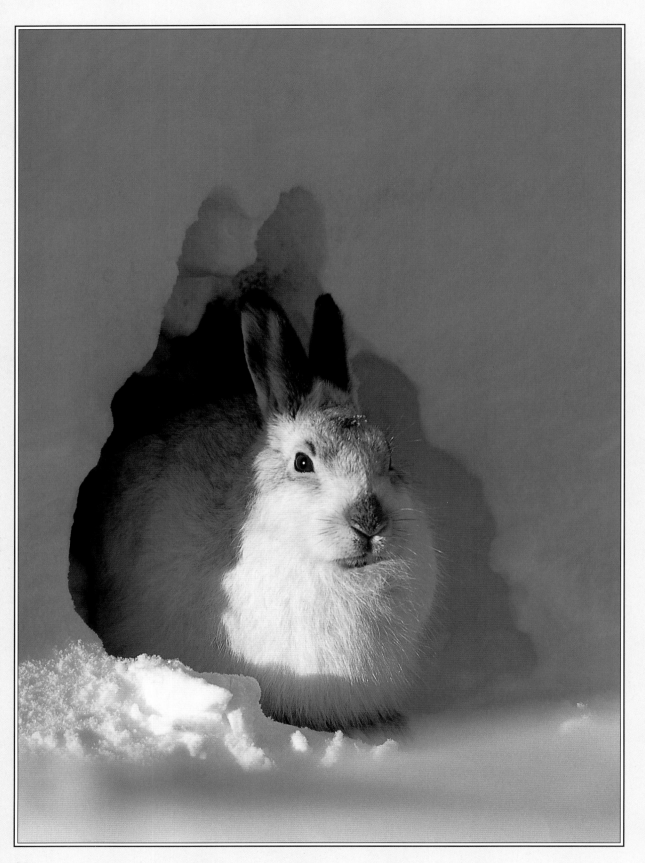

Steve Austin
United Kingdom
HIGHLY COMMENDED

Mountain hare in snow hole

"After several days of heavy snow in Inverness-shire, Scotland, I went into the hills to look for mountain hares. Late in the day I came across this individual catching the last of the afternoon sun. Its snow hole was tailor-made to accommodate its ears at the top. The hare was obliging enough to still be there after I had to return to my rucksack to get another lens."

Canon T90 with 400mm lens; 1/250 sec at f5.6; Fujichrome Provia; beanbag

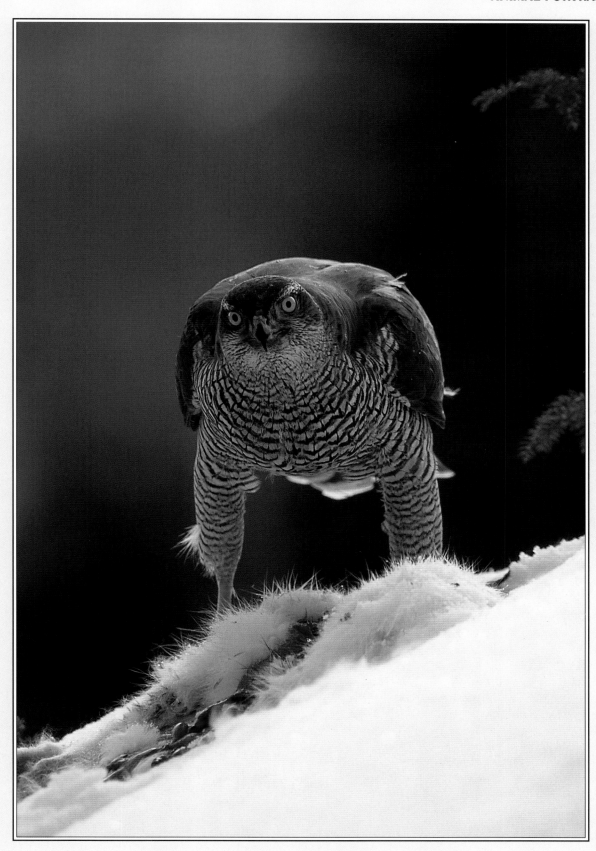

Kari Reponen
Finland
HIGHLY COMMENDED

Goshawk

"Goshawks are quite common near my home in southern Finland. Using a telephoto lens, I had the luxury of homing in on this individual for nearly an hour as it consumed a snow hare. I particularly liked this photograph, which emphasised the goshawk's savage yet majestic appearance."

Nikon F4s with 300mm lens and x2 extender; 1/60 sec at f5.6; Fujichrome Velvia; tripod

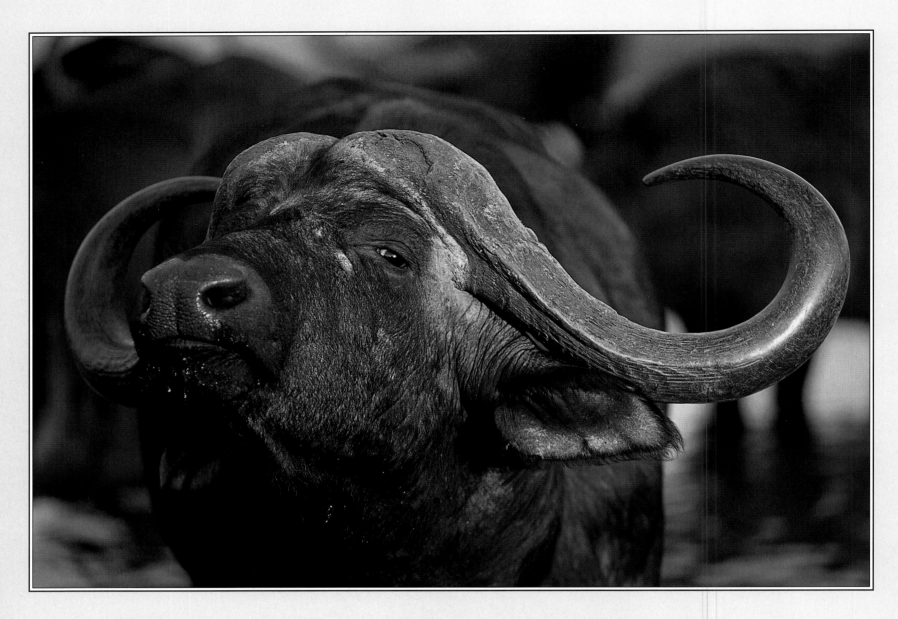

Paul Allen
United Kingdom
HIGHLY COMMENDED

African buffalo

*"A herd of about 500 buffalo came down to drink
at a waterhole in the eastern Transvaal in South
Africa. This male – identifiable by the large 'boss'
on his head where the horns meet – paused from
drinking to regard me with passive curiosity.
A large bull can weigh more than 800 kilograms,
and though usually peaceful, can be dangerous."*

Nikon F4S with 80-200mm lens; 1/500 sec at f4;
Fujichrome Velvia

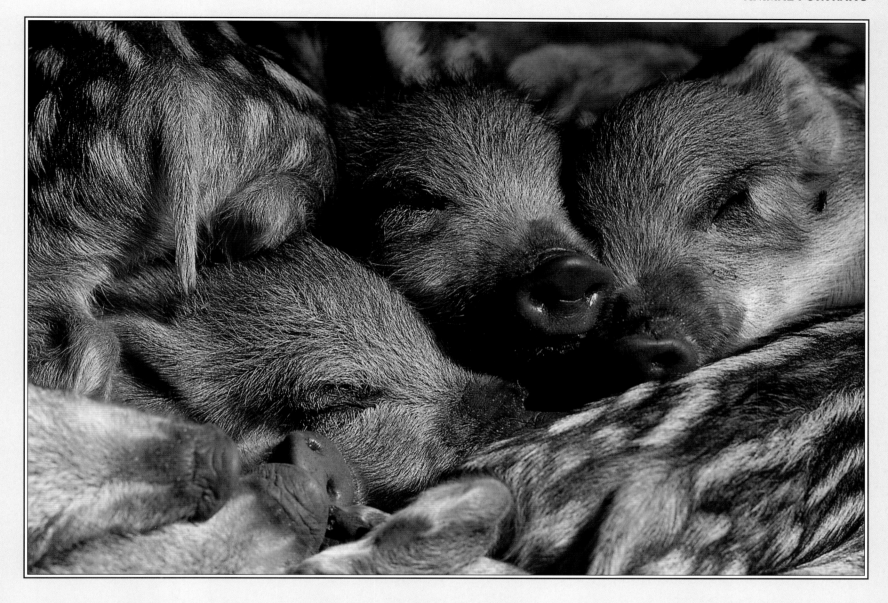

Jan Vermeer
Netherlands
HIGHLY COMMENDED

Wild boar piglets

"Rich forests surround my home, and I'm rarely short of wildlife subjects to photograph there. Veluwe Nature Reserve is part of this forest, and in March I spent several weeks there looking for wild boar piglets. I found this huddle, still in their pyjama-look baby coats, sleeping on the ground in a nest of leaves."

Canon EOS 3 with 500mm lens and x1.4 teleconverter;
1/30 sec at f6.8; Fujichrome Sensia II

ANIMAL BEHAVIOUR
- MAMMALS -

Mammals pictured actively doing something. These images illustrate moments that have both interest value and aesthetic appeal.

Michel Denis-Huot
France
WINNER

Lioness carrying cub

"This lioness carefully transported her litter of four cubs, one by one, to the safety of a new hiding place in the long grass at Maasai Mara National Reserve, Kenya. This particular cub proved to be quite a mouthful, and she had to use her big front paw to keep it from wriggling out."

Canon EOS 1 NRS with 600mm lens; Fujichrome Sensia II 100

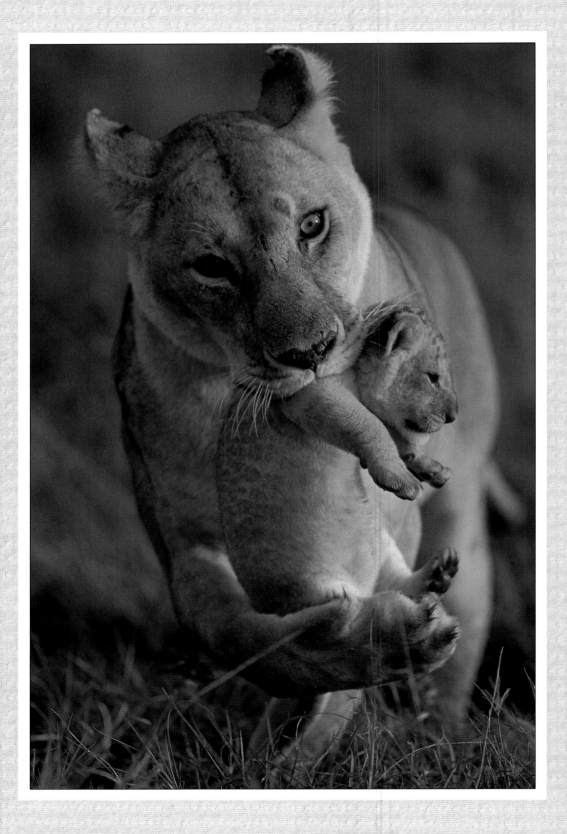

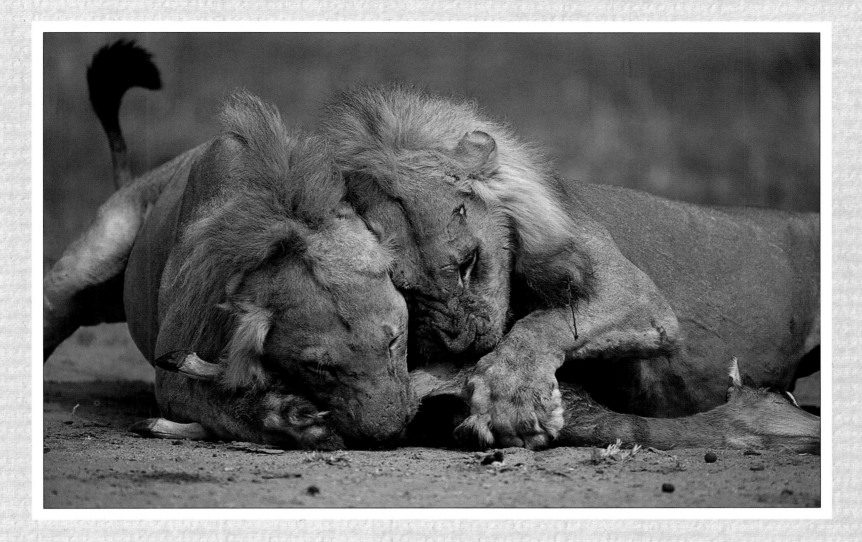

Adrian Bailey
South Africa
RUNNER-UP

Lions fighting over impala kill

"These two lions were the dominant males in the southern part of the Savuti marsh in Botswana's Chobe National Park. This impala kill was stolen from a cheetah after one of the males investigated impala alarm calls near to where the pair was resting for the day. The fight began when the other male arrived on the scene about five minutes later."

Nikon F5 with 500mm lens; Fujichrome

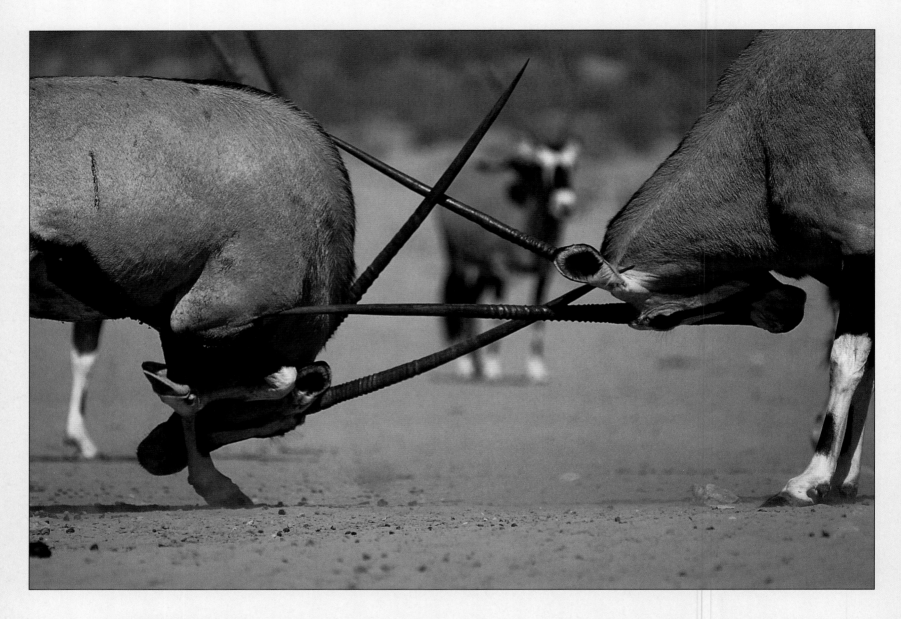

James Warwick
United Kingdom
HIGHLY COMMENDED

Gemsbok sparring

"The heads of two sparring gemsbok normally collide with
a thunderous bang, but on this occasion, the horn tips
made contact long before their heads could, threatening to
pierce like hypodermic needles. Gemsbok have been seen
using their horns to fend off pursuing hyaenas by charging
them with their heads down. The photograph was taken in
the Kalahari Desert's Nossob River valley, Namibia."

Nikon F90x with 400mm lens and x1.4 teleconverter;
Fujichrome Sensia 100; beanbag

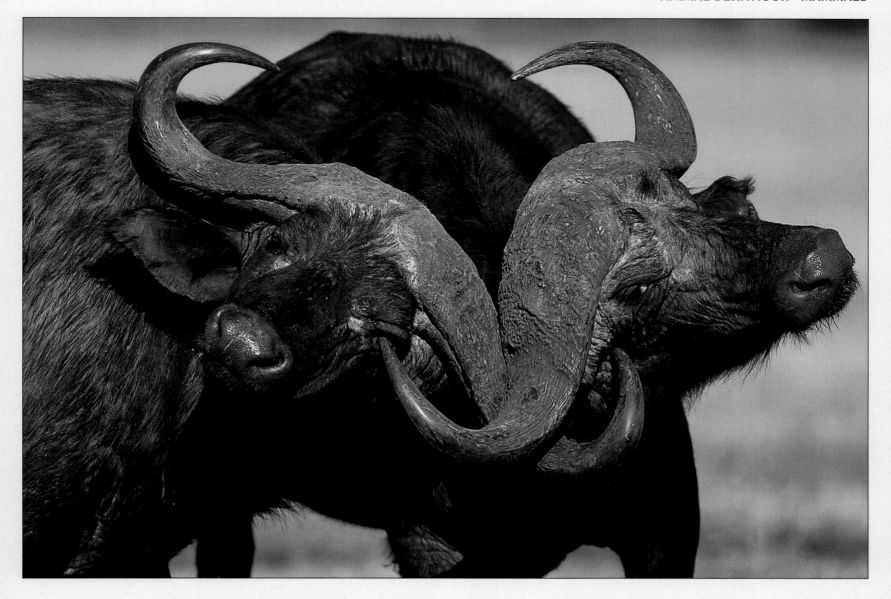

Manoj Shah
United Kingdom
HIGHLY COMMENDED

Cape buffalo fighting

"These two buffalo bulls in Maasai Mara National Reserve, Kenya, separated from the herd and locked horns in a ritualistic trial of strength. Their massive, heavily bossed horns had sharp ends and at times came perilously close to piercing an eye. The rest of the herd loitered, indifferently, nearby."

Canon EOS 1N with 600mm lens; Fujichrome Sensia 100

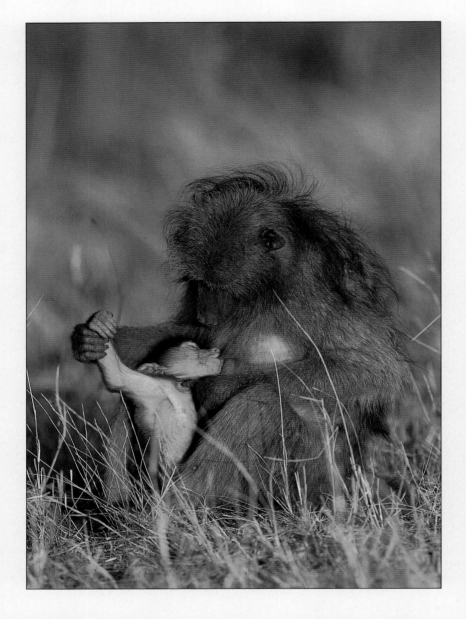

Gil Lopez-Espina
United States of America
HIGHLY COMMENDED

Chacma baboon suckling baby
*"The youngster's mother delicately embraced him
as he fed, and the scene was very peaceful.
But it wasn't long before he resumed his boisterous
play with the rest of the troop, at which point,
his mother relinquished the responsibility of
infant-rearing to a young nanny baboon."*

Nikon F5 with 600mm lens; 1/125 sec at f5.6;
Fujichrome Velvia; beanbag

Anup Shah
United Kingdom
HIGHLY COMMENDED

Lion watching cub
*"One of the two males in the pride I was following
in the Maasai Mara National Reserve, Kenya,
seemed to be transfixed by one of the cubs that a
lioness had presented while he was having a siesta.
When a lioness nears the end of her pregnancy, she
separates from the pride to give birth and remains
in isolation with her litter for up to six weeks."*

Canon EOS 1N with 500mm lens; Fujichrome Sensia 100

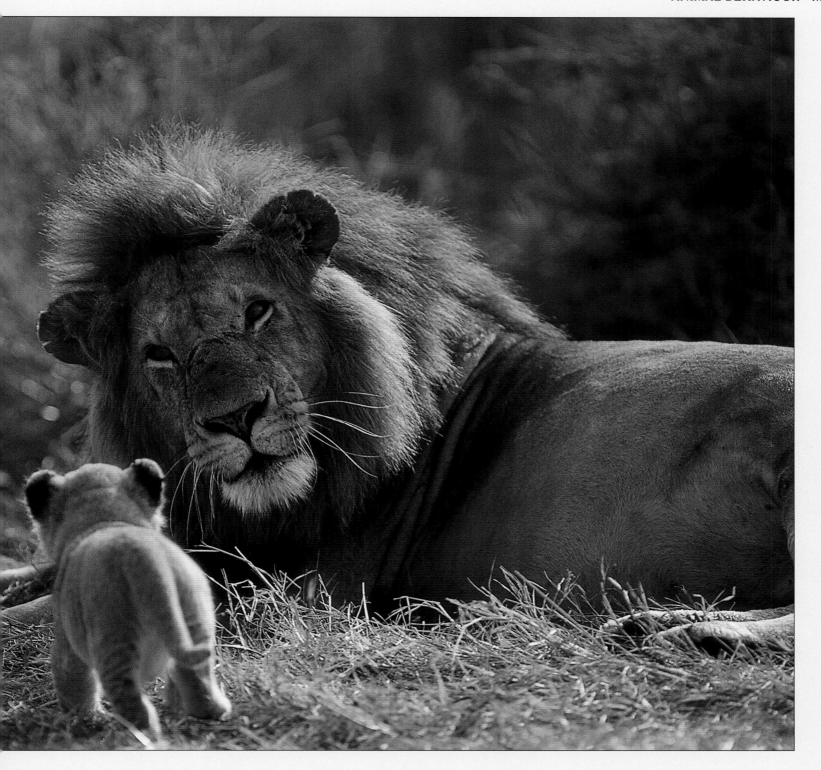

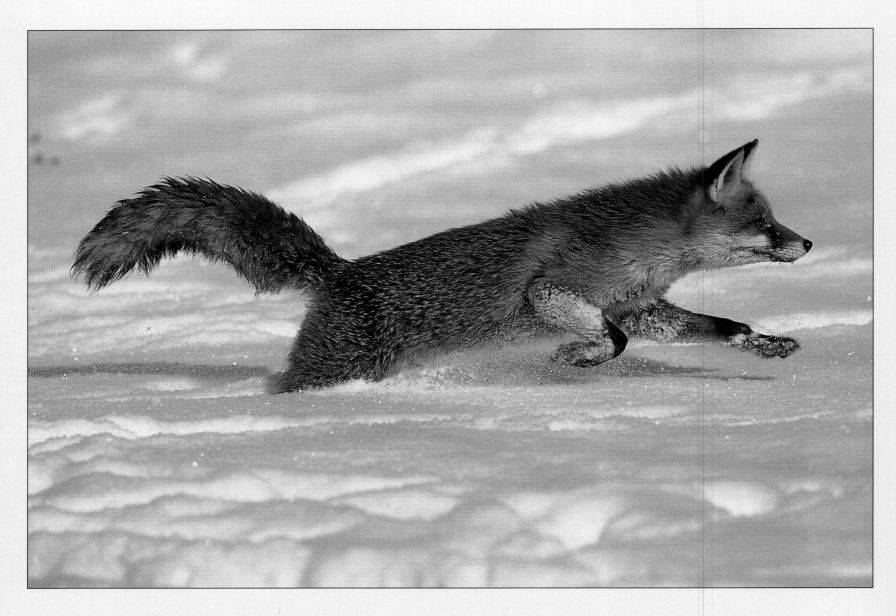

Manfred Danegger
Germany
HIGHLY COMMENDED

Fox running through snow

*"I put out food for the buzzards in winter
near my home on Lake Constance in
southern Germany. On this occasion,
it had been snowing for a few days,
making life difficult for all the animals,
including this fox, who came to take
advantage of the free meal."*

Canon EOS 3 with 600mm lens; 4/1000 sec;
Fujichrome Sensia II 100

44

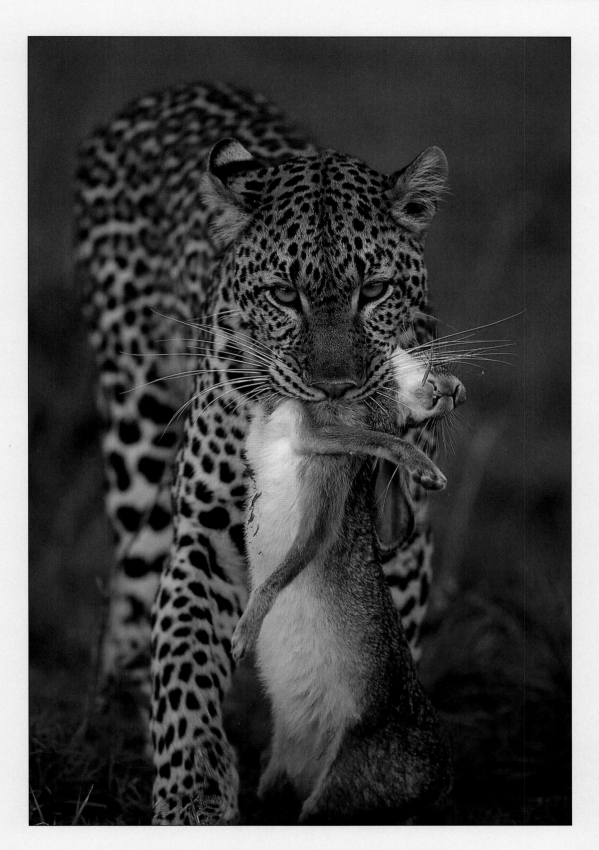

Mike Hill
United Kingdom
HIGHLY COMMENDED

Leopard with African hare
"This is Zawadi, one of the offspring of the famous Maasai Mara leopard Half Tail, star of the BBC series 'Big Cat Diary'. For most of the day we had watched Zawadi resting, and now she was in the mood to hunt. Having no luck with a herd of impala, she headed into a bush and emerged carrying this large African hare. Our driver skilfully positioned us some distance away so that Zawadi walked straight towards the camera."

Nikon F5 with 500mm lens;
Fujichrome Sensia 100; beanbag

Thomas Dressler
Germany
HIGHLY COMMENDED

Ground squirrel at thornbush

"The rainy season in the Kalahari Gemsbok National Park, South Africa, attracts many animals and their young to the rich food supplies. On this particular day, there were no herds of gazelles and antelopes, and so I didn't expect to see any 'excitement'. But before I knew it, I became absorbed by the behaviour of the ground squirrels, which were equally intrigued by me. After their curiosity wore off, they devoted time to feeding, grooming and playing. This youngster was carefully nibbling a thornbush, keen to try whatever came its way."

Canon EOS 5 with 300mm lens; Fujichrome Velvia; tripod

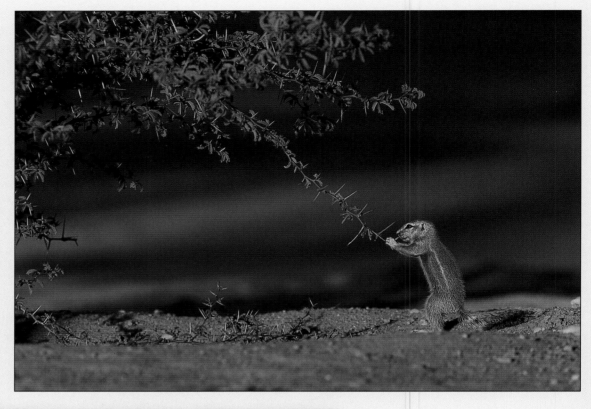

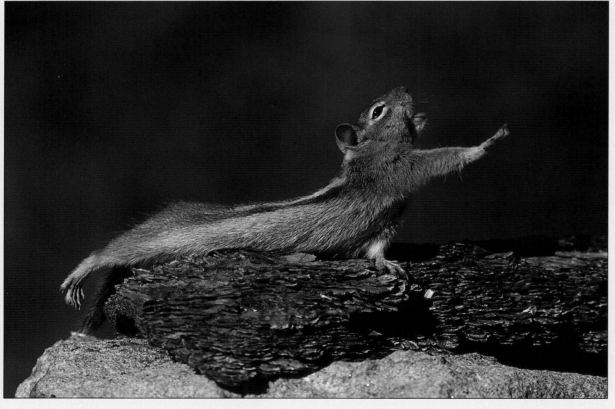

Wendy Shattil & Bob Rozinski
United States of America
HIGHLY COMMENDED

Golden-mantled ground squirrel stretching

"We'd been watching this golden-mantled ground squirrel for a while in the hills above Denver, Colorado, USA. As it grew hotter, the squirrel began yawning and stretching and didn't seem to mind showing us its vulnerable side, appearing completely relaxed in our presence."

Canon EOS 1N with 600mm lens; 1/250 sec at f8; Fujichrome Velvia

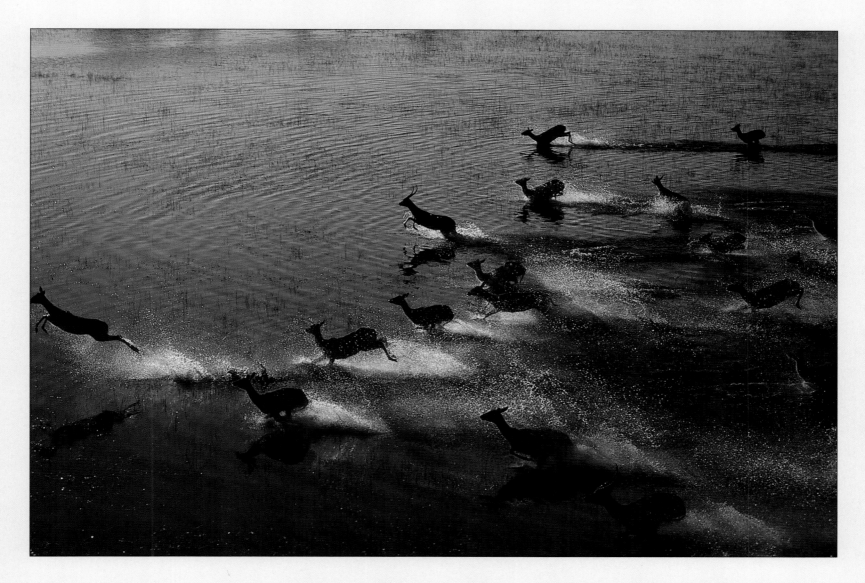

Beverly Pickford
South Africa
HIGHLY COMMENDED

Red lechwe crossing floodplain

"Herds of lechwe follow the route of the annual flood into the Okavango Delta in Botswana to feed on the flush of green. One April dawn, I was flying across a floodplain and saw this herd crossing from one island to another with the spray illuminated from behind by the early sun."

Nikon F4 with 80-200mm lens; Kodachrome 64

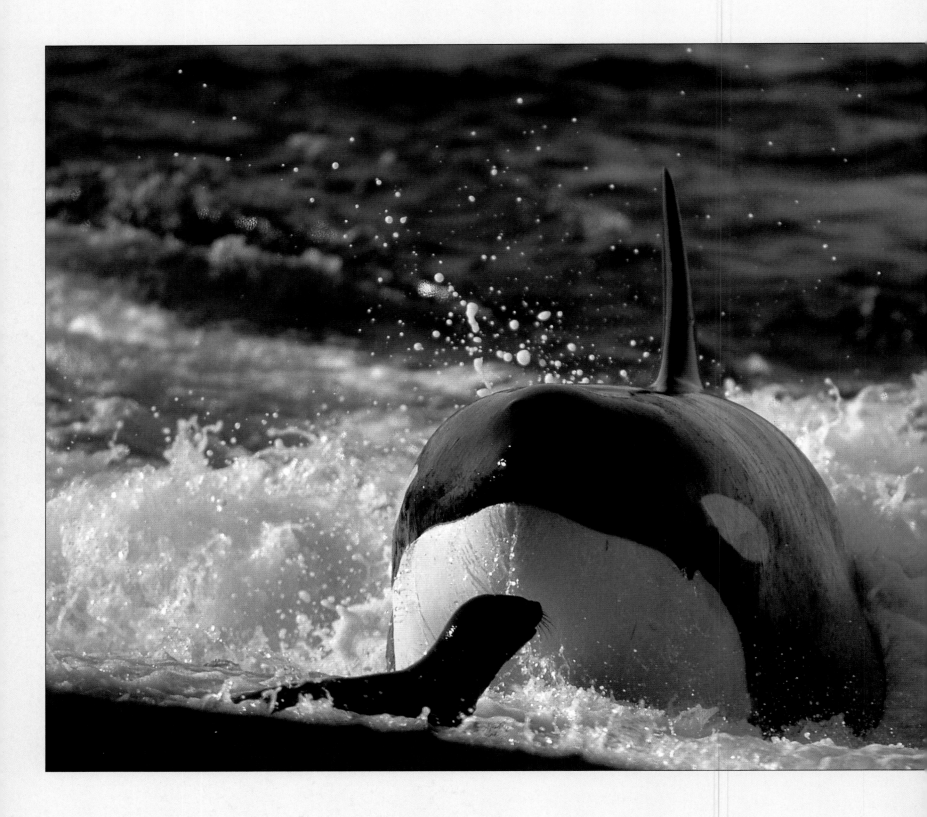

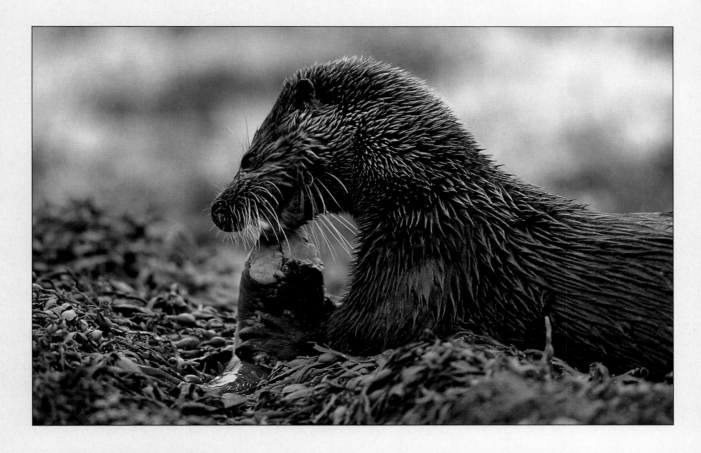

Winfried Wisniewski
Germany
HIGHLY COMMENDED

Killer whale chasing seal
"Killer whales off Patagonia are now
famous for their technique of catching sea
lions by partially beaching themselves.
Elsewhere, very few killer whales have
learnt the trick. This whale, one of a pod
of seven young females hunting off
Península Valdés, Argentina, surged onto
the beach and narrowly missed a young
pup. I was lucky to be in front of the
drama when it happened."

Nikon F5 with 600mm lens; Fujichrome Velvia

Charles Brown
United Kingdom
HIGHLY COMMENDED

Otter eating fish
"One summer, I was sitting by a tidal
pool on the island of Mull, Scotland,
when an otter arrived and began diving
in earnest for fish. I moved near to a spot
where I thought it may land to eat its
prey. Ten or so moves later, I was poised
by this rock, which turned out to be the
very rock the otter chose to use
as a dining table."

Canon EOS 100 with 500mm lens
with x1.4 extender; 1/250 sec at f5.6;
Fujichrome Sensia 100; tripod

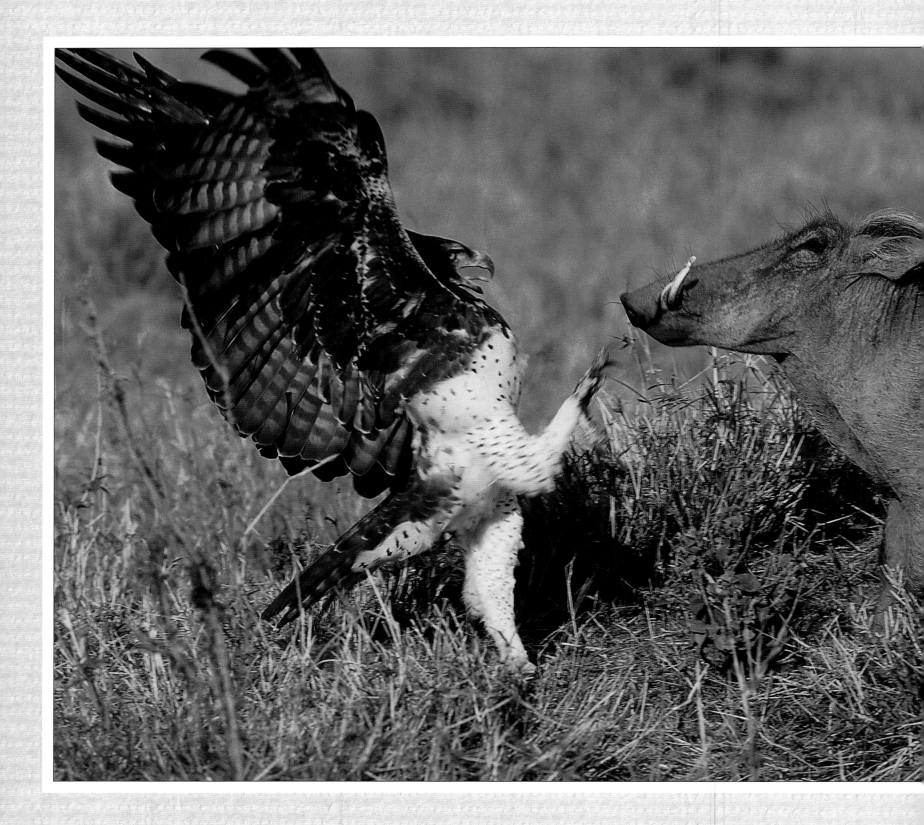

ANIMAL
BEHAVIOUR
- BIRDS -

Birds photographed actively doing something.
These images capture moments that have interest
value as well as aesthetic appeal.

Uwe Walz
Germany
WINNER

Martial eagle and warthog

*"I came across this confrontation while
in the Maasai Mara National Reserve,
Kenya. The warthog, which had two
piglets with her, was bravely facing the
martial eagle, which had its wings spread
open and was hissing. Suddenly, the
warthog charged in an attempt to spear
the eagle with her tusks. But the eagle
retaliated by striking out with its razor-
sharp talons, cutting the warthog's
sensitive snout twice, and causing her to
flee. It was only then that I noticed the
eagle was standing over a dead piglet."*

Canon EOS 1 with 600mm lens; 1/250 sec at f4;
Kodak; beanbag

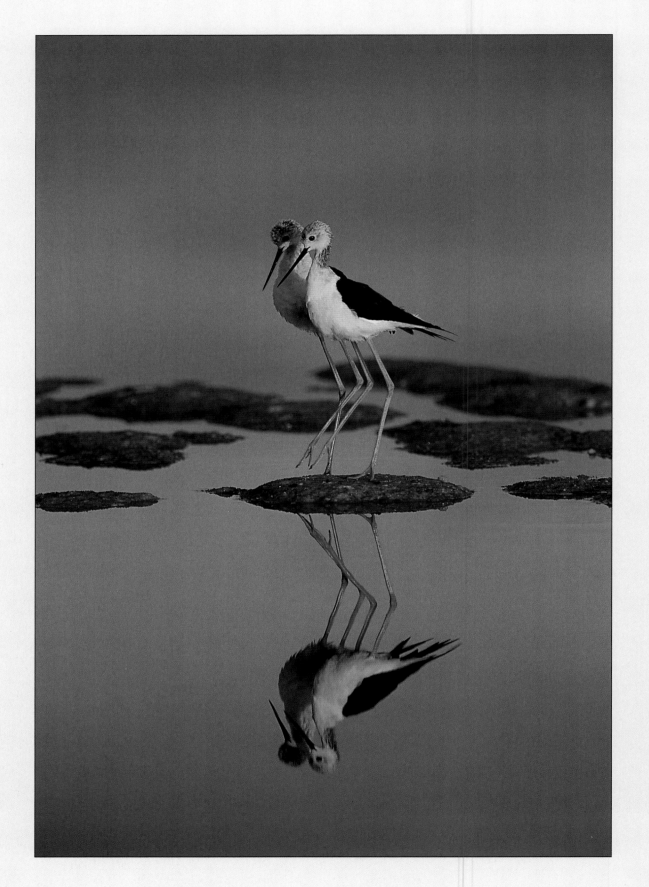

Yossi Eshbol
Israel
RUNNER-UP

Black-winged stilts after mating

"This pair are taking a gentle, post-coital stroll after a thrilling display.
An elaborate, pre-dawn ritual led to the male mounting his mate and embracing her with his wings. When he finished, he continued to hug her with one of his wings, and they walked together in unison. They crossed beaks intimately as they continued their stroll and then stood close together, apparently enjoying each other's company."

Nikon F5 with 600mm lens; 1/250 sec at f4;
Fujichrome Velvia rated at 100; tripod

52

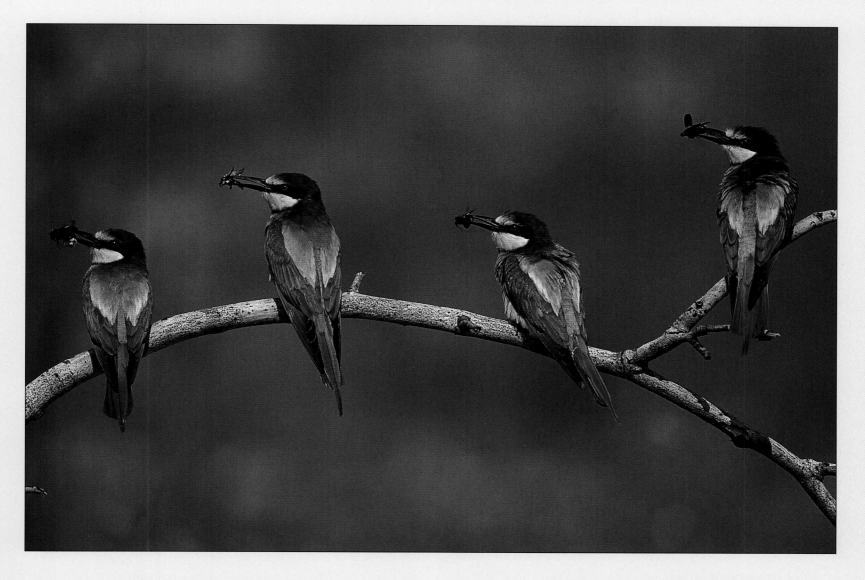

Rainer Müller
Germany
HIGHLY COMMENDED

Bee-eaters with prey

"I spent three days in central Hungary, photographing a colony of Eurpoean bee-eaters. Before feeding their young ones they often returned to this perch for a few minutes. This image of the four bee-eaters with prey, looking in the same direction lasted about 10 seconds."

Canon EOS 1N with 600mm lens;
Fujichrome Velvia

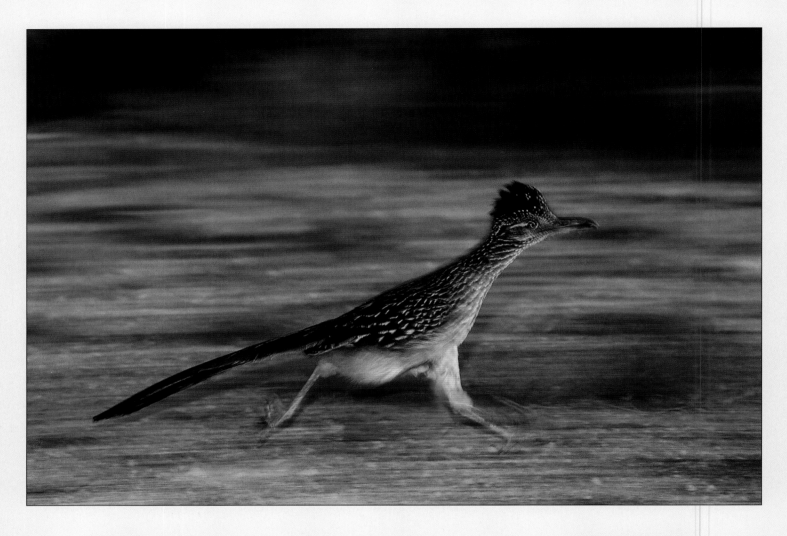

Jeff Foott
United States of America
HIGHLY COMMENDED

Roadrunner

*"I spotted a route in the Mojave Desert,
California, USA, along which a pair of
roadrunners dashed back and forth. They were
carrying food for their two chicks. Stationing
myself along their distribution route, I panned
my camera to catch this individual in full sprint."*

Nikon F4 with 80-200mm lens; 1/15 sec at f11;
Kodachrome 64 rated at 80

Rupert Büchele
Germany
HIGHLY COMMENDED

Mute swans in flight

*"Winter is a good time to photograph swans
because many congregate around food sources,
and so you have ample opportunity to retake
shots. I got through a lot of film using long time
exposures before I achieved the effect I wanted –
the swans landing in the evening sunshine."*

Nikon F5 with 300mm lens and x1.4 teleconverter;
1/8 sec at f11; Fujichrome Velvia; tripod

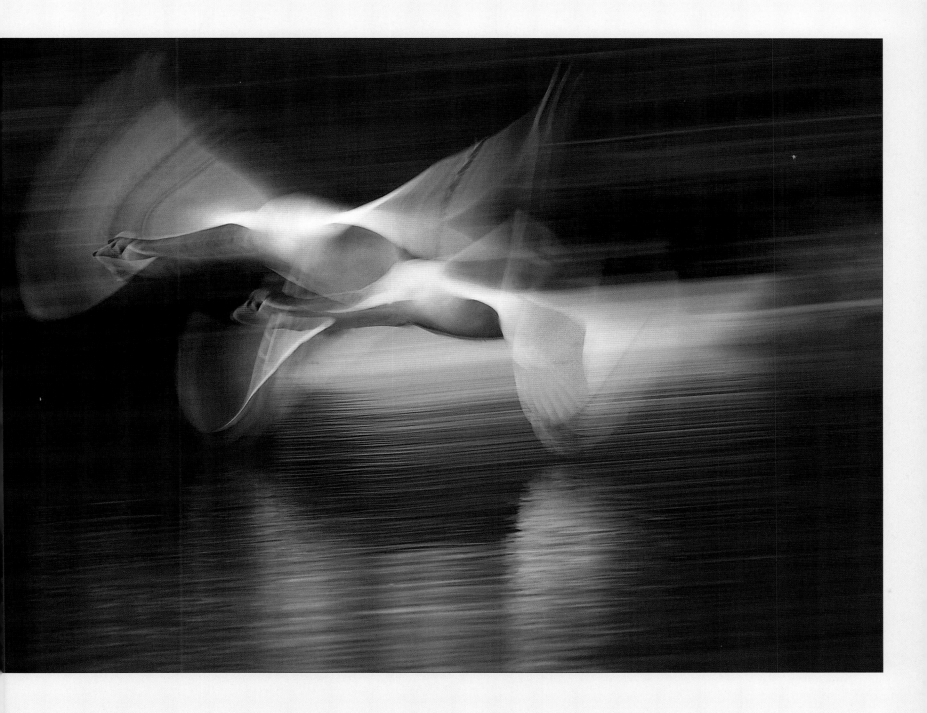

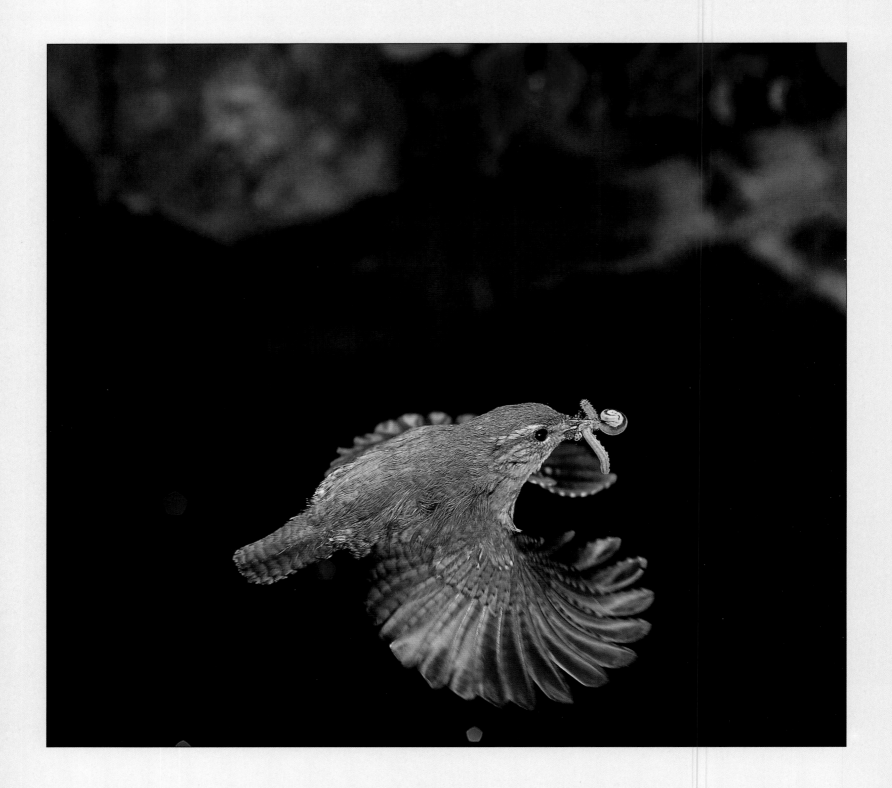

Francesco Velletta
Italy
HIGHLY COMMENDED

Wren carrying caterpillars back to nest

"This male wren had his work cut out feeding two females sitting in two nests a few metres apart on the banks of a canal (bigamy is not unusual for wrens). He would fly in along the same path, just a few centimetres above the water surface, which meant I could set up an infrared beam so he could take his own photograph."

Hasselblad 500 ELX with 120mm lens; 1/30 sec at f11; Fujichrome Velvia; 3 flash photo-cell barrier

Manoj Shah
United Kingdom
HIGHLY COMMENDED

Weaver bird building nest

"Male weaver birds construct their intricate nests to impress and attract mates. This male, in the Maasai Mara National Reserve, Kenya, was making the final touches to his loosely constructed nest before trying to attract a female by hanging upside down at the entrance, fluttering his wings."

Canon EOS 1N with 300mm lens; Fujichrome Sensia 100

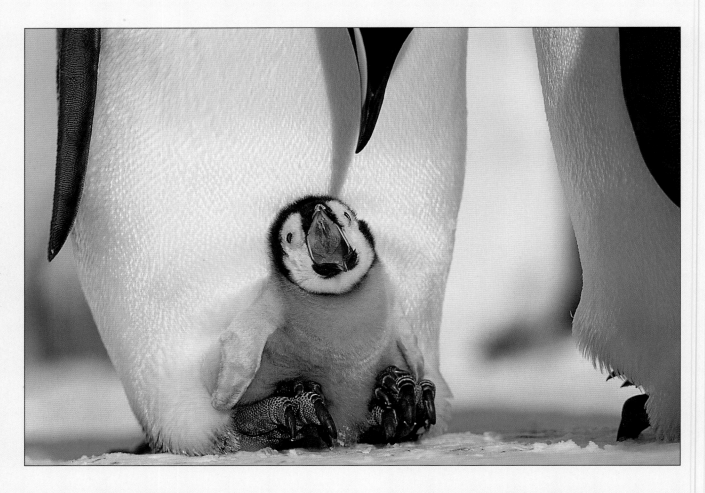

David Tipling
United Kingdom
HIGHLY COMMENDED

Emperor penguin chick

*"In early November, I joined an expedition going to camp next to an emperor penguin colony on the Dawson-Lambton Glacier, Antarctica.
I wanted to see the chicks when they were still small enough to be brooded on their parents' feet.
To make sure I got to the colony quickly, I used a ski plane so I could land directly on the ice.
The chicks were still tiny, and so the effort paid off."*

Nikon F5 with 300mm lens; Fujichrome Velvia

Graham Robertson
Australia
HIGHLY COMMENDED

Wandering albatrosses courting

"I photographed these birds on South Georgia early one morning in a rare moment of squall light, which is arguably the best light you can get, particularly when surrounding a bird that spends its life being blown about in the Southern Ocean. The albatross with its wings outstretched is a male trying to attract the female, who is grass-bound, having been exhausted by the size of the male's ego!"

Nikon F90x with 80-200mm lens; 1/250 sec at f8; Fujichrome Velvia rated at 250

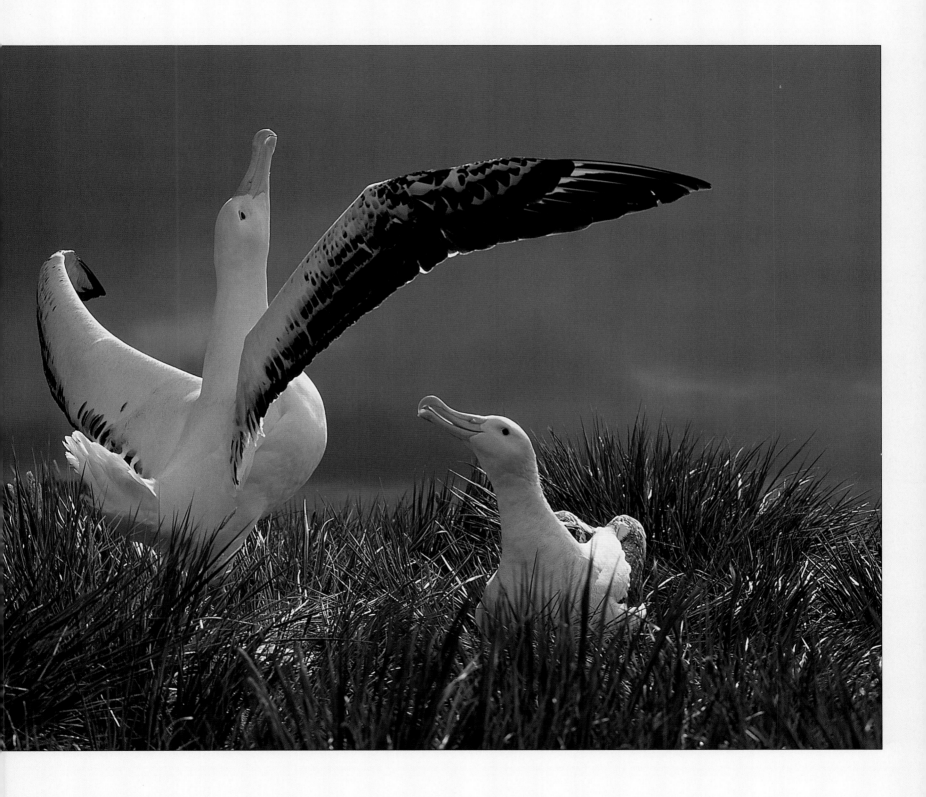

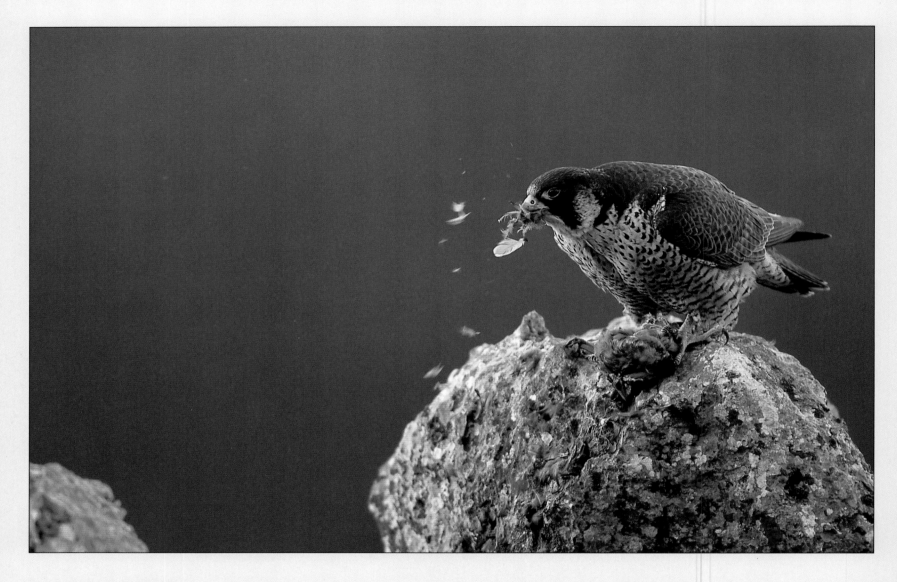

Dietmar Nill
Germany
HIGHLY COMMENDED

Peregrine falcon plucking bird
"I'd been waiting in my hide since the middle of the night to avoid any disturbance and so was feeling cold and stiff when this peregrine arrived just before the sun rose. She perched on her usual 'plucking post', where she devoured the starling."

Canon EOS 1N with 600mm lens;
Fujichrome Sensia 100

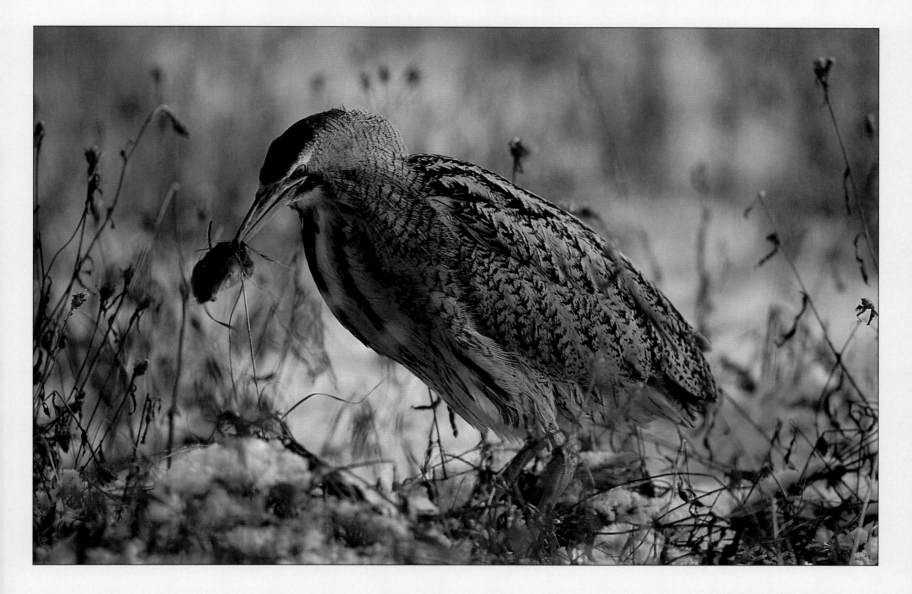

Berndt Fischer
Germany
HIGHLY COMMENDED

Bittern with vole

"A particularly harsh spell, one January in northern Bavaria, froze the ponds for some time. This bittern had switched from fishing to catching voles in the meadows. I watched it for several weeks and one day saw it devour seven voles in half an hour."

Nikon F4 with 500mm lens; 1/250 sec at f4;
Fujichrome Velvia; beanbag

61

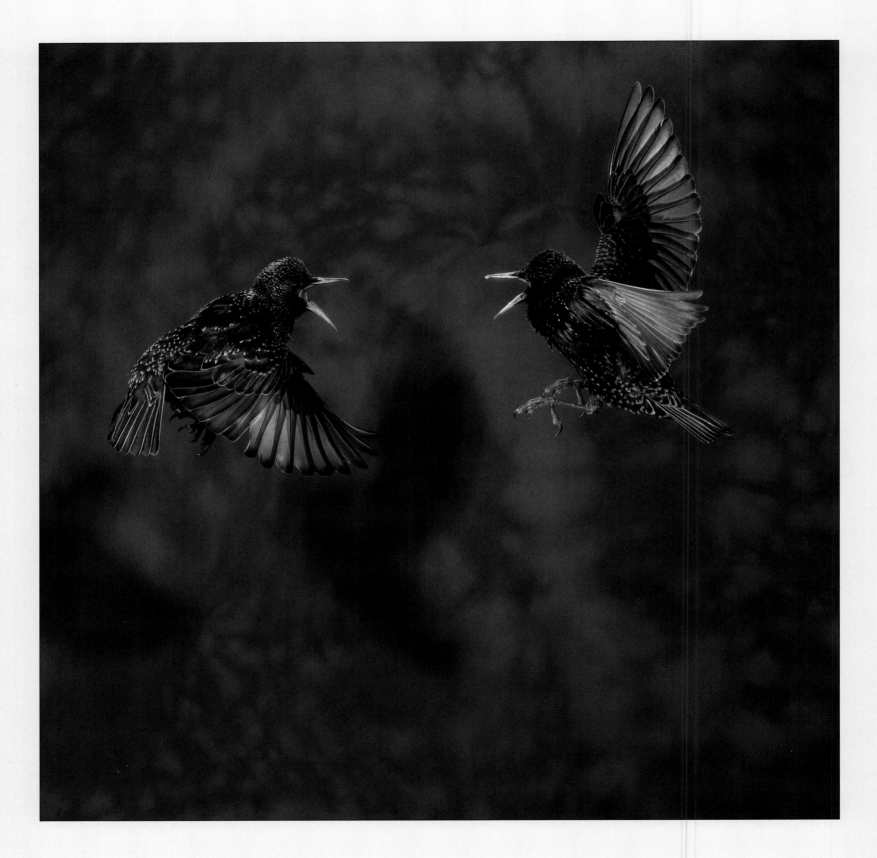

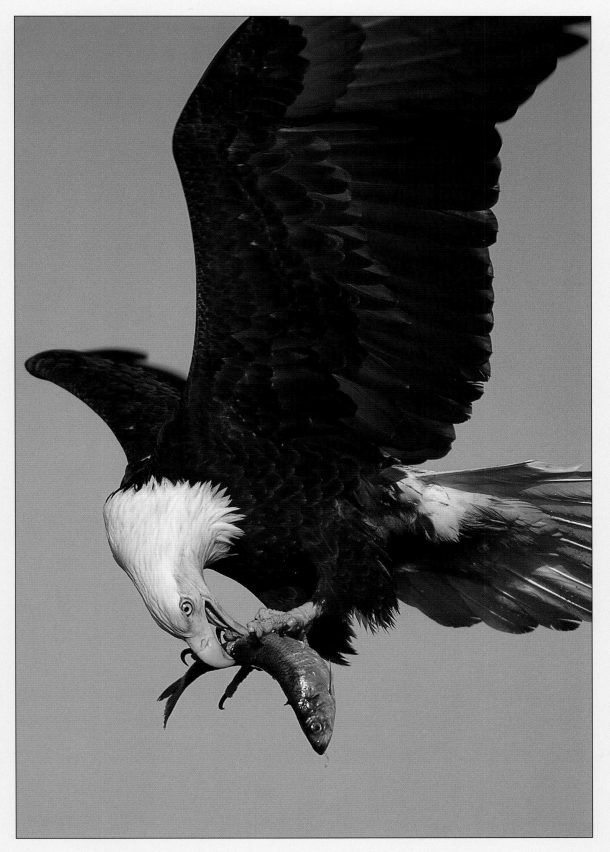

Alan C Parker
United Kingdom
HIGHLY COMMENDED

Starlings fighting

*"For several years, I had tried to take
a photograph of starlings fighting in a
snowstorm. Last winter, snow, good light and
action came together on cue in my
back garden in Essex."*

Bronica SQ AM with 110mm lens; 1/30,000 sec at f16;
Fujichrome Provia 100; 3 high-speed flash units

Sylvain Cordier
France
HIGHLY COMMENDED

Bald eagle with salmon

*"I have visited Alaska a few times and only
dreamt of taking this kind of picture, the bald
eagles seeming so elusive. In March, at the
Kenai peninsula, I watched this individual
catch a salmon and then start devouring it on
the wing. Maybe it urgently needed food
because of the cold, or else it was trying to
eat its fish before a rival snatched it."*

Canon EOS 1N with 500mm lens; 1/640 sec at f4.5;
Fujichrome Sensia 100; tripod

ANIMAL BEHAVIOUR

- ALL OTHER ANIMALS -

Subjects photographed actively doing something. From insects to reptiles, these images reveal moments that have interest value as well as aesthetic appeal.

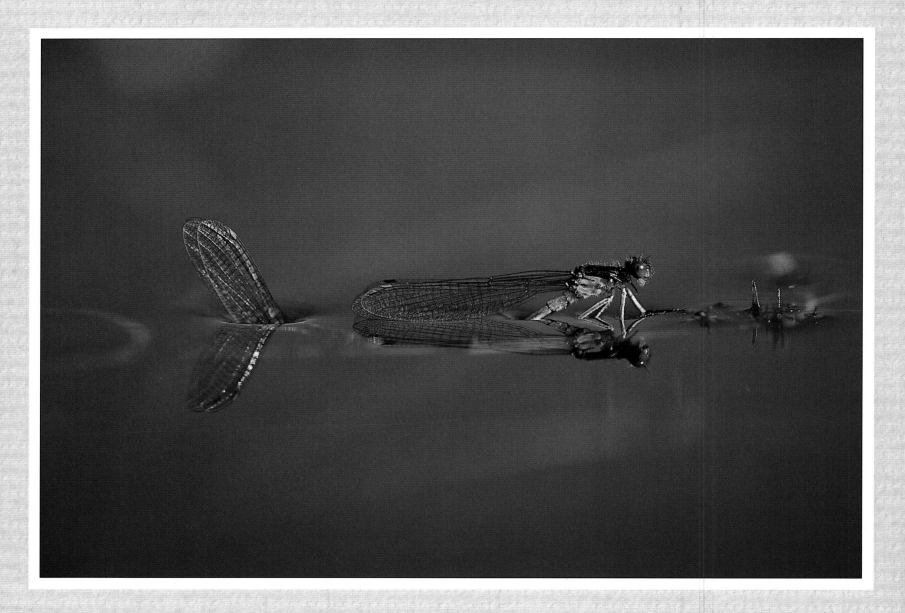

Thomas Endlein
Germany
WINNER

Red-eyed damselflies laying eggs

"In July, you can see these damselflies flying across vegetation-rich ponds, such as this one near my hometown of Rothenburg in Germany. The female dives slowly under the surface to lay her eggs, taking an air-bubble with her so she can stay under water for some time while still connected to the male. To photograph this at water level, I used a self-made floating tripod."

Canon EOS 1NRS with 180mm macro lens; 1/60 sec at f3.5; Fujichrome Velvia; tripod

Robert & Virginia Small
Canada & United States of America
RUNNER-UP

Diamondback rattlesnakes

"It was late spring and we were travelling through Laguna Atascosa National Wildlife Refuge, south Texas, USA, when we came upon this pair of western diamondback rattlesnakes. At first glance, we thought they were engaged in a courting ritual. However, after further research, we discovered that what we actually witnessed was the rarely observed 'combat dancing'. This takes place between male diamondbacks as part of the selection process prior to mating."

Canon EOS 1NRS with 600mm lens; Fujichrome Velvia rated at 100; tripod

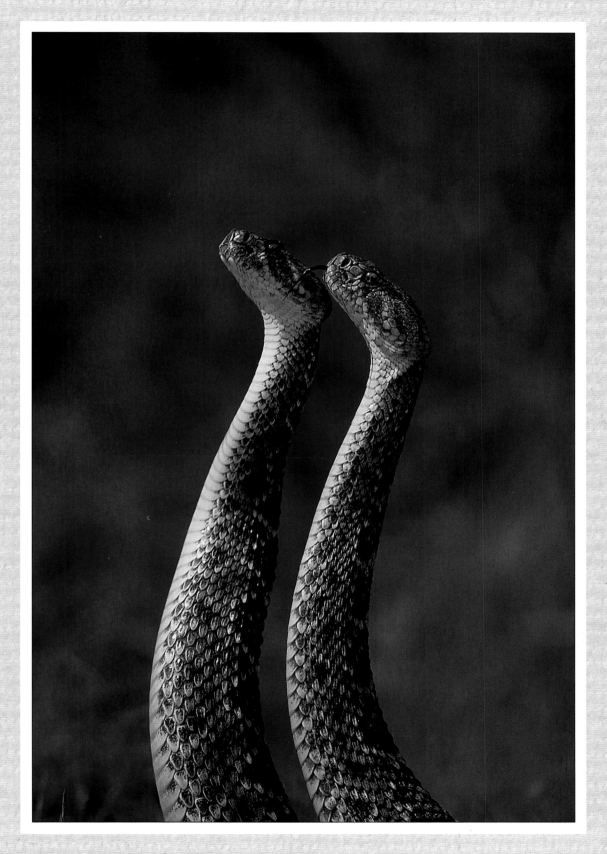

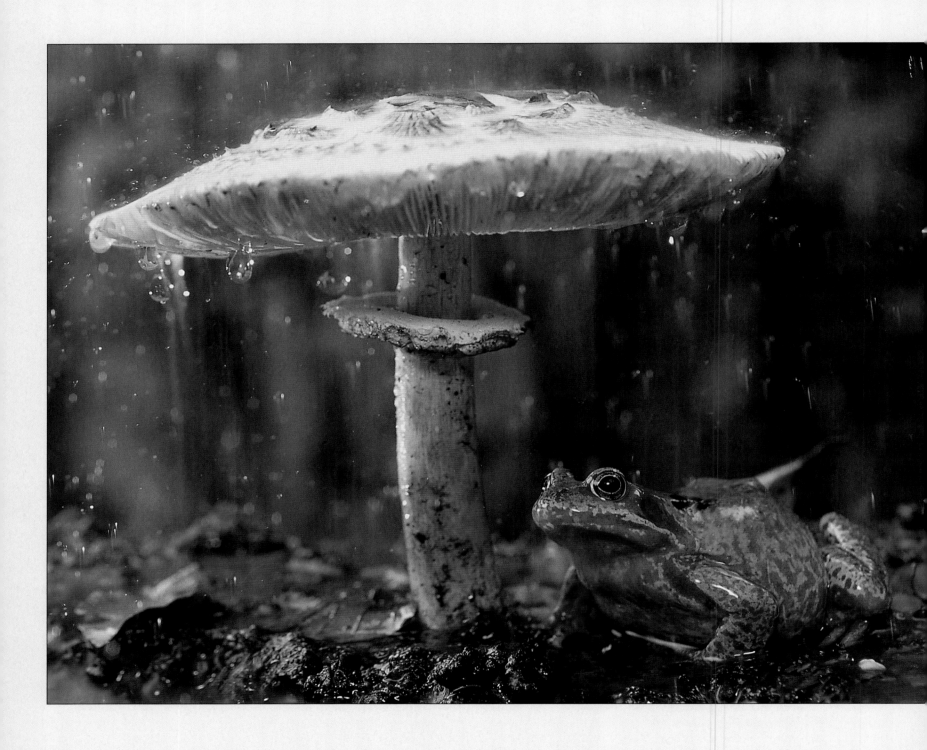

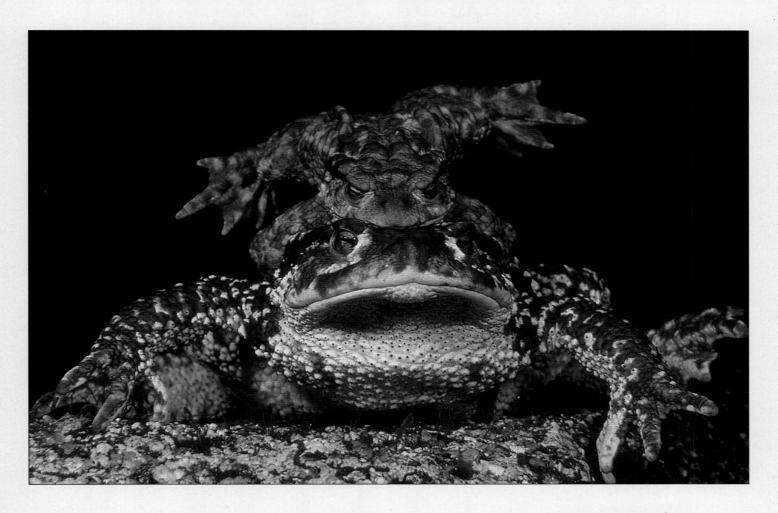

Jose L Gonzalez
Spain
HIGHLY COMMENDED

Common toads mating

"In spring, the male common toad's main goal is to mate. The female is considerably larger than her suitor, who will cling to her until she deposits her eggs. Sometimes one female has several males wrapped around her, all trying to be the one who succeeds in fertilising her eggs. I took this picture while snorkelling in a river in Galicia, northwest Spain."

Nikon F4s with 60mm micro lens; 1/60 sec at f16; Fujichrome Provia 100; underwater housing, two flashes

Edwin Giesbers
Netherlands
HIGHLY COMMENDED

Sheltering frog

"I set off to photograph fungi in a forest near my home in Arnhem, but it was raining hard. I spotted this toadstool and then noticed the frog. I approached very slowly and used a slow shutterspeed to show up the rain."

Nikon F801s with 200mm lens; 1/15 sec at f8; Fujichrome Sensia 100

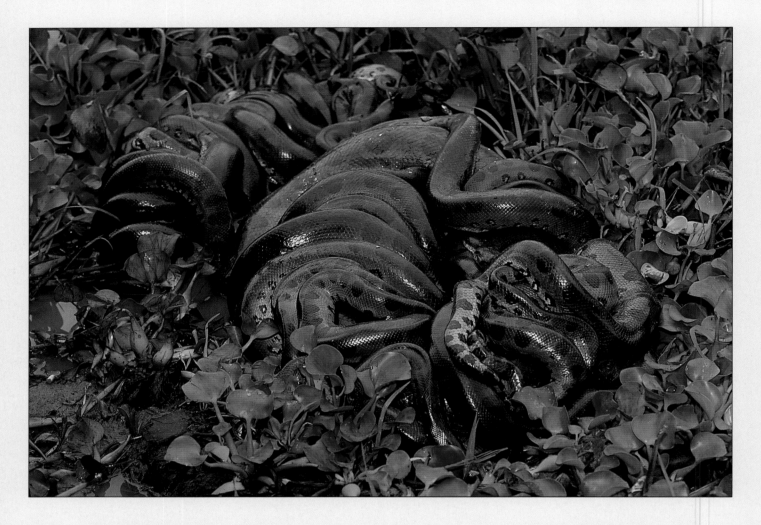

François Savigny
France
HIGHLY COMMENDED

Anaconda mating ball

"When I spotted this massive 'snake knot' in the Llanos swamps of Venezuela, I didn't realise the animals were alive. Only when I got close could I count ten heads of small males tangled around a huge female. She appeared to be around five metres long and 60 kilograms in weight. Other male recruits continued to join the throng, trying to squeeze their way to the female in a frantic quest to breed with her."

Canon EOS 3 with 70-200mm lens; 1/125 sec at f6.3;
Fujichrome Velvia rated at 100

Jürgen Freund
Germany
HIGHLY COMMENDED

Cuttlefish

"Three or four females in a group of 18 cuttlefish were laying eggs in between the coral off Dimakya Island, in the Philippines. A large male guarded them against the attentions of lurking younger males (and me). The larger male had previously spent a few days fighting a succession of smaller rivals and had become so tired that some had managed to sneak in and mate with the females."

Nikon F4 with 16mm fisheye lens; 1/60 sec at f11;
Fujichrome Sensia; underwater housing,
two underwater strobes

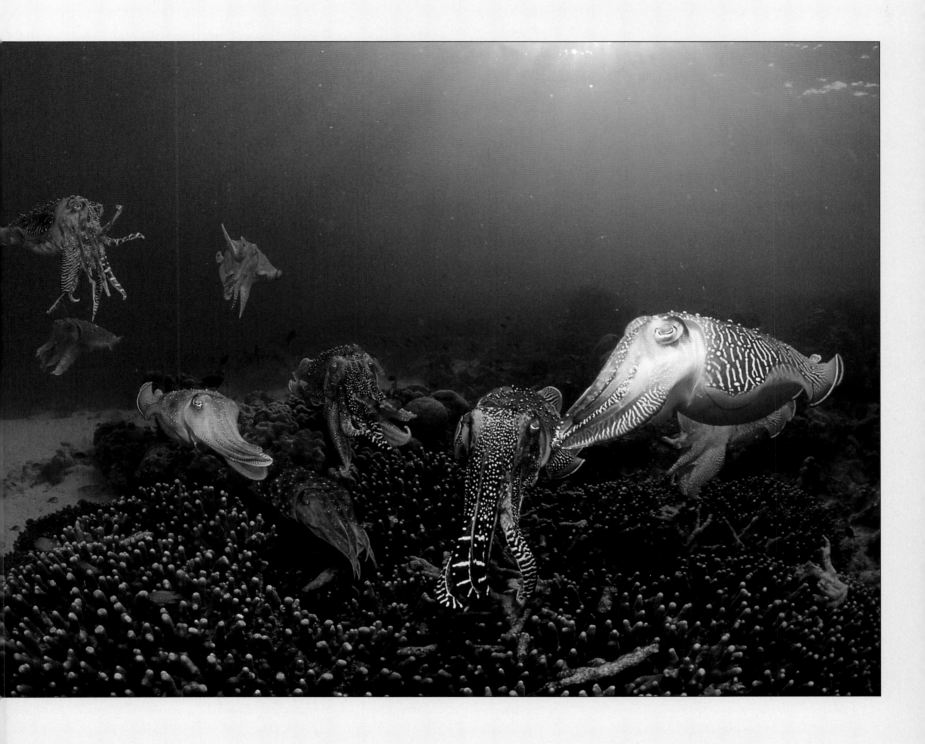

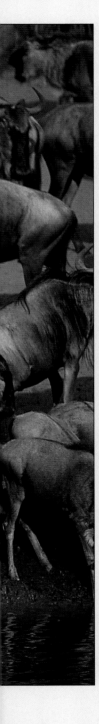

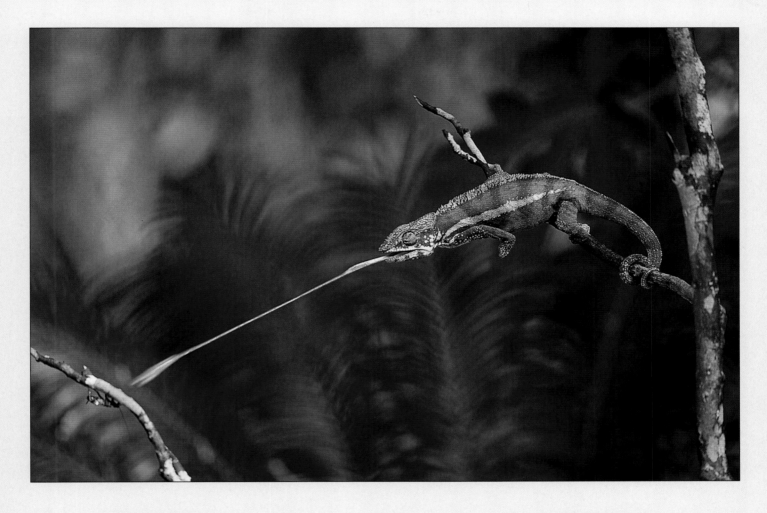

Manoj Shah
United Kingdom
HIGHLY COMMENDED

Crocodile attacking wildebeest

"Migrating wildebeest on the Serengeti-Mara
plains of East Africa provide essential annual
fodder for a Nile crocodile. This giant reptile
values the potential feast so much that it is
prepared to launch at the drinking herd.
But, as can be seen, in spite of wall-to-wall
wildebeest, the technique is chancy,
and the crocodile often misses."

Canon EOS 1N with 200mm lens; Fujichrome Sensia 100

Berndt Fischer
Germany
HIGHLY COMMENDED

Chameleon hunting

"This chameleon, 'Furcifer pardalis', is a
wonderful subject to photograph because of its
extraordinary colours and slow motion – except
when it is hunting and fires its enormous tongue
at lightning speed. It is widespread in
Madagascar, favouring open landscape."

Nikon F5 with 300mm lens; 1/1250 sec at f2.8;
Fujichrome Sensia II 100; tripod

71

BRITISH WILDLIFE

Wild plants or animals in rural or urban settings within the United Kingdom.

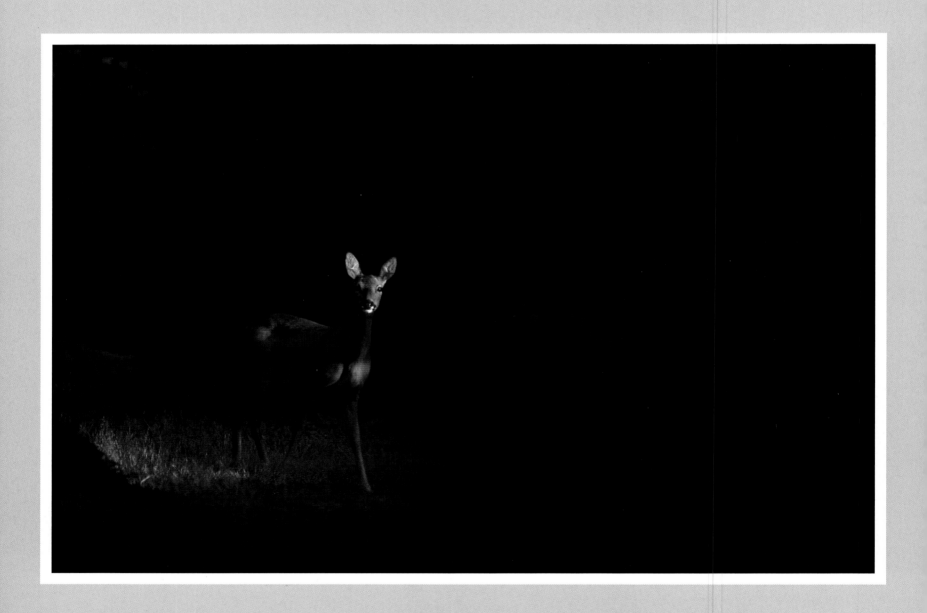

Ron Perkins
United Kingdom
WINNER

Roe deer in glade

"I set out to take this picture early one July morning during the roe deer rutting season. Wearing full camouflage and with my tripod set up, I waited in an Oxfordshire woodland. After half an hour I panned my lens very slowly to bring an approaching doe into frame, willing her to step forward into a shaft of sunlight so that I could get a good picture. She did."

Nikon FE2 with 500mm lens; 1/250 sec at f4.5; Fujichrome Sensia II 100; monopod

Terry Andrewartha
United Kingdom
RUNNER-UP

Grey partridge displaying

"I was photographing pink-footed geese on a Norfolk farm, when a covey of grey partridges stole centre-stage. I abandoned the geese and for the next three, cold February weeks, went into the hide just after dawn to photograph the early rising partridges. Of the many photos I took, I particularly like this one taken on a frosty morning, of a handsome cock partridge, calling into the eerie mist."

Canon EOS 1N with 600mm lens; 1/250 sec at f6.3; Fujichrome Sensia II rated at 200

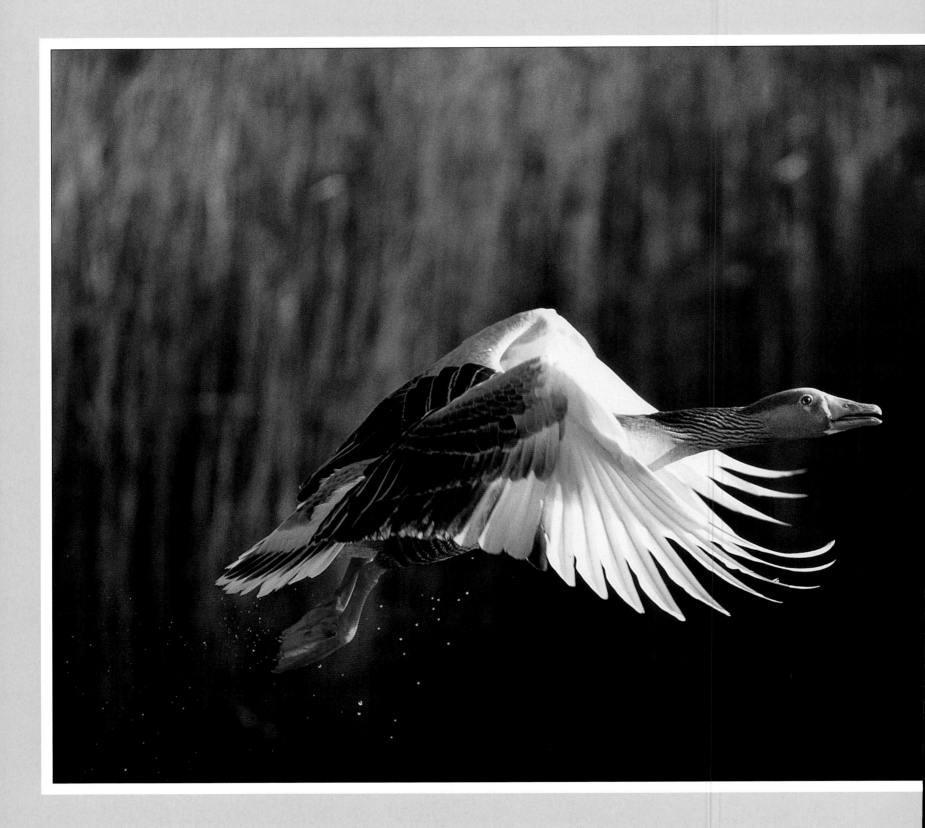

Geoff du Feu
United Kingdom
HIGHLY COMMENDED

Greylag goose taking off

"The odds of me getting this shot were against me. I was driving a boat on Hickling Broad, Norfolk, struggling to keep my balance as I stood while holding a camera . . . thank God for fast shutter speeds."

Canon EOS 1N RS with 300mm lens;
1/2000 sec at f2.8;
Kodak Elite 100 rated at 400

Chris Packham
United Kingdom
HIGHLY COMMENDED

Northern fulmar in flight

"I took this from the deck of the 'Oriana' while cruising around the Scottish Isles in June. The bird was hanging alongside in a stiff breeze."

Canon EOS 1 with 400mm lens;
Kodak Ektachrome 100

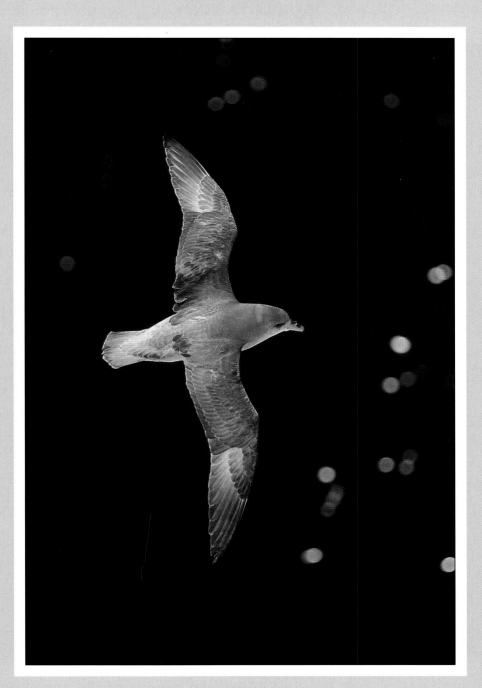

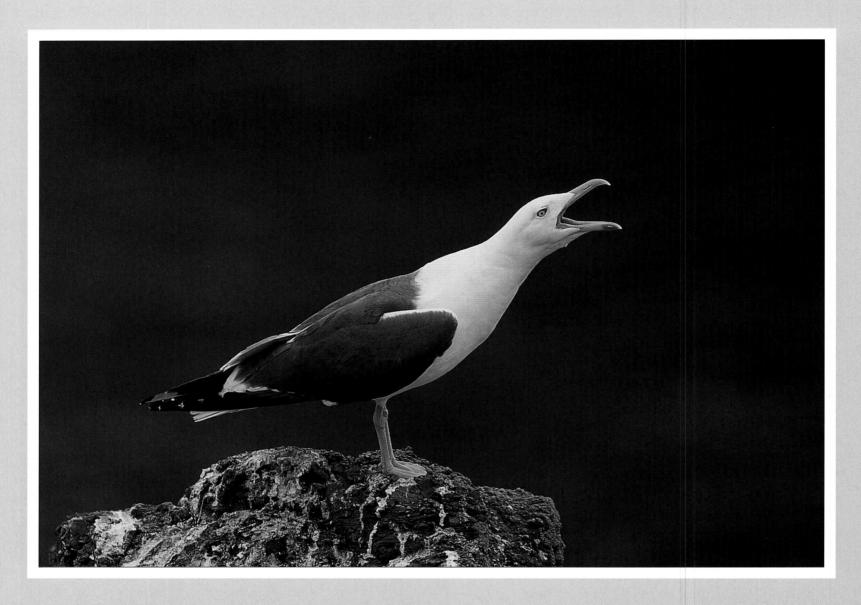

Rainer Müller
Germany
HIGHLY COMMENDED

Lesser black-backed gull calling

*"I was photographing puffins on Skomer
Island, off the coast of southwest Wales.
Unfortunately, there were no puffins to be
seen so I concentrated on photographing
some lesser black-backed gulls instead."*

Canon EOS 5 with 500mm lens; Fujichrome Velvia

David Element
United Kingdom
HIGHLY COMMENDED

Marmalade hoverfly

"*I photographed this hoverfly in my back garden in Collier's Wood, London. The insect obligingly hovered in the early evening sunshine, and I could see that its eyes touched at their tops, indicating that this was a male. There are more than 270 species of hoverfly recorded in Britain, this one being a very common species.*"

Nikon FE2 with 180mm lens; 1/250 sec at f16-22; Kodachrome 64

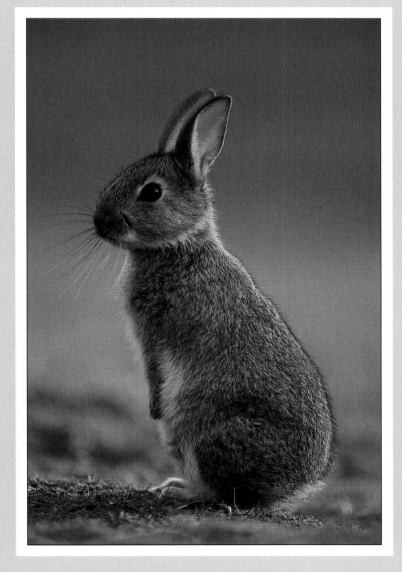

Neil McIntyre
United Kingdom
HIGHLY COMMENDED

Young rabbit

"*Each June evening, young rabbits would appear at their burrow entrance 100 metres from my house in Strathspey, Scotland. To photograph them, I would get in position half an hour before they emerged. After a week and several rolls of film, I managed to get this shot, ironically on the last frame of the last film.*"

Canon EOS 1N with 500mm lens; 1/125 sec at f4.5; Fujichrome Velvia; beanbag

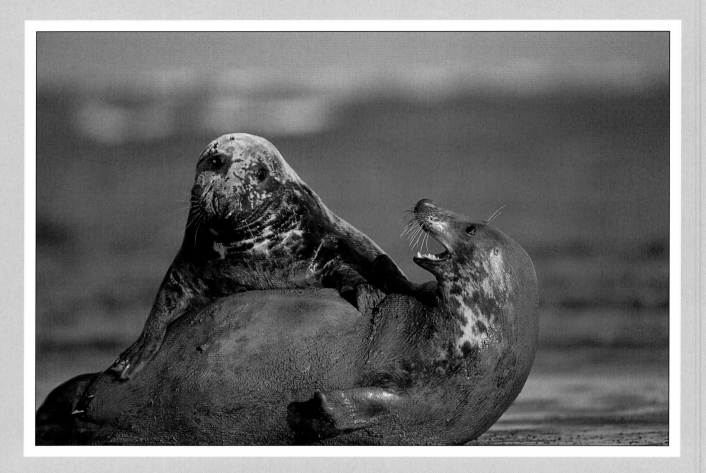

Allan G Potts
United Kingdom
HIGHLY COMMENDED

Grey seals in threat display

"One early morning in October, I was watching three sub-adult grey seals sparring. When a heavily pregnant female struggled up the beach, one of the young bulls lumbered towards her. She snarled at him, being more intent on reaching the beach to give birth than to be wooed. You can almost see the expression of disappointment on his face."

Nikon F5 with 500mm lens; 1/250 sec at f5.6; Fujichrome Sensia 100; tripod

Chris Gomersall
United Kingdom
HIGHLY COMMENDED

Bottlenose dolphin breaching

"This young bottlenose dolphin belongs to the world's most northerly population of the species, which lives in the Moray Firth, Scotland. I have watched this group over several years, devoting many hours and rolls of film in trying to get the 'perfect' breach. One evening everything came together, with beautiful sunlight for once coinciding with some extravagant dolphin activity."

Nikon F5 with 500mm lens; 1/1000 sec at f4.5; Fujichrome Sensia 100 rated at 200; tripod

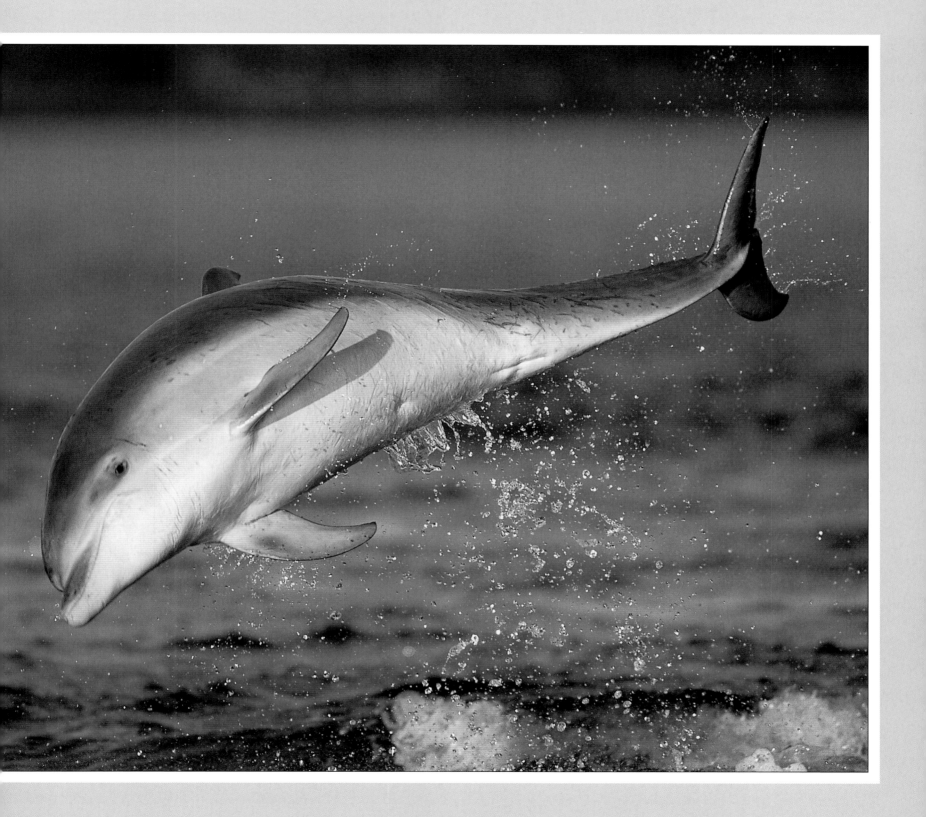

In Praise
of
Plants

Images that showcase the beauty and importance
of flowering and non-flowering plants.

Olaf Broders
Germany
WINNER

Foxgloves

*"It was midday when I came across this
assembly of foxgloves on a foothill in the
Olympic Mountains, Washington, USA.
The bright sunlight made the flowers produce
shadows, disturbing the pattern between the
evenly distributed flowers and the tree trunks in
the background. So I returned at dusk, using the
soft, evening light to lower the contrasts and a
long exposure time to create a harmony
of forms and colours."*

Nikon F90 with 80-200mm lens; 1/30 sec at f16;
Fujichrome Velvia rated at 40; tripod

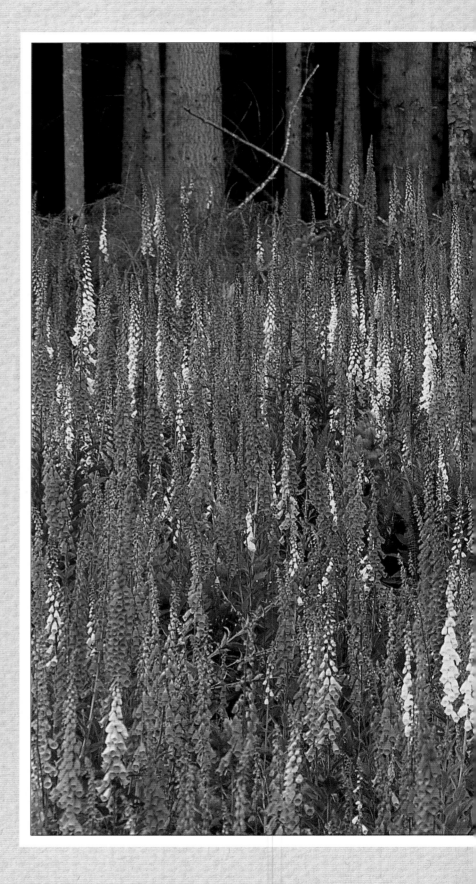

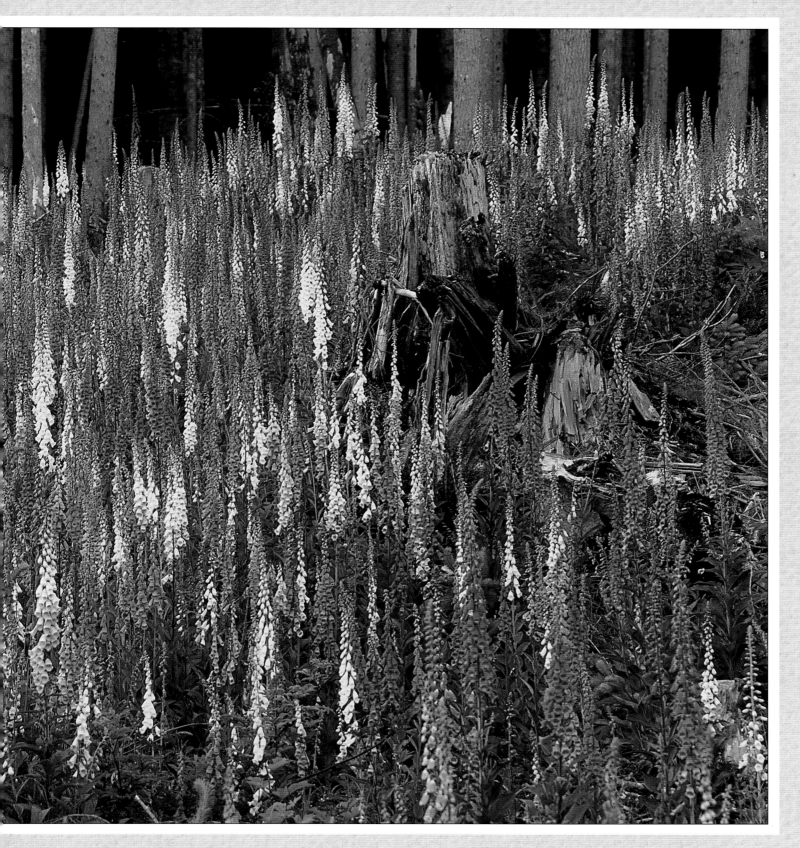

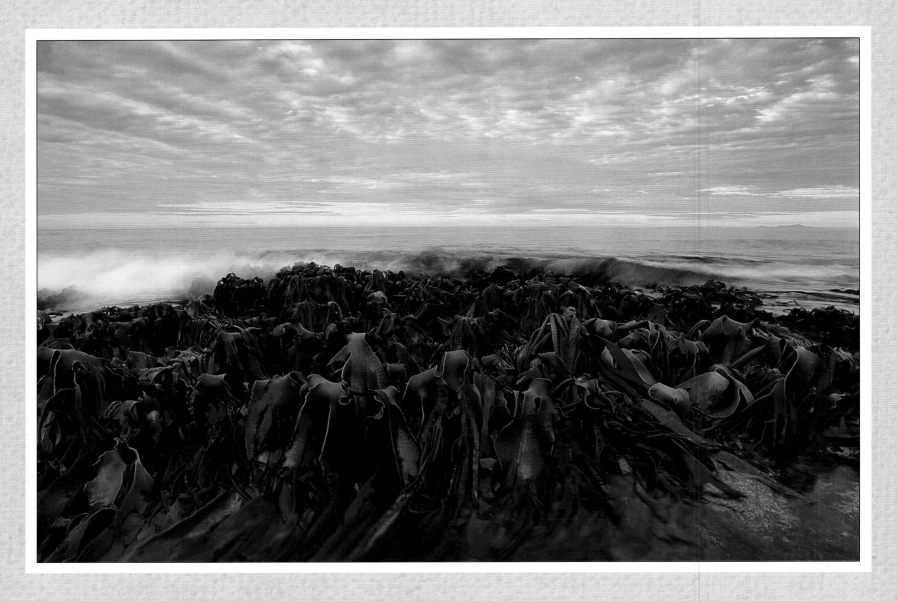

Darryl Torckler
New Zealand
RUNNER-UP

Bull kelp at low tide

*"Dawn at Waipapa Point on the southern tip of
South Island, New Zealand, is usually wild and
grey. Despite a twice-daily pounding, the bull
kelp maintains a strong footing, its long, leathery
fronds (up to three metres long), surviving
all but the fiercest storms."*

Nikon F90 with 20-35mm lens; 1 sec at f8;
Fujichrome Velvia; tripod

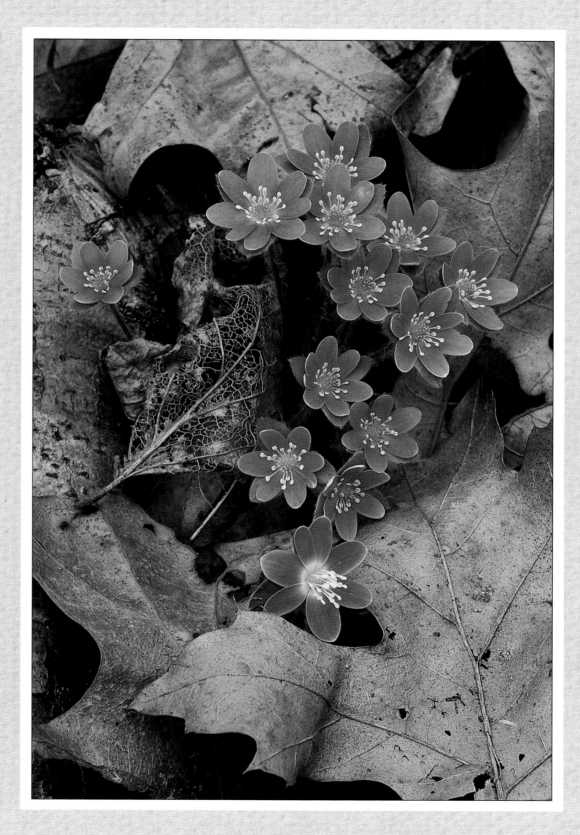

Loretta Williams
United States of America
HIGHLY COMMENDED

Hepaticas

"I consider the hepatica to be the harbinger of spring in Michigan, USA. I set off to photograph the blooms before sunrise, and because hepaticas don't open until the sun has warmed them, I had plenty of time to look around for the best specimen. This grouping was perfect, with the fresh flowers pushing their way through last autumn's leaves, and the lacy leaf completed the composition."

Nikon F3 with 100mm macro lens; 1/30 sec at f16; Kodachrome 25; tripod

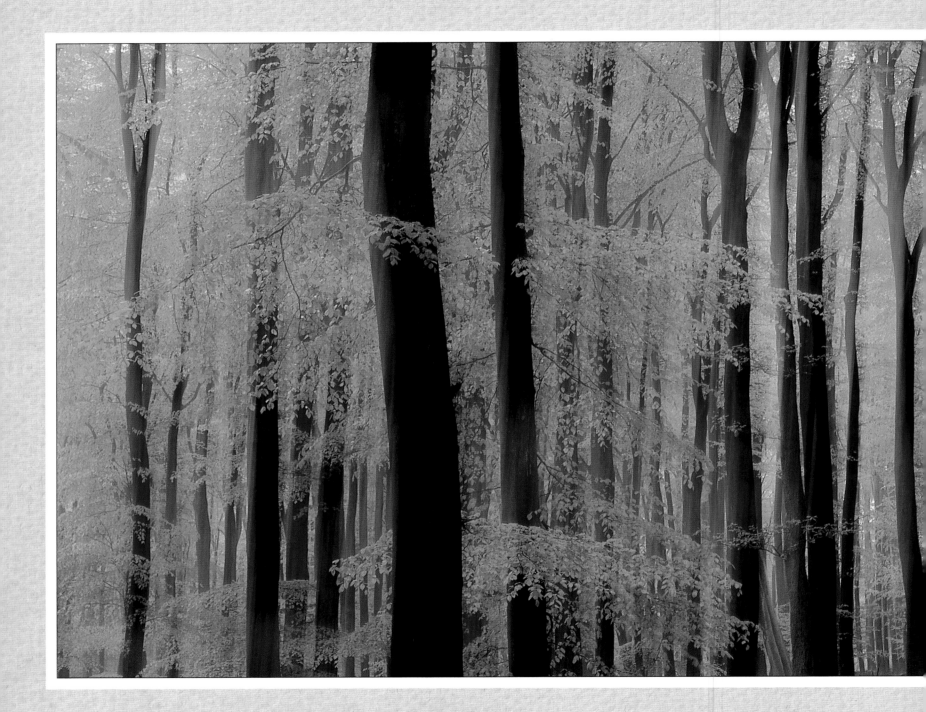

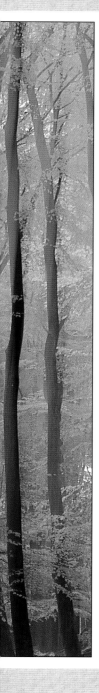

Jan Vermeer
Netherlands
HIGHLY COMMENDED

Beech forest in spring

"After a long winter, the vivid green of young beech leaves can't fail to uplift the soul. I wanted to capture their youthful colour, which fades so fast. I chose a rainy morning and used a long exposure time to photograph the trees, moving the camera slightly to give the image a painterly feel."

Canon EOS 3 with 200mm lens; 1/8 sec at f11; Fujichrome Velvia; tripod

Laurie Campbell
United Kingdom
HIGHLY COMMENDED

Wood sorrel growing on oak tree

"I have often photographed wood sorrel on woodland floors, but I couldn't believe my luck when I found it growing on this tree in Inversnaid, near Loch Lomond, Scotland. It made such an evocative, natural composition."

Nikon F4 with 500mm lens; 1/8 sec at f16; Fujichrome Velvia; tripod

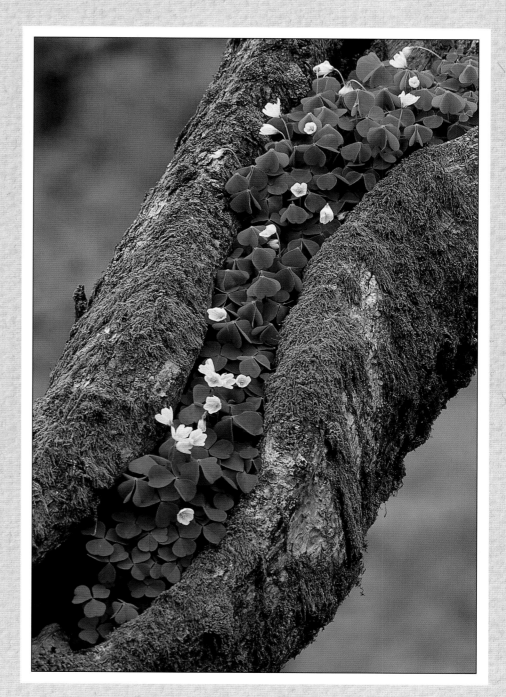

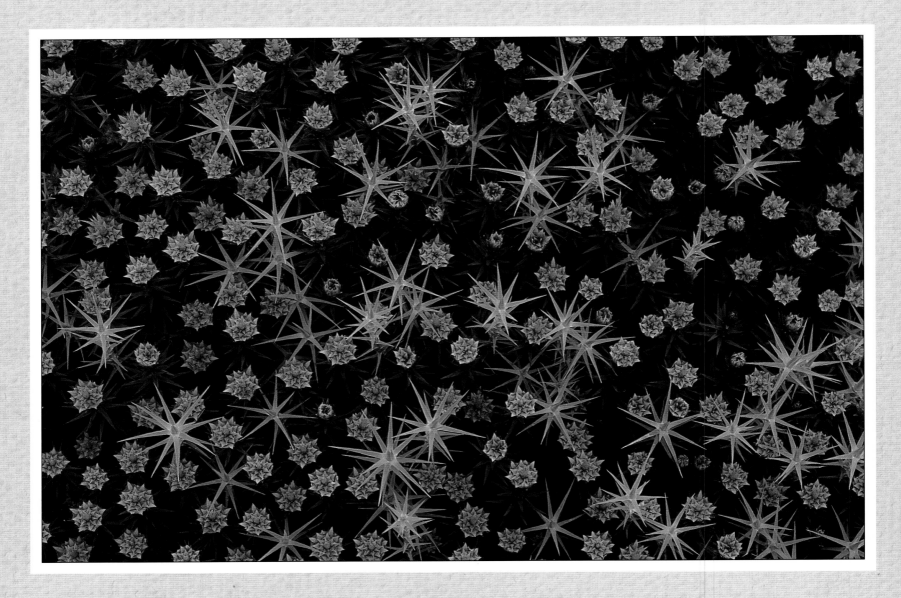

Lorne Gill
United Kingdom
HIGHLY COMMENDED

Bog moss

"The overcast daylight picked out the wonderful subtleties of texture and colour of this 'Polytrichum moss', growing on an area of burnt land in Braehead Moss National Nature Reserve, a lowland raised bog in central Scotland. Particularly beautiful were the contrasting olive-green and reddish flower-like 'inflorescence' of the male plants."

Nikon F5 with 105mm micro lens; 1/4 sec at f22;
Fujichrome Velvia; tripod

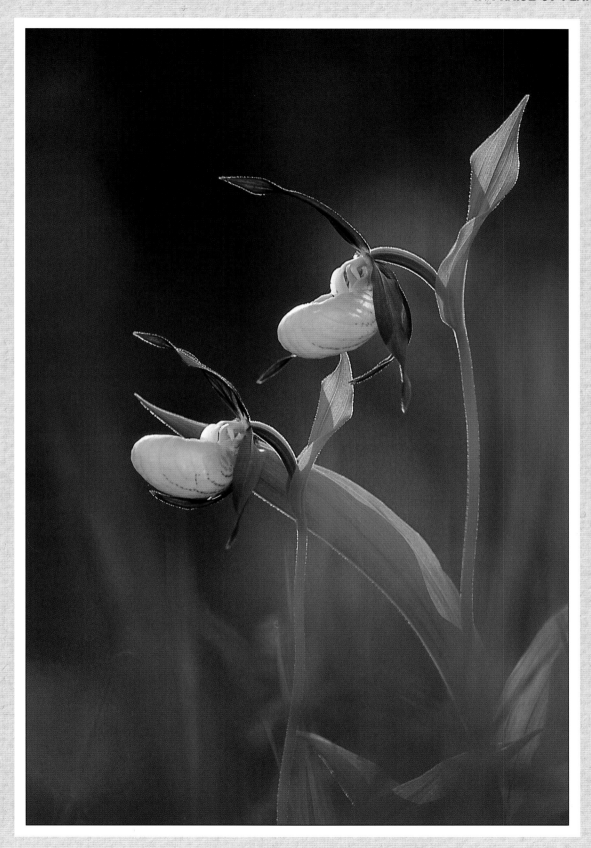

Paavo Hamunen
Finland
HIGHLY COMMENDED

Lady's-slipper orchids

"I chose to take this photograph at sunrise because the light is at its very best then. Yellow lady's-slipper orchids are rare in Finland, but in Oulanka National Park, where I photographed this specimen, there are still a few hundred plants."

Nikon F4 with 200mm macro lens; 1/30 sec at f4;
Fujichrome Velvia; tripod

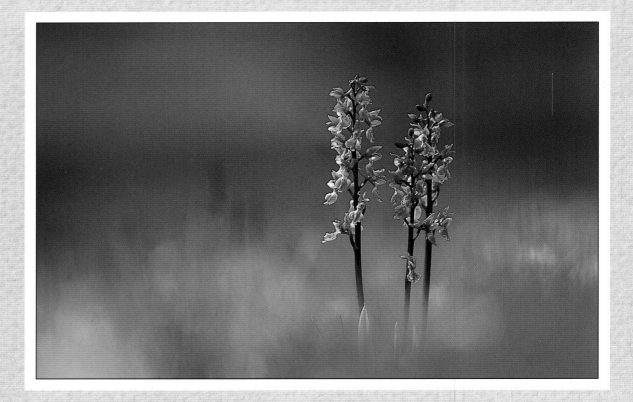

Colin Varndell
United Kingdom
HIGHLY COMMENDED

Early purple orchids

"I found these early purple orchids growing in a hay meadow near my home in Dorset in late April. I decided to photograph them at ground level with a long lens at maximum aperture to make the subject stand out from the surrounding vegetation. I knew I was in luck when the sun came out."

Nikon FE2 with 300mm lens; 1/125 sec at f2.8; Fujichrome Velvia; tripod

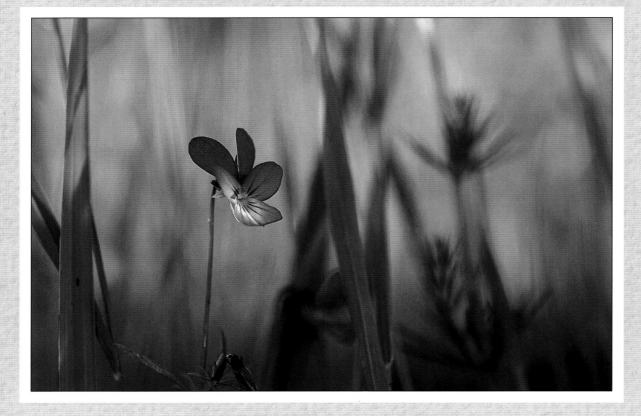

Björn Ullhagen
Sweden
HIGHLY COMMENDED

Wild pansy

"One warm, June evening in Västergötland, southwest Sweden, I lay with my camera in a meadow and found this wild pansy. I studied it for a long time before deciding how I wanted to photograph it. The colours were enhanced by the mellow light."

Nikon F5 with 60mm micro lens; Fujichrome Velvia; tripod

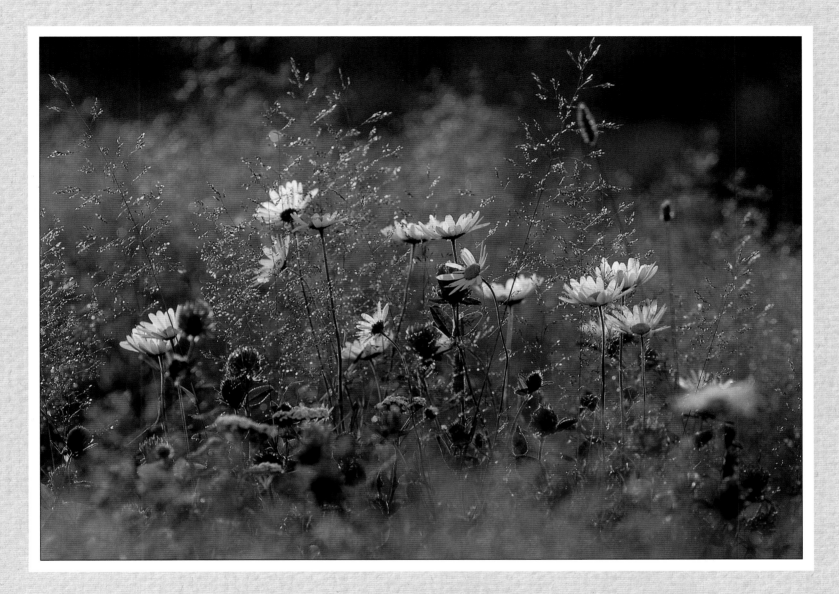

Torbjörn Lilja
Sweden
HIGHLY COMMENDED

Ox-eye daisies and red clover
"These meadow flowers were, in fact,
growing on a rubbish tip outside the small
town of Västerbottne in northern Sweden,
and were photographed as the sun
set over the dump."

Pentax 645 with 600mm lens; Fujichrome Velvia

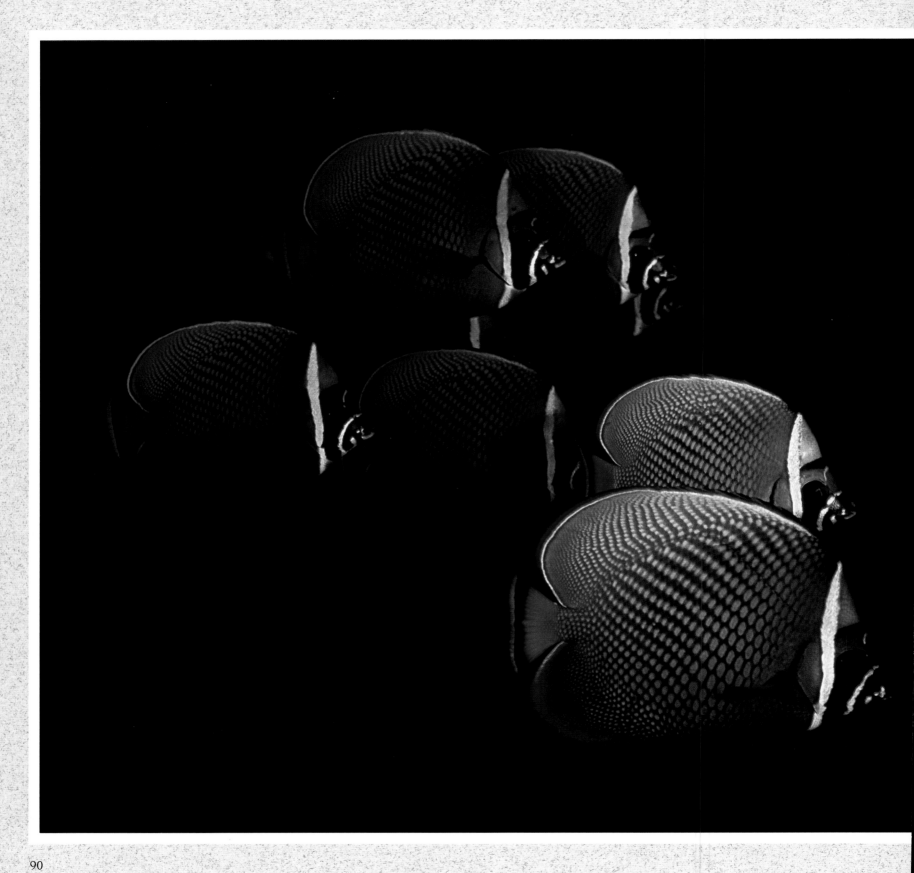

The UNDERWATER WORLD

Pictures taken below the surface, illustrating marine or freshwater wildlife.

Gayle Jamison

United States of America

WINNER

Red-tailed butterfly fish

"I saw this group of red-tailed butterfly fish at a depth of about 18 metres as I rounded a rock formation in Thailand's Similan Islands. Butterfly fish are usually seen only in pairs, larger aggregations being uncommon and scattering at a diver's approach. But by moving slowly while averting both my gaze and camera lens, I was able to get close enough to these shy fish to take just one photo before the group dispersed."

Nikonos RS with 50mm lens; 1/125 sec at f11;
Fujichrome Velvia; two underwater strobes

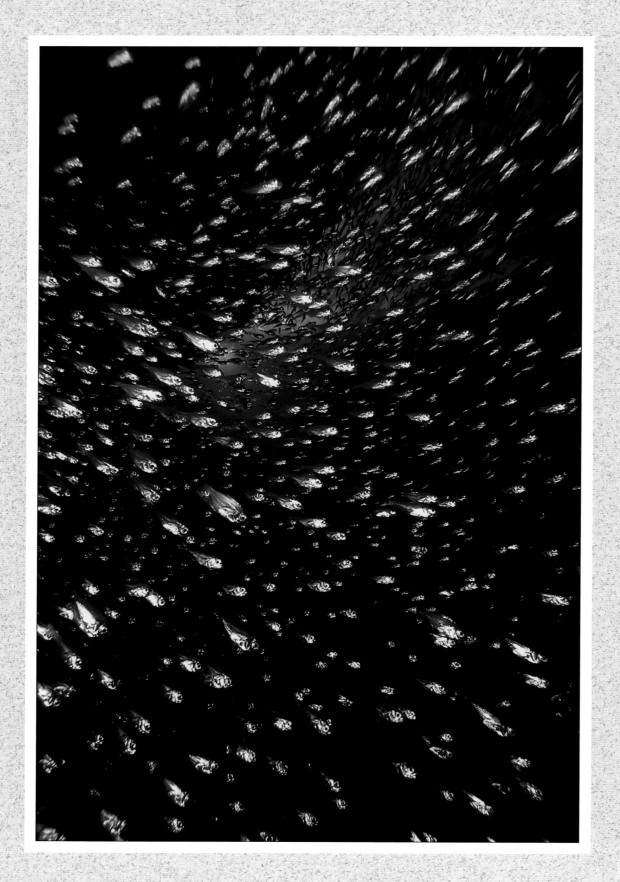

Peter Ladell
United Kingdom
HIGHLY COMMENDED

Glassy sweepers

"Glassy sweepers are common on most coastal coral reefs around the world. They feed away from the reef at night on zooplankton and shoal around coral heads, caves and wrecks in the day. Predators such as lionfish and groupers prey upon them. I photographed this particular shoal at Coral Beach, Eilat, Israel."

Nikon F90x with 18-35mm lens; 1/60 sec at f11; Fujichrome Velvia; underwater housing, 2 strobes

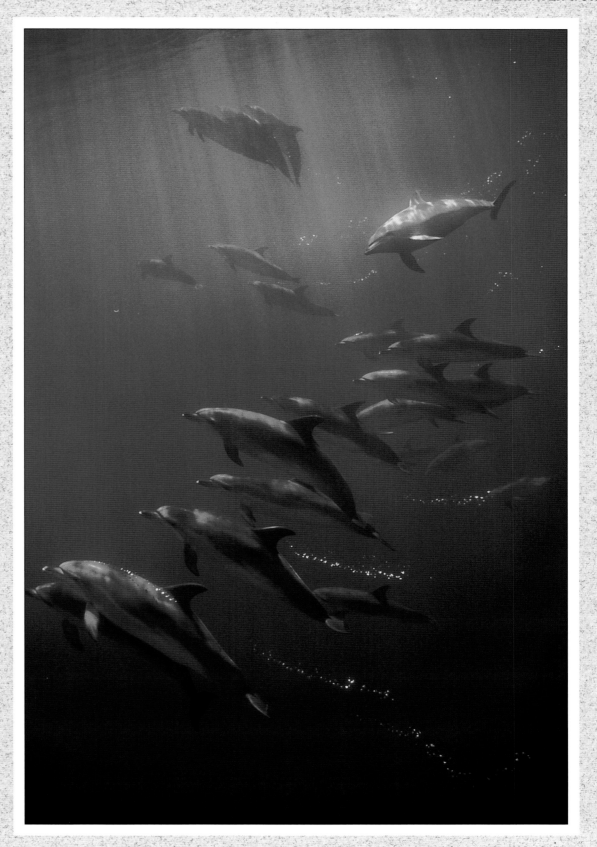

Stephen Wong
United Kingdom
HIGHLY COMMENDED

Atlantic spotted dolphins

"Atlantic spotted dolphins frequent the
Azores in summer. I jumped many
times into the cold sea off the islands
trying to photograph these dolphins,
but even though they were quite
friendly, I usually managed to take
just tail shots. But my persistence
finally paid off when this pod
synchronised and 'danced'
through the turquoise sea."

Nikon RS with 20-35mm lens; 1/250 sec at f3.3;
Fujichrome Velvia rated at 100

Ryo Maki
Japan
HIGHLY COMMENDED

Seal hunting

*"This young Galapagos seal was hunting
at Cousin Rock near the Galapagos
Islands when it encountered this huge
shoal of striped salema.
The seal dived into the shoal making the
fish scatter in alarm as it picked
out individuals."*

Nikon RS with 13mm fisheye lens;
1/125 sec at f5.6; Fujichrome Provia; two strobes

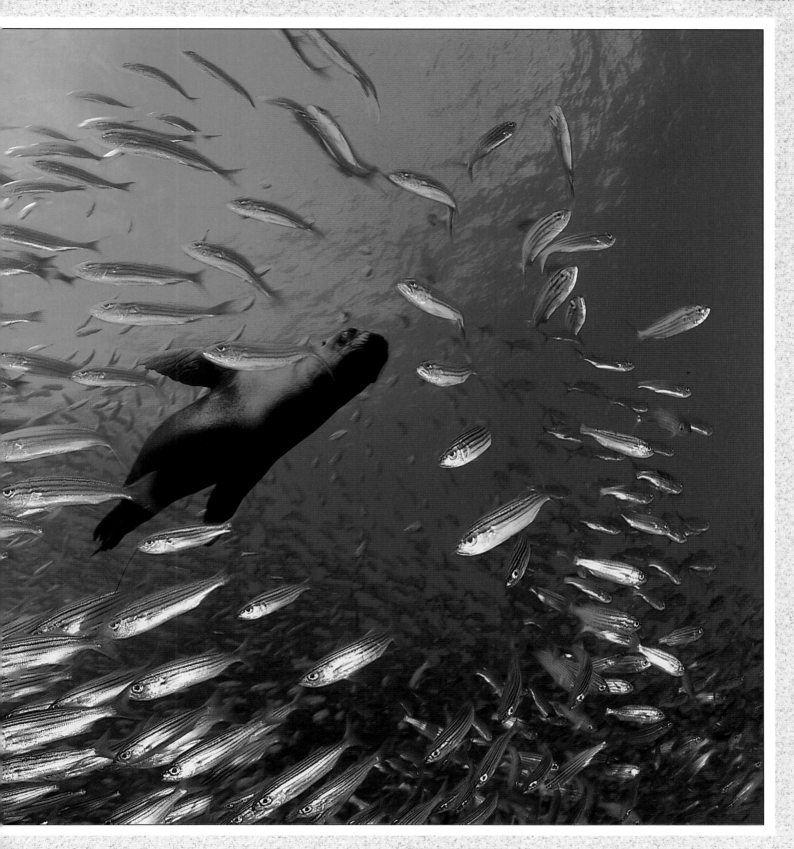

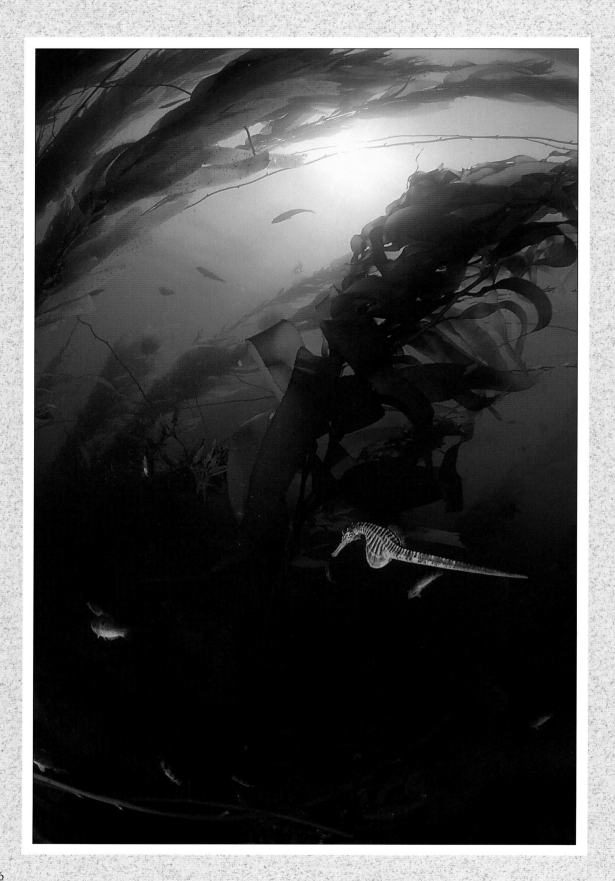

Darryl Torckler
New Zealand
HIGHLY COMMENDED

Yellow seahorse in kelp forest

"Dense, deep kelp forests provide perfect camouflage for many species, and spotting small seahorses can be challenging. This tiny individual was floating effortlessly in the kelp off Stewart Island, New Zealand."

Nikon F90 with 16mm fisheye lens; 1/30 sec at f8; Fujichrome Velvia; underwater housing, two underwater strobes

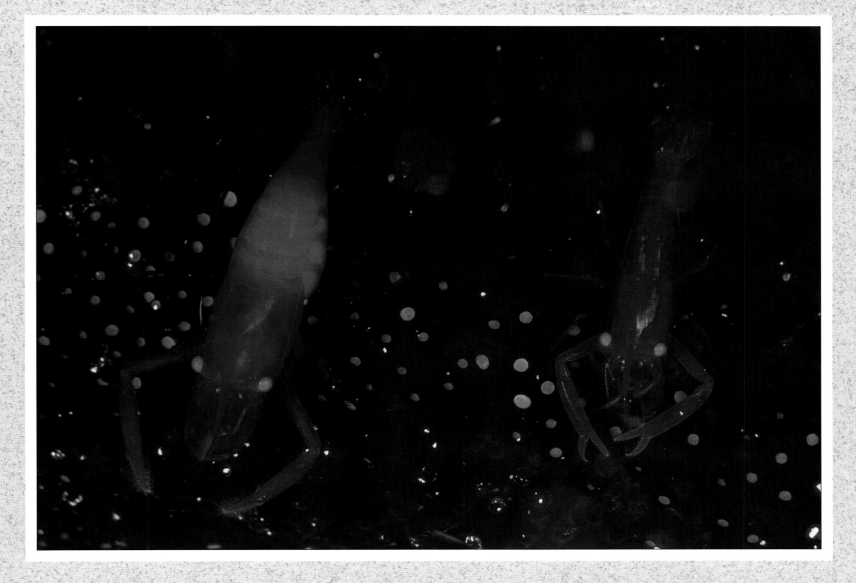

Setsuko Maki
Japan
HIGHLY COMMENDED

Red shrimps on sea cucumber

"I found a group of black sea cucumbers on the sandy floor off House Reef, Mabul Island, Malaysia, at a depth of about eight metres. These sea shrimps were darting among the cucumbers, never settling for an instant. I used strong strobe-lighting to highlight the scene's natural colours."

Nikon F4 with 105mm macro lens; 1/250 sec at f11; Fujichrome Velvia; two strobes

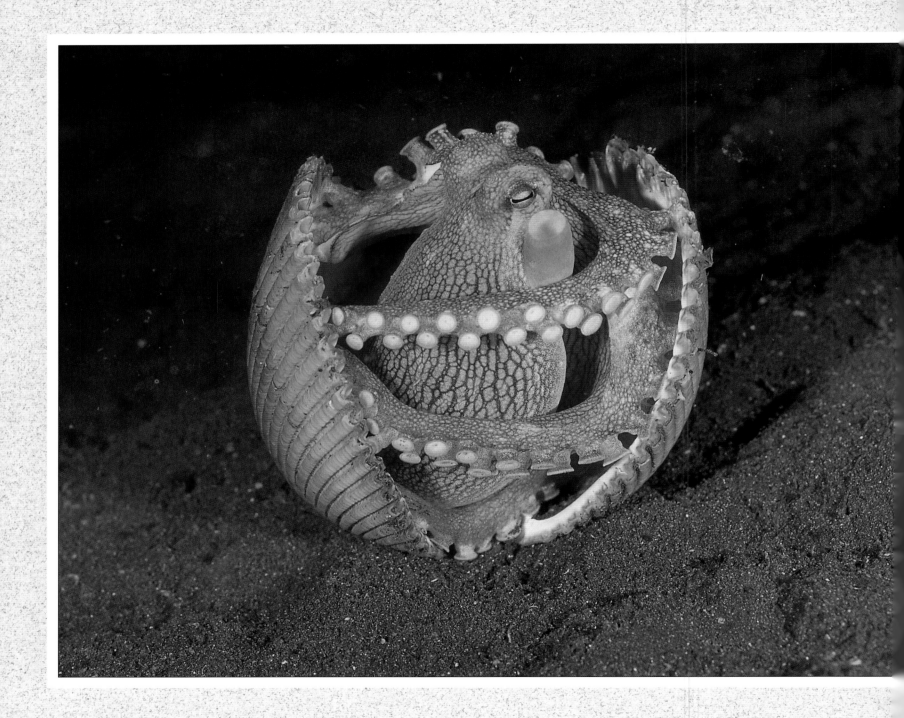

Constantinos Petrinos
Greece
HIGHLY COMMENDED

Octopus in shell

"On a night dive in the Lembeh Strait
in northern Sulawesi, Indonesia,
I was amazed to see this octopus,
'Octopus marginatus', using a seashell for
cover. Despite its bigger size compared to
the shell, it had no problem squeezing
itself into its improvised home. I watched
for a while as it opened and closed the
shell with immense dexterity."

Nikon F4 with 60mm lens; 1/250 sec at f11;
Fujichrome Provia 100; underwater housing,
two strobes

Espen Rekdal
Norway
HIGHLY COMMENDED

Wolf eel

"In spring, wolf eels come to feast on the
magnitude of molluscs that are fed by the
strong tidal currents running in the abyss
between the islets at Øygarden, Norway.
Lying half out of a cave, this wolf eel
withdrew as I approached. I waited
patiently by the cave, and after a few
minutes he came back out for another
look. He was perfectly surrounded by
dead man's fingers (soft corals),
and I shot two portraits of the scene
before he retreated back into his cave."

Nikon F50 with 50mm lens; 1/125 sec at f22;
Fujichrome Velvia; underwater housing,
two strobes

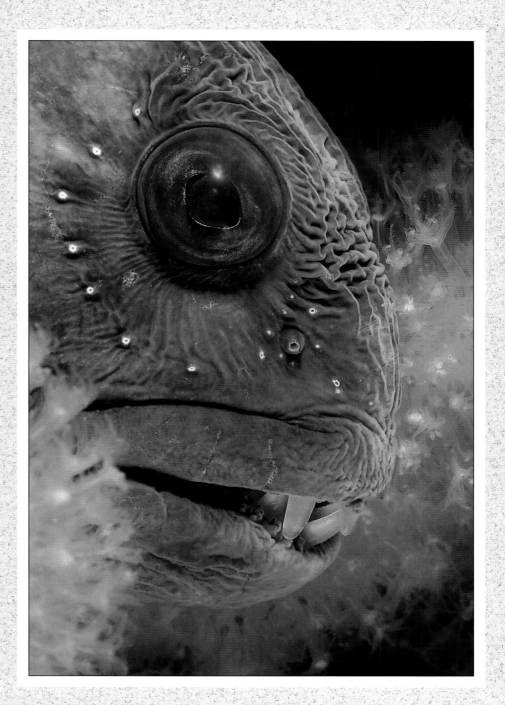

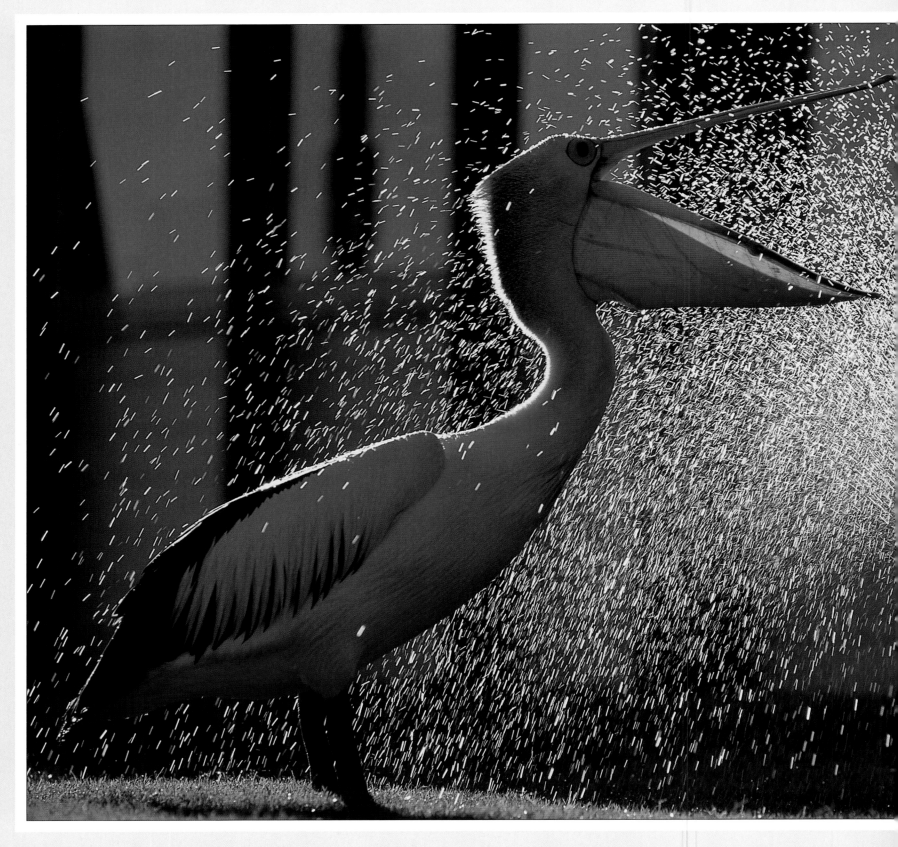

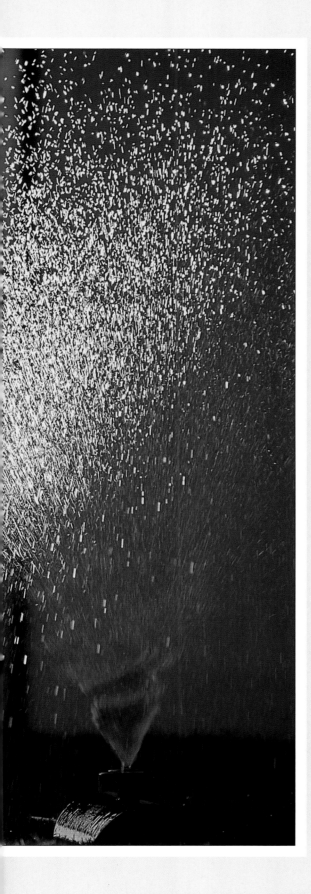

Urban and Garden Wildlife

Animals or plants in a garden or an obviously urban/suburban setting.

Theo Allofs
Germany
WINNER

Pelican drinking from garden sprinkler

"As soon as the sprinklers on this lawn at the Monkey Mia resort, Western Australia, were switched on in the morning, this Australian pelican would swim to shore. It waddled across the beach and headed straight to the sprinkler. It would drink by collecting the spray in its open bill. The back-lighting provided by the sun made the spray sparkle and the pelican's beak glow."

Nikon F5 with 300mm lens; Fujichrome Velvia

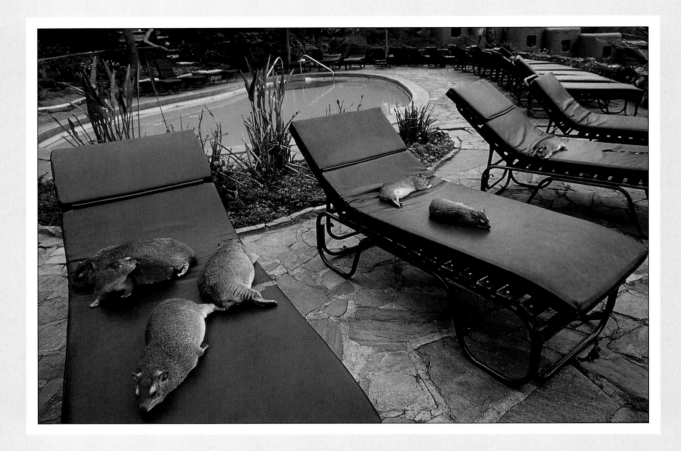

Norbert Wu
United States of America
RUNNER-UP

Rock hyrax lounging around pool

"I spotted this scene in the grounds of a hotel in the Maasai Mara, Kenya. The hyraxes were relatively tame here, and they seem to enjoy lazing on the sunbeds in the sunshine. Hyraxes are the closest living relative of the elephant. Good job their cousins didn't decide to join them on the loungers."

Nikon N90s with 24mm lens; 1/125 sec at f8; Fujichrome Sensia 100

Chris Gomersall
United Kingdom
HIGHLY COMMENDED

Sparrowhawk at feeder

"After their population crash in the 1960s (the result of DDT crop pesticide poisoning), British sparrowhawks have almost recovered their numbers. These birds of prey have recently begun to exploit the concentrations of small birds using birdfeeders in gardens.
This male sparrowhawk had a regular lunch date in a garden close to my home in Bedfordshire. The coal tit escaped this time, possibly protected by the squirrel-proof feeding device."

Nikon F4S with 300mm lens; 1/500 sec at f4; Fujichrome Provia 100

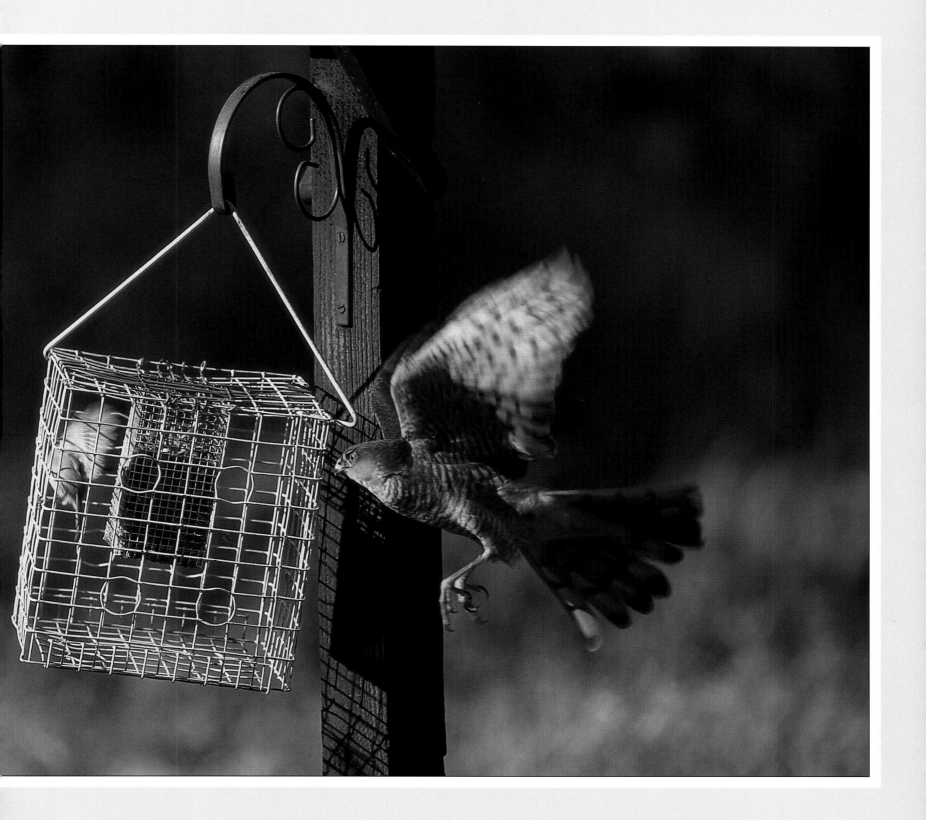

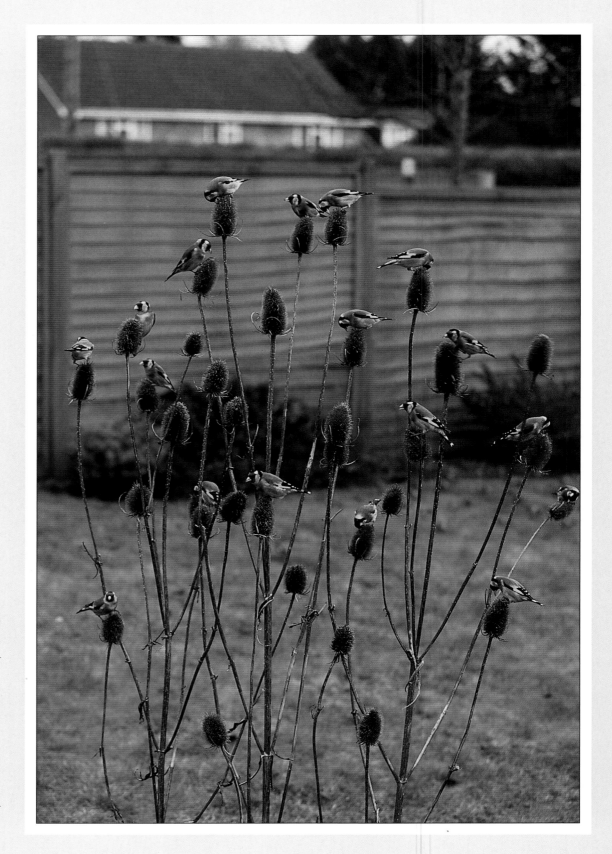

David Kjaer
United Kingdom
HIGHLY COMMENDED

Goldfinches on teasels

"I filled some teasel heads with niger seed and put them in my garden to entice European goldfinches. It proved so successful that, by February, I had a charm of almost 110 goldfinches. Though most of these birds usually disperse in March and April, at least four pairs and their young returned to my feeder in June."

Canon EOS 1N with 70-200mm lens; f4.5 on auto;
Fujichrome Sensia 100 rated at 160

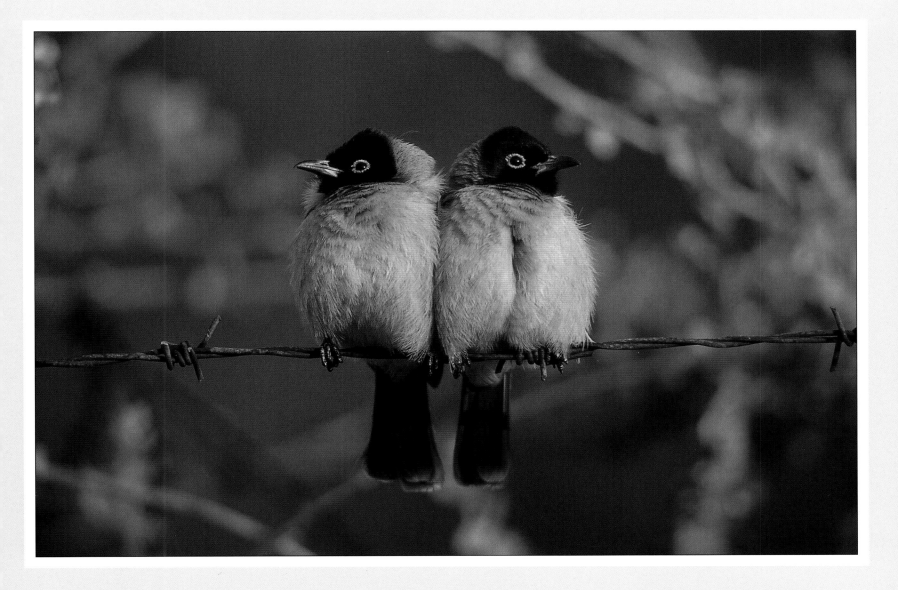

Duncan Usher
United Kingdom
HIGHLY COMMENDED

Common bulbuls on barbed wire

"Bulbuls are common in residential areas in the Jordan Valley, South-west Asia. This particular February morning at 6.30am, it was very cold and this pair nuzzled together for warmth on some barbed wire. With feathers all puffed-out their 'mirror-image' posture, created a sense of peacefulness."

Canon EOS 3 with 400mm lens and x1.4 teleconverter; 1/200 sec at f4; Fujichrome Sensia 100; tripod

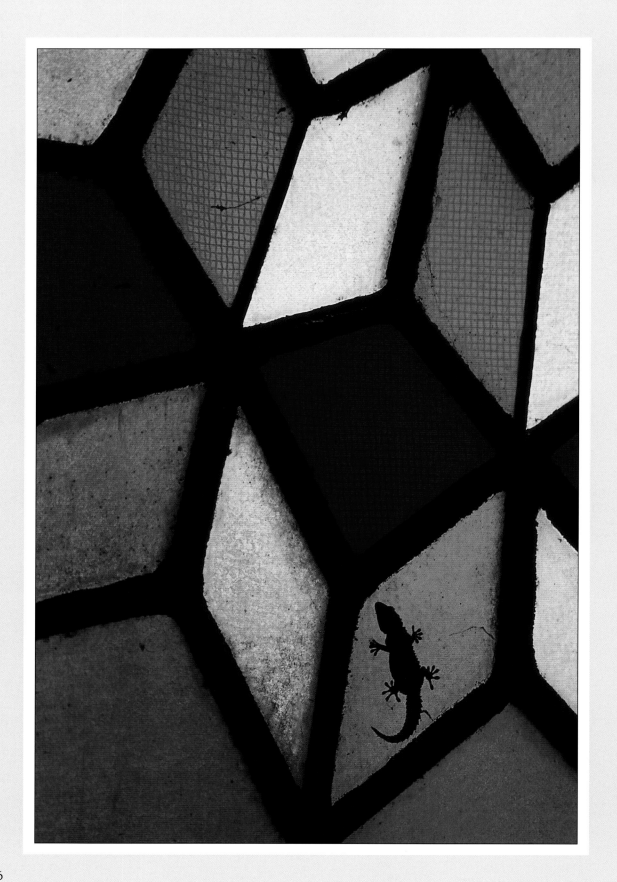

Claudio Contreras
Mexico
HIGHLY COMMENDED

Gecko on stained-glass window

"This gecko silhouette was photographed from the inside of a cathedral in Córdoba in Spain. Geckos have 'adhesive' pads on their toes so that they can hunt for insects on sheer surfaces as smooth as this glass."

Minolta AF 7000 with 70-210mm lens;
Fujichrome RD 100 rated at 125

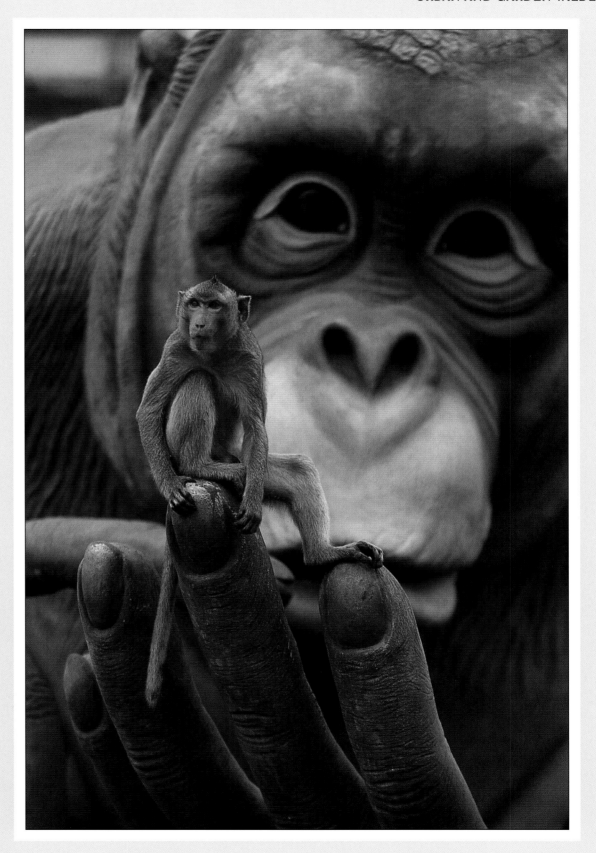

Jim Leachman
United States of America
HIGHLY COMMENDED

Macaque on orang-utan statue

"Lop Buri, Thailand, is home to
hundreds of urban macaques.
They originally came here to eat offerings
left at the temples. As Lop Buri grew,
the macaques became streetwise –
stealing from local vendors and tourists
and digging through garbage bins.
They play on train tracks and telephone
wires, and love to perch on things such as
this giant, fibreglass orang-utan statue."

Canon EOS 1N with 300mm lens; 1/250 sec at f4;
Fujichrome Provia 100

COMPOSITION AND FORM

Illustrating natural subjects in abstract ways.

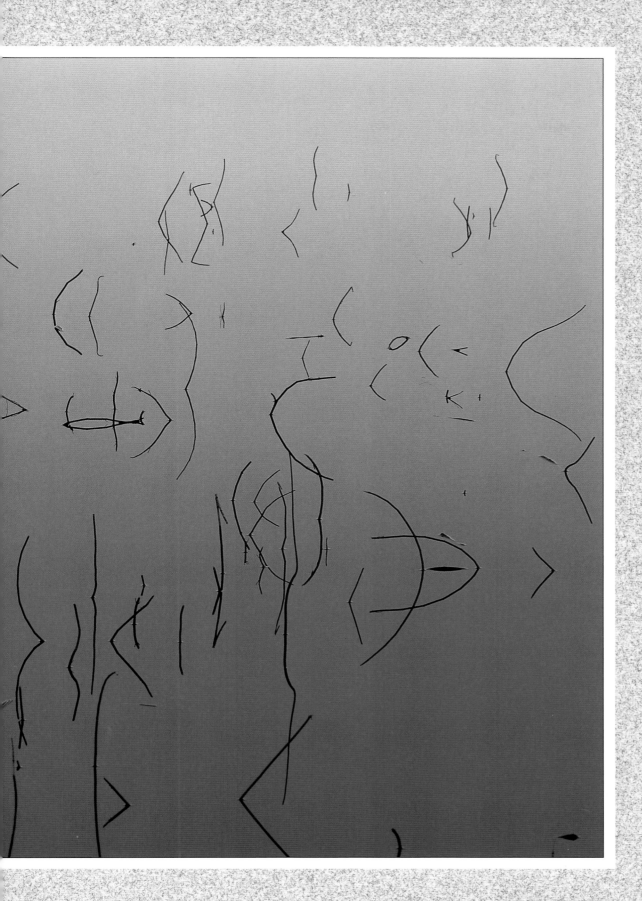

Jan-Peter Lahall
Sweden
WINNER

Reed reflections

"These hieroglyphics etched into the water were taken on a lake in Sweden. I spent a week canoeing and camping with friends in northern Sweden and saw many wonderful things to photograph, but this image of the reeds captured my imagination the most. They looked like a message scrawled out by nature."

Pentax 6x7 with 300mm lens; 1/5 sec at f22; Fujichrome Velvia

Stephen G Maka
United States of America
RUNNER-UP

Oak leaf frozen in ice

"This oak leaf was encased several centimetres below the ice surface of a pond. Little tubes were formed by air bubbles that had been trapped when the pond had frozen, thawed and refrozen in quick succession. The refraction of the leaf colours in the tubes was most pronounced in the midday sun, which is when I took this picture. I was intrigued by the optical illusion of the leaf speeding through the ice."

Nikon F4 with 105mm lens; 1/8 sec at f22; Fujichrome Velvia rated at 40; tripod

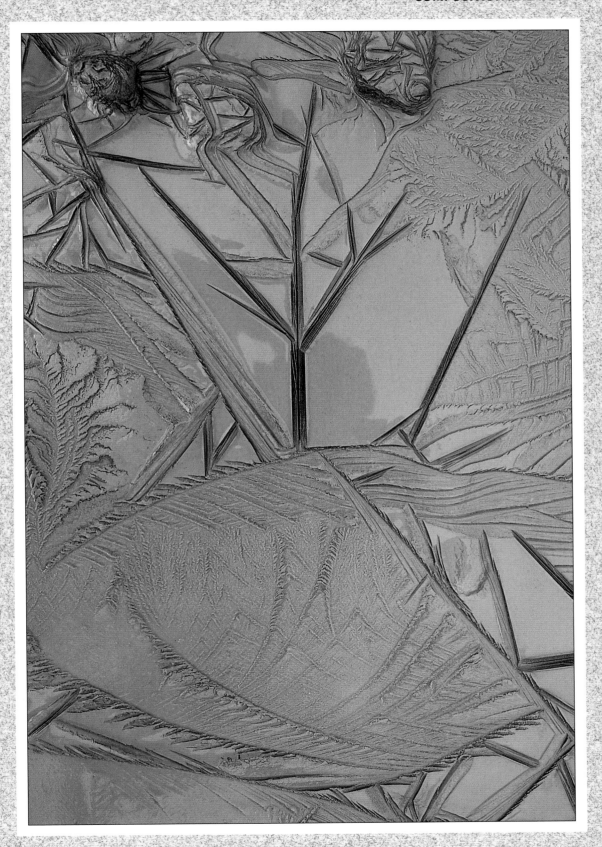

Elio Della Ferrera
Italy
HIGHLY COMMENDED

Ice pattern

"I was transfixed by this image on the cracked surface of a frozen pool, which I came across last winter in the loop of a river in Stelvio National Park, Italy."

Canon EOS 1N with 100mm lens; 1 sec at f16; Kodachrome 64; tripod

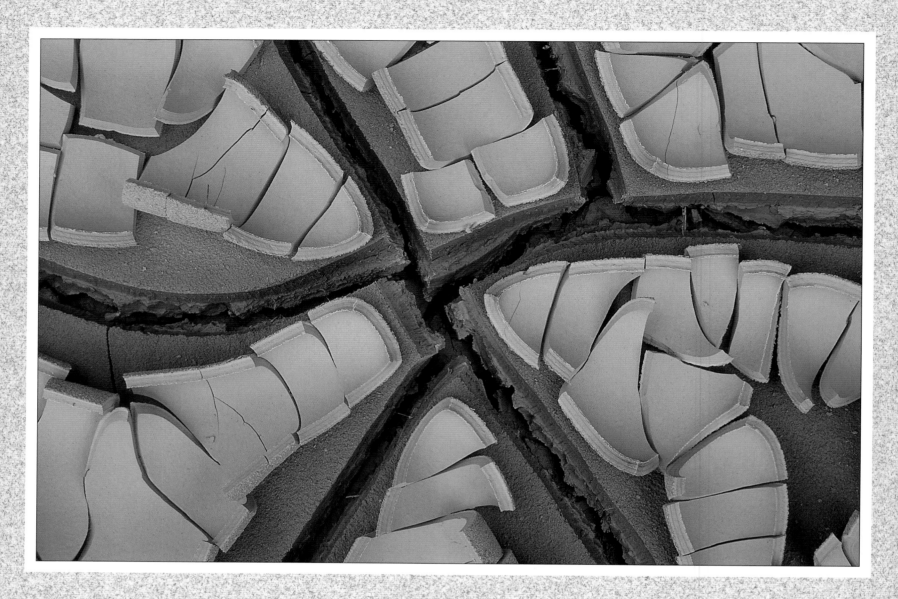

Thomas Dressler
Germany
HIGHLY COMMENDED

Cracked earth

"These dramatically bent upper layers of
mineral-rich (mainly copper and iron) soil
stopped me in my tracks one dry, overcast
morning near the open-cast mineworkings
in Huelva Province, Andalucía, Spain.
Just a few days later, heavy April rains
converted the same place into a quagmire."

Canon EOS 5 with 28-105mm lens; 1/10 sec at f22;
Fujichrome Velvia

Jan-Peter Lahall
Sweden
HIGHLY COMMENDED

Ice on sandy beach

*"In February, I visited the West coast of Sweden,
and in spite of terrible weather, I found a lot to
photograph along the frozen coast.
These diamond-like nuggets of ice lying on the
sand really caught my eye. I circled them many
times before I knew how I wanted to
present them in this picture."*

Pentax 6x7 with 135mm lens; I sec at f22; Fujichrome Velvia

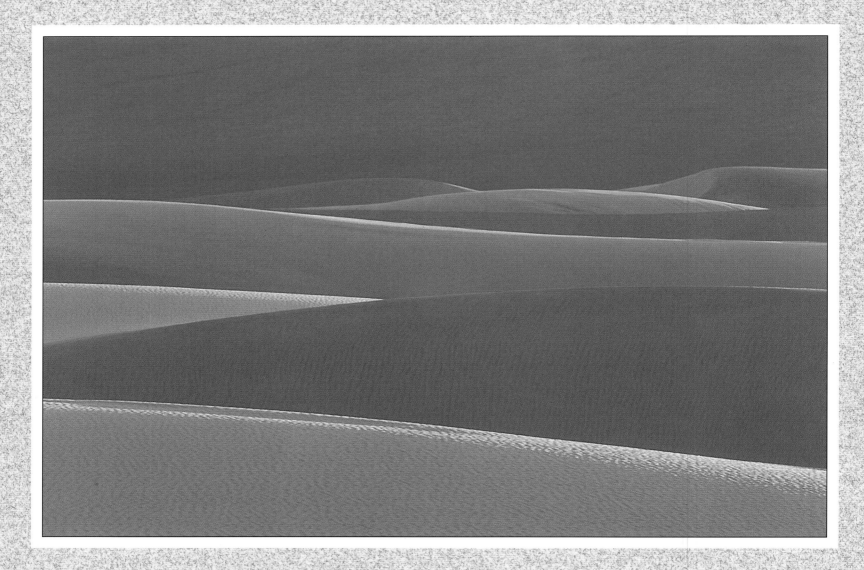

Gerry Ellis
United States of America
HIGHLY COMMENDED

Evening sunlight on sand dunes

"These gypsum dunes are in the
Chihuahuan Desert, New Mexico, USA.
This is one of the world's most biologically
diverse and endangered ecoregions – home
to more mammal species than Yellowstone
National Park and more birds than the
Florida Everglades. But the desert faces
continuous destruction from farming,
irrigation, water diversion and overgrazing."

Nikon F5 with 300mm lens; 1/30 sec at f8;
Fujichrome Velvia

Heikki Ketola
Finland
HIGHLY COMMENDED

Scots pine trees
"The pine forest in Kuusamo, Finland, was wet after a July thunderstorm. As I set up my camera, the setting sun broke through, and during the exposure, I moved the camera slightly to give the picture an impressionistic feel."

Canon AE1 with 50mm lens, 1/2 sec at f22, Fujichrome Velvia

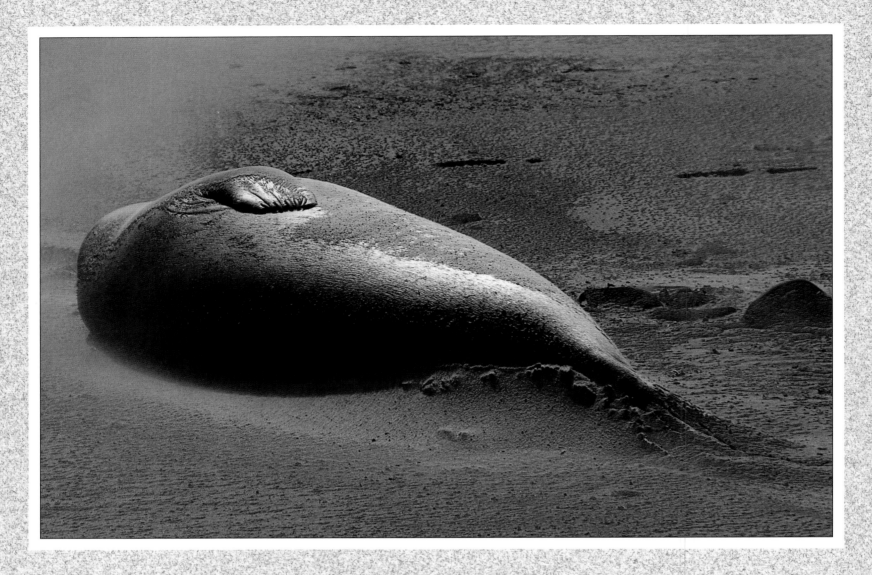

Dr Dorit Engl
Austria
HIGHLY COMMENDED

Elephant seal pup in sandstorm

*"More than 500 elephant seals are born each
year on Sea Lion Island, Falkland Islands.
This photograph was taken the morning after
a day-long storm, which has transformed
the elephant seal pups into extensions of the
windblown sand dunes. Even though the storm
was over, this weanling stayed sound asleep,
its grey fur glittering like silver."*

Canon AE-1 with 200mm lens; 1/125 sec at f8;
Fujichrome Sensia II 100

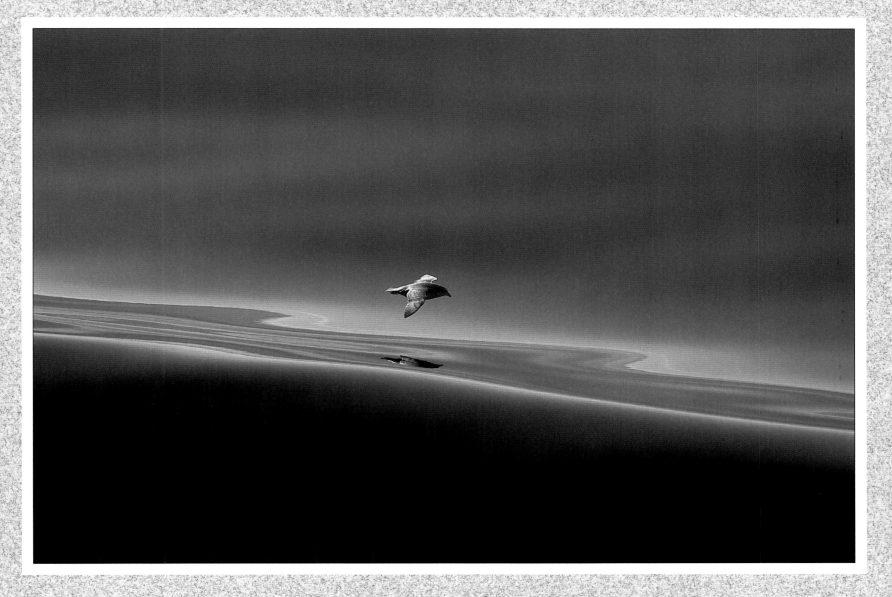

Chris Packham
United Kingdom
HIGHLY COMMENDED

Northern fulmar following ship's wake

"This was taken from the stern of the 'Oriana' off the Scottish Isles. The cold water lay like a barely rippled sheet as a fulmar skimmed along this fold. The bird is in the centre of the picture, which disappoints me, but that's the result of using the auto-focus system. Must try harder!"

Canon EOS 1 with 400mm lens; Ektachrome 100

WILD PLACES

Scenes that convey a feeling of wilderness or create
a sense of wonder or awe.

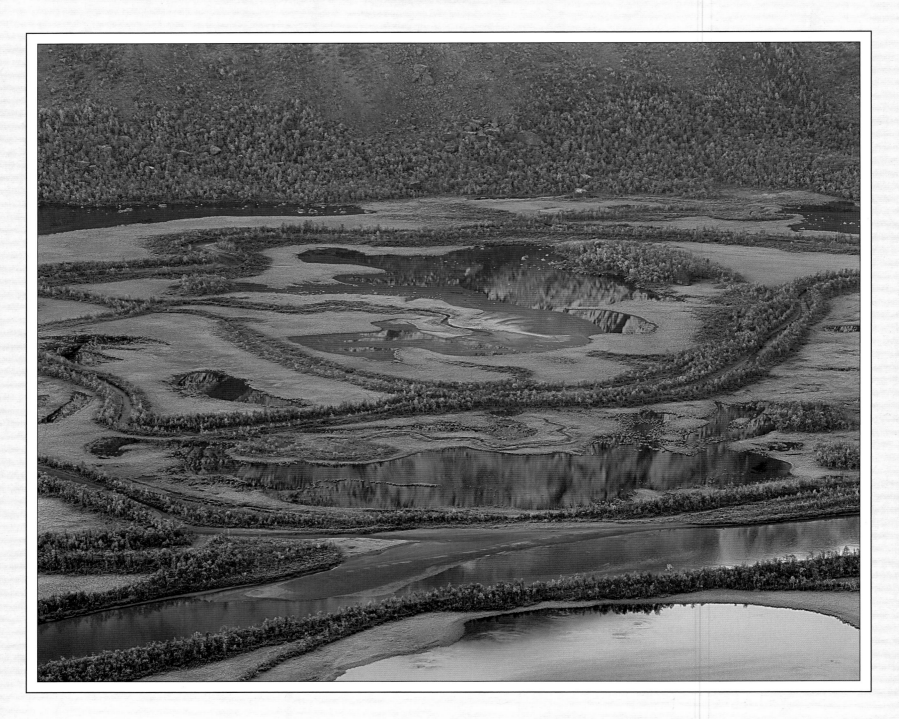

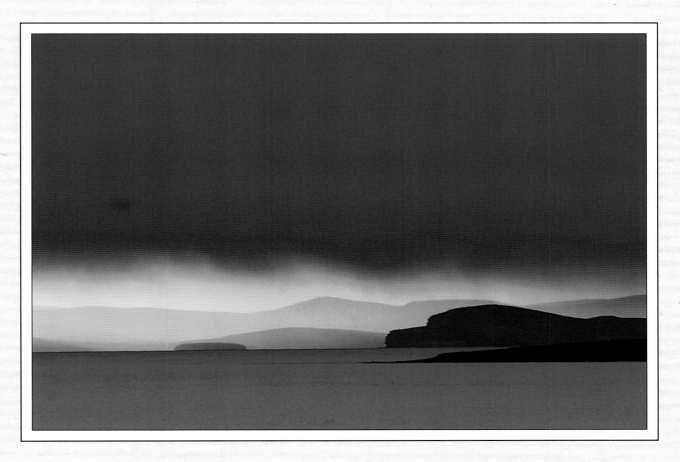

Jan-Peter Lahall
Sweden
WINNER

Delta landscape, Lapland

*"After much perseverance – a two-week trip
in bad weather and the expense of hiring
a helicopter – I took this photograph in Sarek
National Park in Sweden. At dawn on the last
morning everything was covered in frost,
and I saw this river delta from the helicopter,
with the mountain reflecting a warm glow
across the whole image."*

Pentax 6x7 with 300mm lens; 1 sec at f16;
Fujichrome Velvia

Manfred Pfefferle
Germany
RUNNER-UP

New Island, Falklands

*"One December, a storm woke me before
sunrise. From my window, I saw a light break
through a gap in the dark, cloudy sky.
Realising the magic of the moment, I grabbed
my camera. A few minutes later, pouring rain
washed away the scene."*

Canon EOS 1N with 300mm lens; 1/250 sec at f4;
Fujichrome Velvia rated at 40; tripod

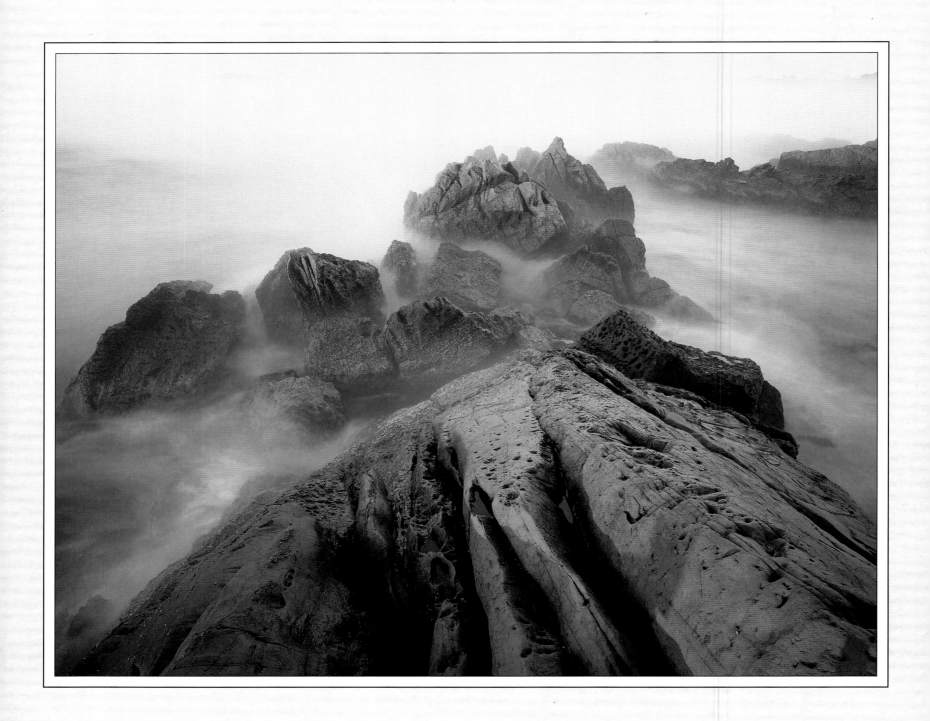

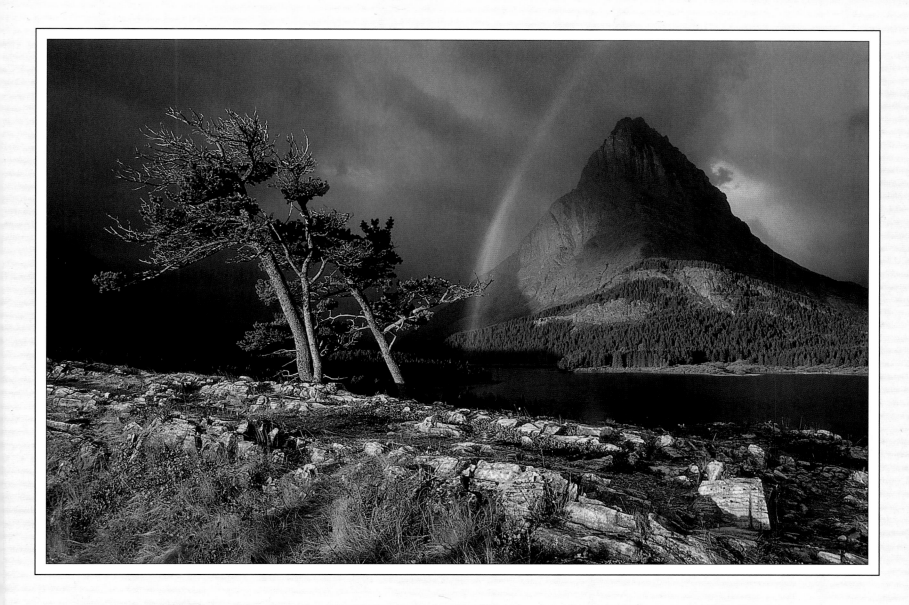

Raoul Slater
Australia
HIGHLY COMMENDED

Mossy Point at sunrise, Australia

"The south coast of New South Wales, Australia,
comprises a string of deserted beaches, knotted
together with wild and rocky headlands.
While working in the area, I noticed that winter
sunrises caused mist to rise from the warm wash of
the waves onto the beach. One particularly cold,
clear dawn, this scene unfolded before me."

Linhof Technika with 90mm lens; 4 sec at f32;
Fujichrome Velvia; tripod

Florian Schulz
Germany
HIGHLY COMMENDED

Glacier National Park, Montana, USA

"While photographing black bears in Glacier
National Park, in mid-September, I was caught in a
thunderstorm. Lightning tore the furiously dark sky,
but shortly after, the sun broke through the clouds.
A rainbow appeared as though to bring peace,
but I only had a few moments to capture the mood."

Nikon F90x with 28-70mm lens; Fujichrome Sensia 100; tripod

Jeremy Woodhouse
United Kingdom
HIGHLY COMMENDED

Sunrise, northern Maine, USA

"I'd made a special trip to Sandy Stream Pond
in Baxter State Park to photograph moose in
autumn. I'd had no luck on this particular dull,
grey morning and was packing-up my cameras
when the sun suddenly broke through.
I rushed to put my camera back together and was
rewarded with this scene – but no moose."

Fuji 617 with 105mm lens; 8 sec at f22;
Fujichrome Velvia rated at 40

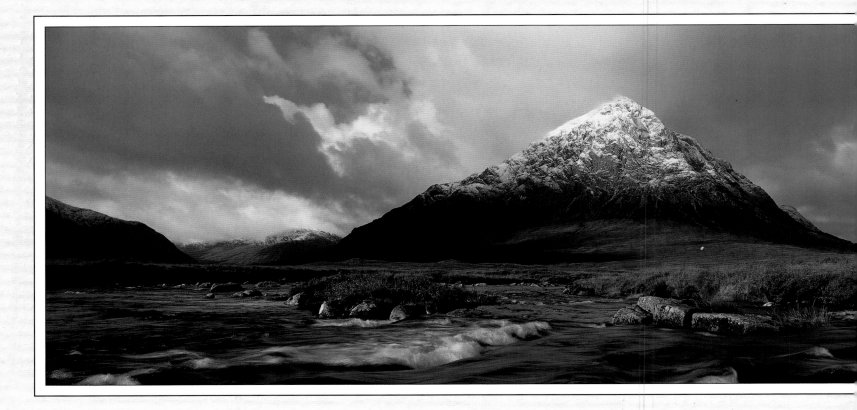

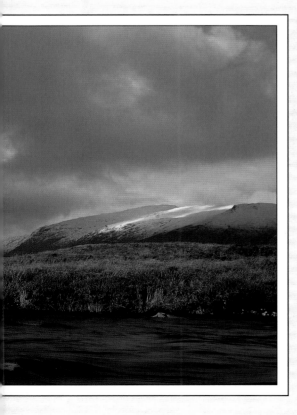

Ed Collacott
United Kingdom
HIGHLY COMMENDED

Glencoe, Scotland

*"The chance of getting all the elements
to co-operate for this image was remote.
I had been trying for years to photograph
Buachaille Etive Mor, which is a classic Scottish
mountain, some 1,022 metres high.
More often than not the weather is appalling,
but this October morning the sun broke through,
the cloud formations were perfect, the water was
rippling, the autumn colours were glowing
and the mountain was even snow-capped."*

Fuji 6î7 with 90mm lens; 1/2 sec at f22;
Fujichrome Velvia; tripod

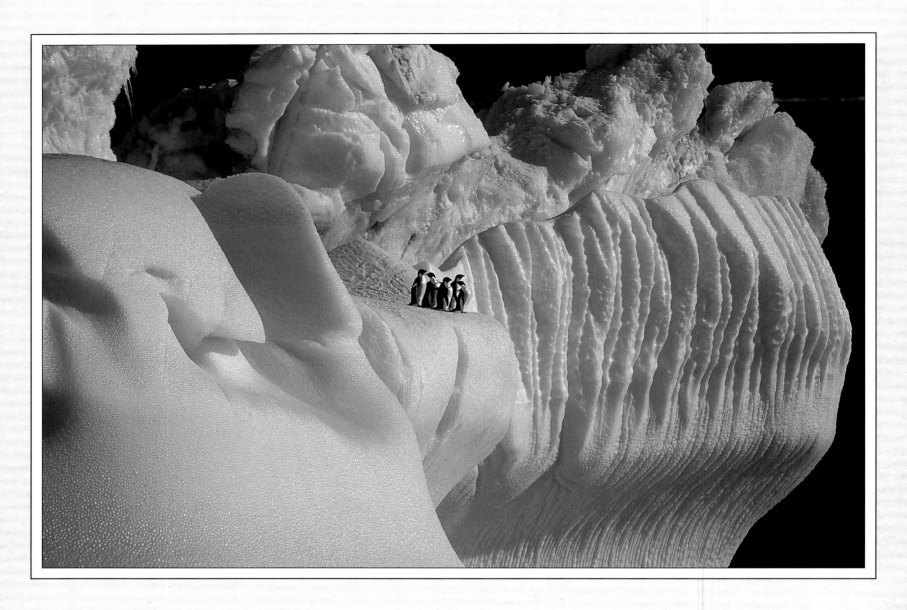

Günter Lenz
Germany
HIGHLY COMMENDED

Paulet Island, Antarctica

*"I was cruising to Antarctica and South Georgia
in February when I was captivated by this
shifting iceberg off Paulet Island.
A dark background and evening sun gave the
sculptured ice a sleek sheen. The group of Adélie
penguins on the ice ledge looked vulnerable,
as though poised on the edge of the world."*

Nikon F5 with 300mm lens; 1/250 sec at f11;
Fujichrome Velvia; tripod

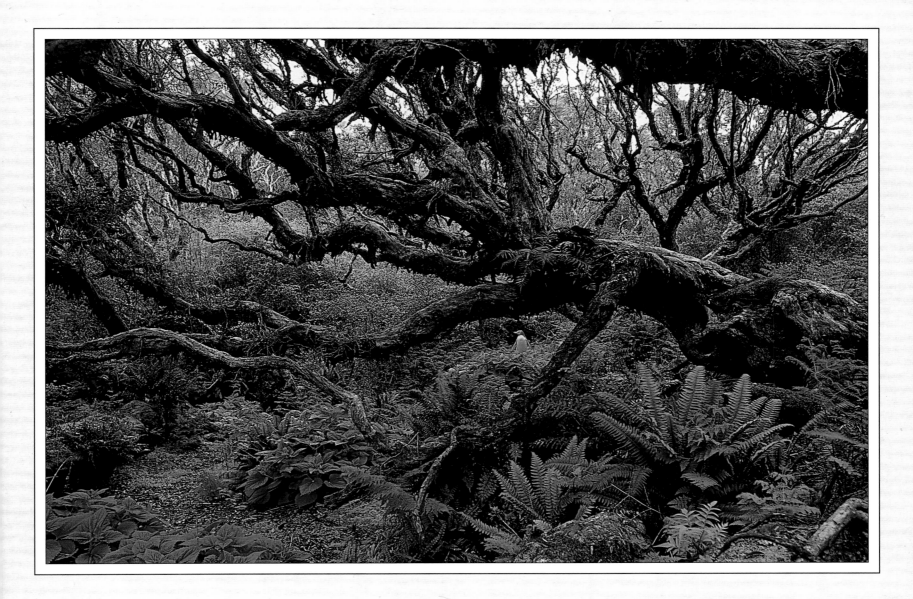

Konrad Wothe
Germany
HIGHLY COMMENDED

Rata Forest, Enderby Island,
New Zealand

"A rough, windy climate has sculpted the rata trees on Enderby Island into bizarre, creeping forms, growing no taller than a metre or so on the coast. The yellow-eyed penguin, one of the world's rarest penguins, finds shelter there."

Canon EOS IN with 17-35mm lens; 1/8 sec at f8;
Fujichrome Velvia; tripod

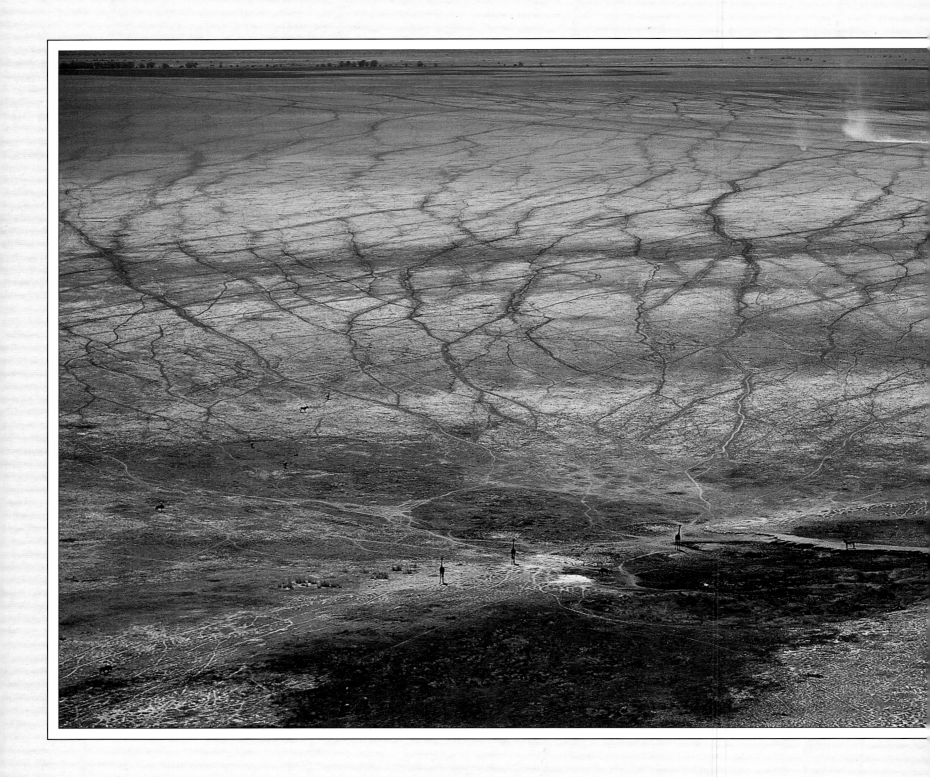

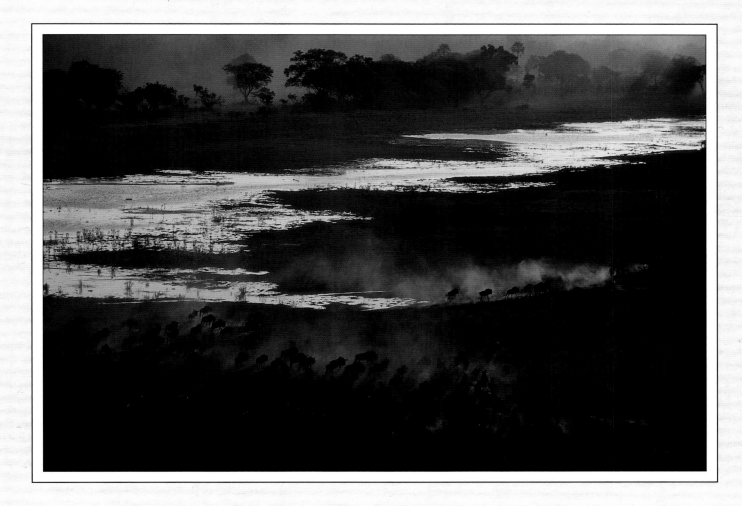

Steve Bloom
United Kingdom
HIGHLY COMMENDED

Peter Pickford
South Africa
HIGHLY COMMENDED

Amboseli National Park, Kenya

"The animal tracks covering this vast, dry lake bed in Amboseli in Kenya contribute to the sense of remoteness of the place. The giraffes at the waterhole are dwarfed by the emptiness of the vast plain behind them. Even at the height of the dry season, permanent waterholes exist, fed by springs emanating from Mount Kilimanjaro, which dominates the park. I photographed this scene while flying over Amboseli in the dry season."

Okavango River, Botswana

"I took this from a microlight in June when the annual flood-waters of the Okavango spread out across the dry floodplains. As the flood moves across the delta, it attracts animals, such as this herd of blue wildebeest, to the flush of green left in its wake."

Nikon F4 with 80-200mm lens; 1/250 sec at f5.6; Kodachrome 64

Canon EOS 1N with 70-200mm lens; 1/2000 sec at f2.8; Fujichrome Velvia rated at 80

127

The WORLD IN OUR HANDS

Powerful images that illustrate – in a symbolic or graphic way – our dependence on the natural world or our capability of inflicting harm on it.

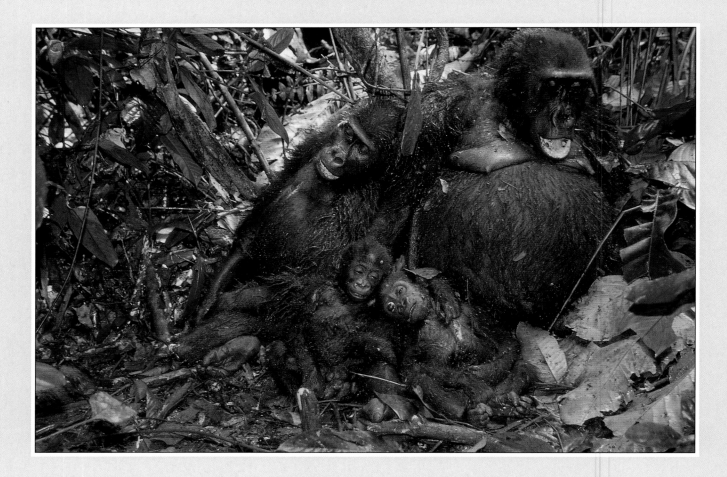

Karl Ammann
Switzerland
WINNER

Slaughtered lowland gorillas

"To expose this massacre required co-operation with the murderers themselves. Commercial logging in Cameroon had driven the gorillas to within a few kilometres of a village, which made them especially easy prey. A trained dog chased three female gorillas up the trees. The hunters blasted into the trees until the gorillas and their two babies fell out. I persuaded the hunters to huddle the bodies together for this photograph before they began butchering them. They told me that they would get about £30 for the three adults' meat, but the babies would fetch nothing and be given to local children to play with, cut up and cook."

Nikon N90s with 20-35mm lens; Fujichrome Sensia 100

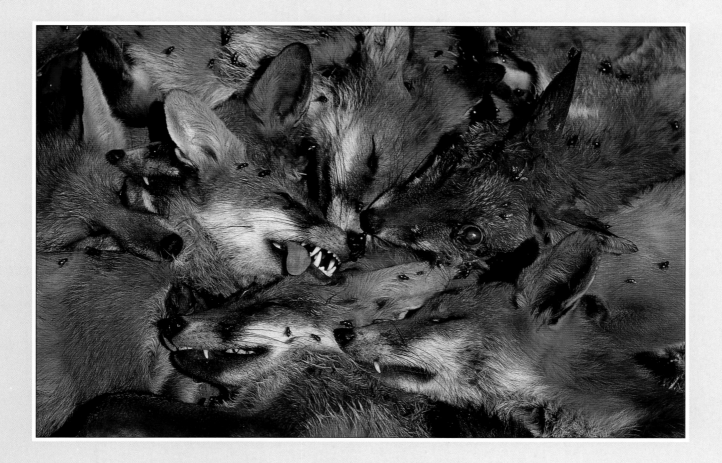

William Osborn
United Kingdom
RUNNER-UP

Dead foxes

"This pile of foxes is the result of a night shoot on a country estate in southwest England, where fox numbers are culled as part of a 'vermin-control programme'. The animals are picked out with spotlights and shot with high-powered rifles. Foxes are considered vermin by gamekeepers because they hunt pheasants that are reared for shooting."

Canon F1 with 28mm lens; 1/125 sec at f11; Fujichrome Velvia; tripod

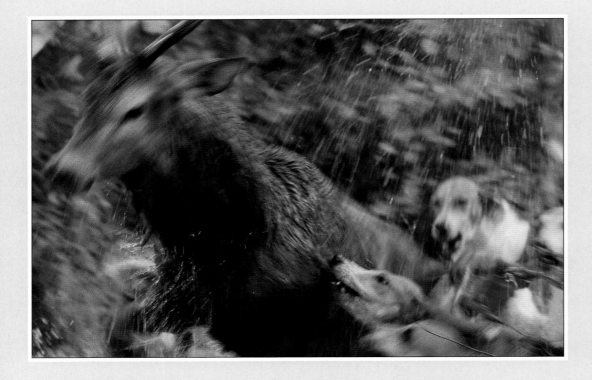

Thierry Moreau
France
HIGHLY COMMENDED

Red deer hunt

"This red deer hunt in Touraine, central France, is a typical and traditional way to regulate deer populations in France. At the end of the hunt, when the dogs catch up with the deer, they kill it by ripping out its throat."

Nikon F4 with 300mm lens; Fujichrome 100

Lorne Gill
United Kingdom
HIGHLY COMMENDED

Woodpigeon imprint on window

"The windows on this farm had raptor outlines stuck on the glass to deter birds from flying into them. A pigeon flying in dim winter light hadn't noticed the silhouettes and crashed into the glass. The ghost-like image, caused by the feather-dust that helps keep the feathers clean, was aesthetically interesting enough. But it was also symbolic to me of all the wildlife that perishes through the kind of human activity that has no perceived threat."

Nikon F5 with 300mm lens; 1/125 sec at f8; Fujichrome Velvia; tripod

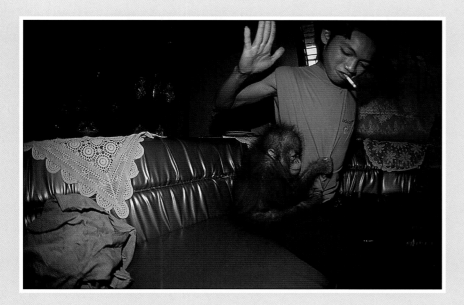

Karl Ammann
Switzerland
HIGHLY COMMENDED

Animal dealer disciplining orphaned orang-utan

"This 18-month-old male orang-utan was for sale. Hidden in a dark-shuttered room in a house by the Mahakam River, Indonesia, his owner tried to prove he was a good pet by picking him up. The animal was obviously afraid and bit the dealer, who then hit him. Sailors from Taiwan and Japan order these animals as pets, along with a piece of electronic equipment for disciplining purposes."

Nikon N90s with 20-35mm lens;
Fujichrome Sensia 100

Luidger Weyers
Germany
HIGHLY COMMENDED

Fur seal caught in fishing net

"We were visiting Husvik, an abandoned whaling station on South Georgia, Antarctica, when we came across this seal. To our relief, the seal let us rip the fishing net from its neck. Although the slaughter of seals and whales stopped years ago in this area, this photograph shows that nature is still at risk from human activity."

Nikon F90x with 28-70mm lens; 1/125 sec at f5.6;
Fujichrome Sensia

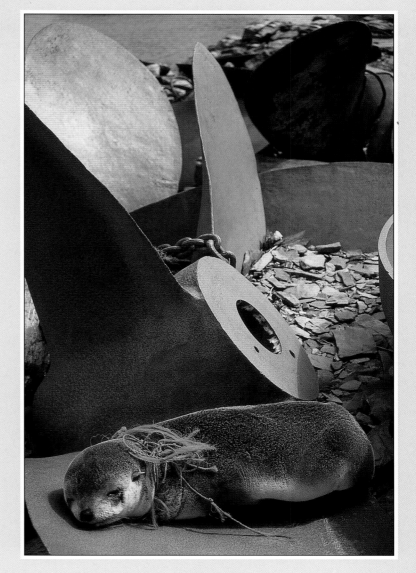

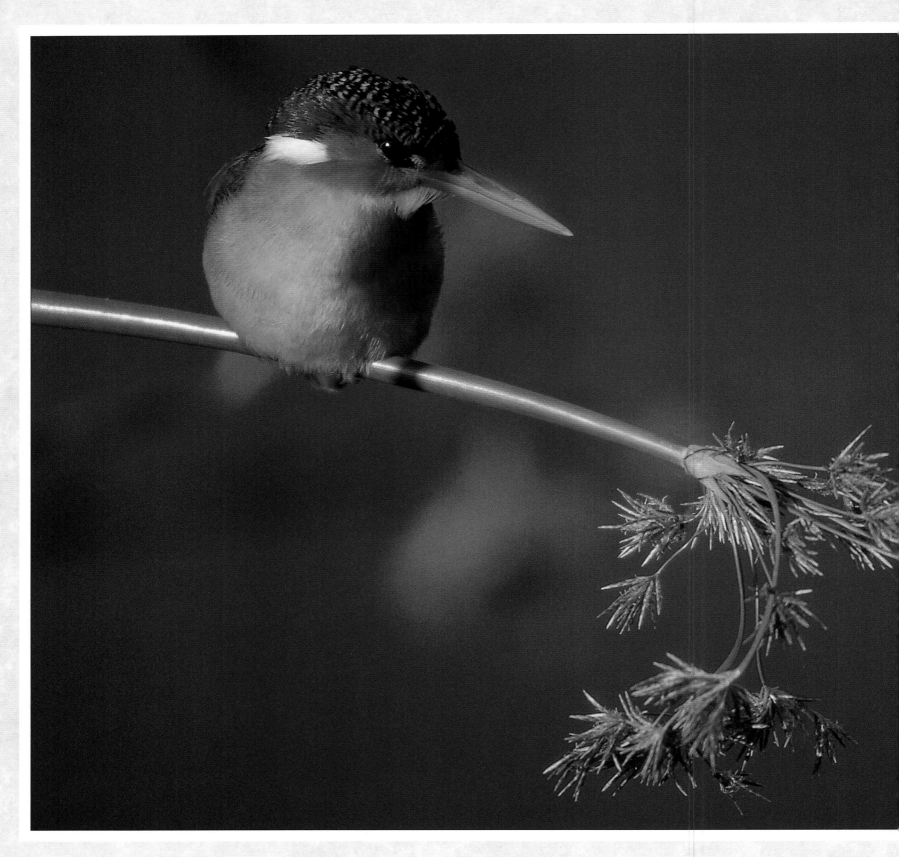

YOUNG WILDLIFE PHOTOGRAPHER *of the* YEAR

This section of the Competition is open to photographers aged 17 and under. It is divided into three age categories: 10 years and under, 11 to 14 years old and 15 to 17 years old. There are two special Awards, the YOC Award and the meg@ Award.

The YOC is the junior membership of the Royal Society for the Protection of Birds – an international wild bird and environmental conservation charity with over a million members worldwide. meg@ is a lively, weekly, UK-based young people's newspaper produced by The Times. Both Awards were set up to acknowledge and encourage new talent in the field of wildlife photography.

Nick Wilton
South Africa
BG YOUNG WILDLIFE
PHOTOGRAPHER OF THE YEAR
1999

Malachite kingfisher

"This kingfisher paused very briefly while hunting fingerlings at the water's edge. I had to react extremely quickly to photograph it before it flitted off in a blur of colour. The shot was taken on a cold August morning in Kruger National Park, South Africa."

Nikon N90 with 150-500mm lens;
1/125 sec at f8; Fujichrome Provia

This year's overall winner, 16-year-old Nick Wilton, hails from Johannesburg, South Africa, where he is currently a student at St John's College. Nature photography in the Kalahari, Kruger, Chobe and the Okavango has been an inspiring passion, and in 1996 he was also awarded the title of BG Young Wildlife Photographer of the Year. He has continued to build on that success and this year he has won again with this beautiful image of a malachite kingfisher.

Nick hopes to go on to study Environmental Law at the University of Cape Town, as well as continuing to pursue his interest in wildlife photography.

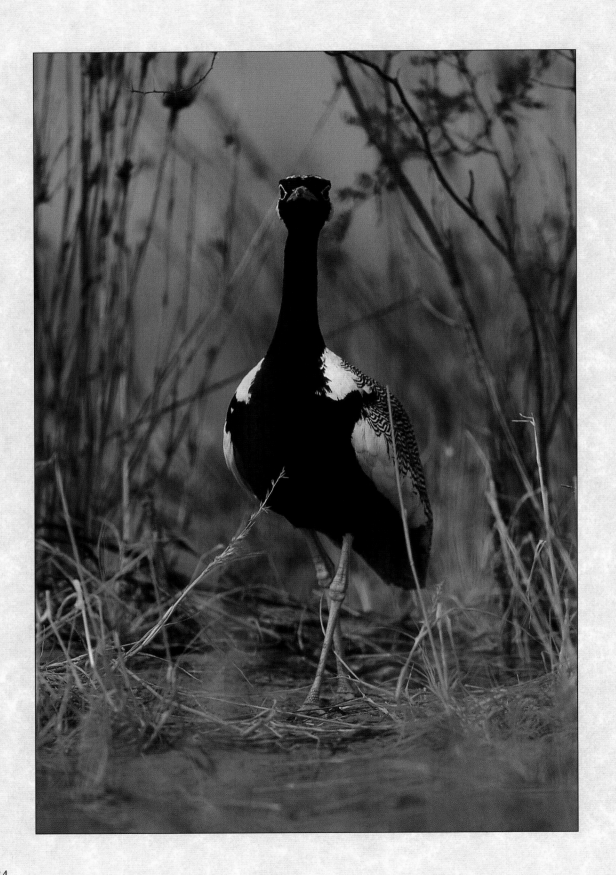

Ashleigh Rennie
South Africa
WINNER
10 YEARS AND UNDER

Korhaan

"We were driving through the dunes of the Kalahari Gemsbok National Park, South Africa, because the road along the riverbed was flooded. Passing through a cutting, we met this black korhaan standing alert at the same level as the car window. This made it easy to shoot off quite a few photos as it stared into my camera."

Canon EOS 5 with 300mm lens;
Fujichrome Sensia 100; beanbag

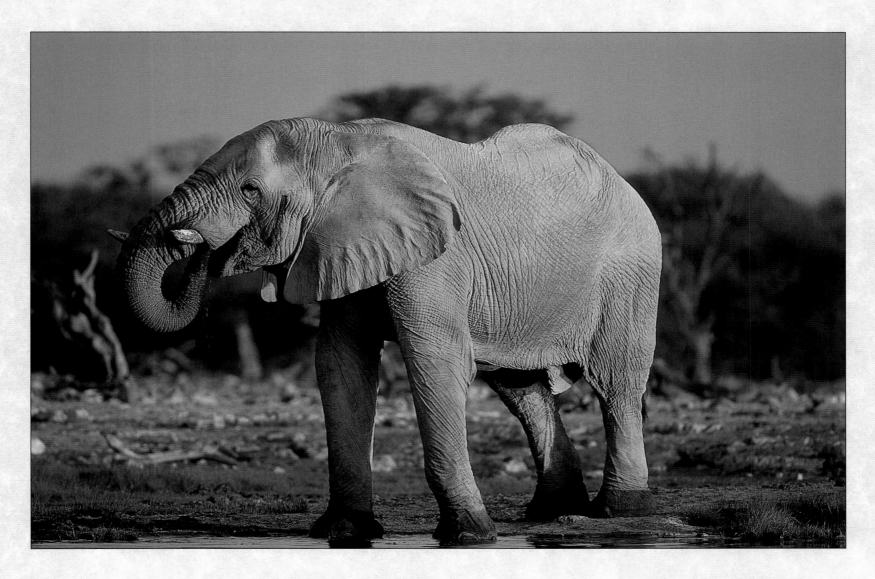

Adam P Bloom
United Kingdom
RUNNER-UP
10 YEARS AND UNDER

Elephant drinking

"I took this photograph in Etosha National Park, Namibia. We were out for an evening drive and stopped off at the Goas water hole. For a long time nothing happened, but eventually this huge elephant came for a drink and gave me my big chance."

Canon EOS 1N with 300mm lens;
Fujichrome Velvia; beanbag

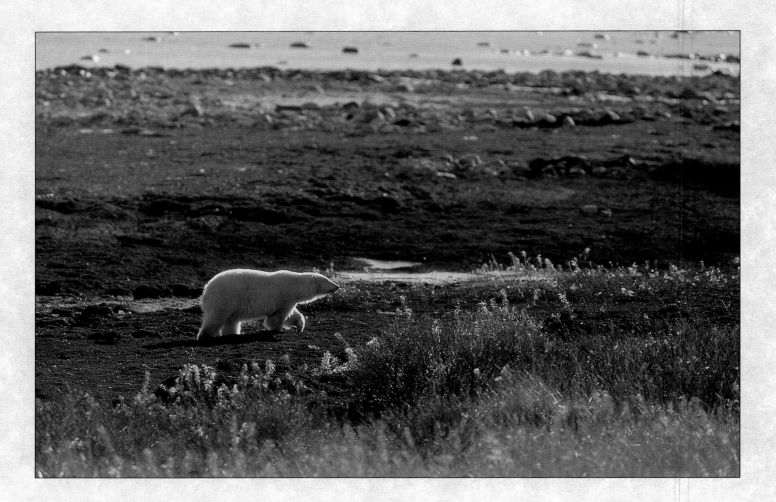

David Denis
France

HIGHLY COMMENDED
10 YEARS AND UNDER

Polar bear

"Late October 1998 was unusual in Churchill,
Canada, because there was no snow.
This polar bear had spent the summer on the
tundra eating what it could (even vegetation if
it had to) and was now desperate for the seas to
refreeze so it could get out to feed on the seals.
It looked like a lost soul ambling through
this snowless landscape."

Canon EOS 5 with 300mm lens; 1/250 sec at f4;
Fujichrome Sensia 100

Becky L Chadd
United Kingdom

WINNER
11-14 YEARS OLD

Mute swan

"By March, swans have marked out their
territories for the breeding season, and so
I suppose this cob saw me as an intruder.
He drew himself up into the classic threat
posture, which had double the impact being
reflected in the dark water."

Canon EOS 50E with 80-200mm lens; 1/350 sec at f5.6;
Fujichrome Sensia II 100 rated at 200; tripod

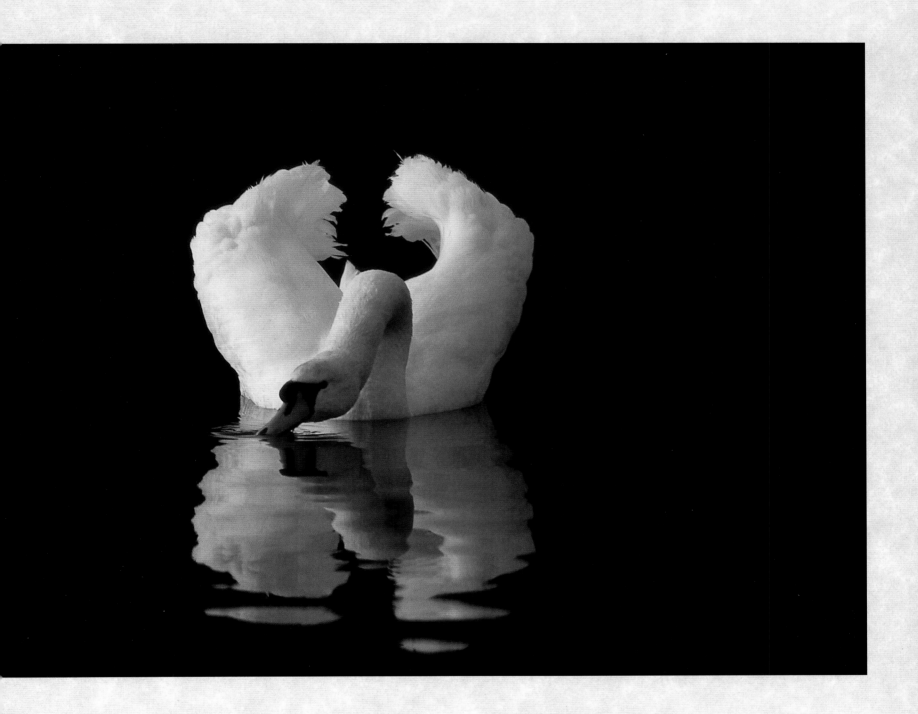

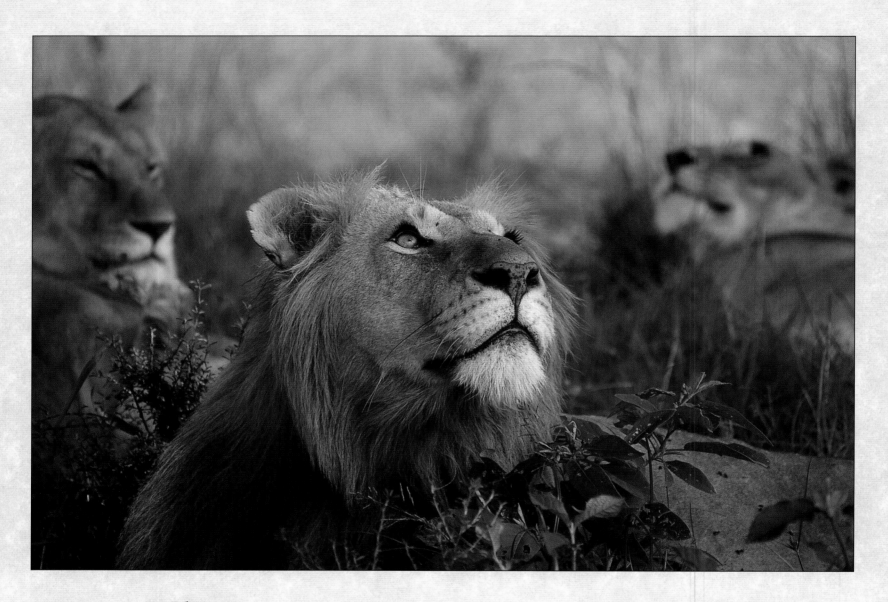

David Scott
United Kingdom
RUNNER-UP
11–14 YEARS OLD

Lion watching baboons in tree

"We were watching lions at the edge of Musiara Marsh in the Maasai Mara National Reserve, Kenya, where they had been hunting a buffalo. We returned after our breakfast to find the whole pride lying under a tree. The pride male kept looking up, and it turned out that a group of baboons had sought refuge up the tree. Each time he gazed up, sunlight glinted in his eyes, which was just what I needed to give life to the photograph."

Canon EOS 1 with 35-350mm lens; 1/125 sec at f5.6;
Fujichrome Sensia 100; beanbag

138

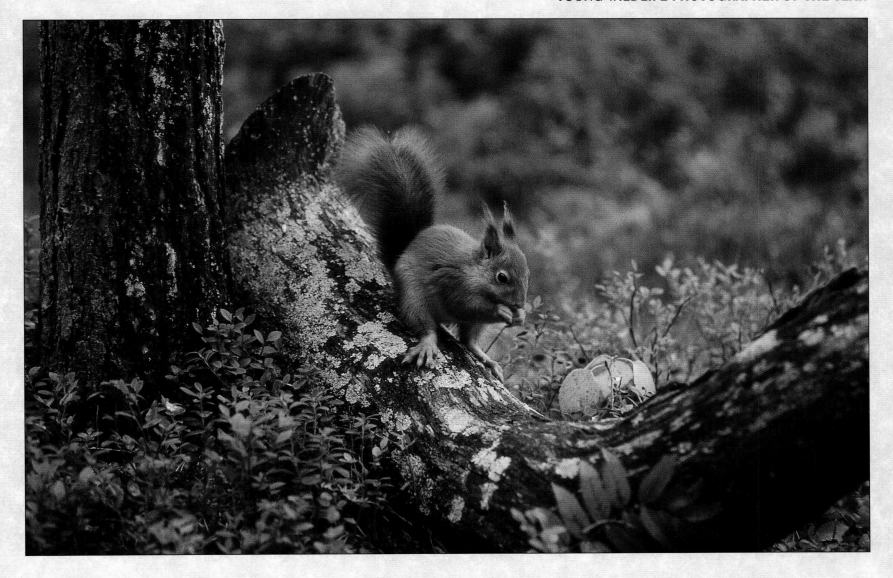

Janina Salo
Finland
HIGHLY COMMENDED
11–14 YEARS OLD

Red squirrel

"I've photographed squirrels in Lapland for some years now. By looking for signs of where they eat, I can decide the best places to lie in wait. I may be rooted to the spot for a few hours, but as this photograph shows, it's always worth the effort."

Nikon F50 with 80-200mm lens

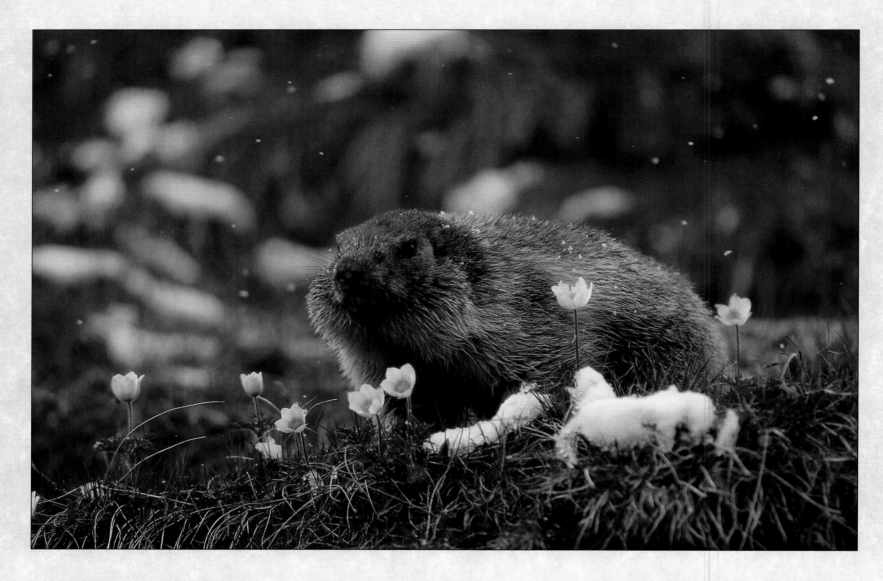

Fabian Fischer
Germany
WINNER
15–17 YEARS OLD

Alpine marmot in snowfall

*"This marmot was living 2,800 metres
up the Austrian Alps. Although it was
spring and the alpine flowers were out,
it suddenly began to snow, and the
temperature fell quite sharply.
But this marmot seemed oblivious
and continued to eat."*

Nikon F90x with 300mm lens and
x2 teleconverter; 1/125 sec at f5.6;
Fujichrome Sensia II 100; tripod

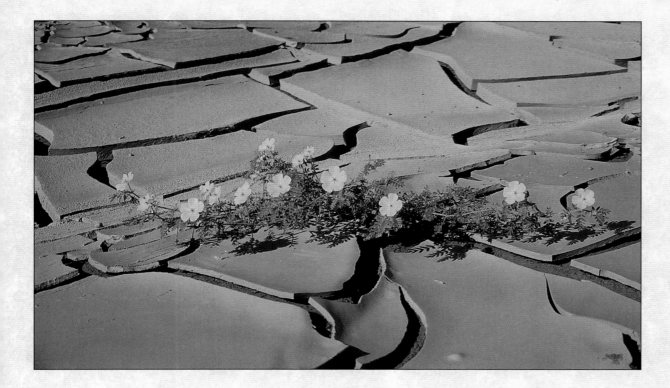

Silvia Morgante
Italy
RUNNER-UP
15–17 YEARS OLD

Devil's thorn plant

"The devil's thorn plant is a very common flowering plant in Namibia. I photographed this one in Sossusvlei in the Namib Desert after a downpour had flooded the area. The yellow flowers provided a welcome relief from the cracked, wet sand."

Nikon F601 M with 28-105mm lens; automatic at f5.6; Fujichrome Sensia

Fabian Fischer
Germany
HIGHLY COMMENDED
15-17 YEARS OLD

Goshawk plucking partridge

"One cold February day, I was out birdwatching when I saw this goshawk kill a partridge. I cycled home as fast as I could to get my camera and bird-hide. When I arrived back at the spot, there were just a few remains of the prey. I set up my hide and waited, half frozen. Four hours later, the goshawk approached the partridge on foot and obligingly finished its meal."

Nikon F90x with 300mm lens and x2 converter; 1/125 sec at f5.6; Fujichrome Sensia II 100; tripod

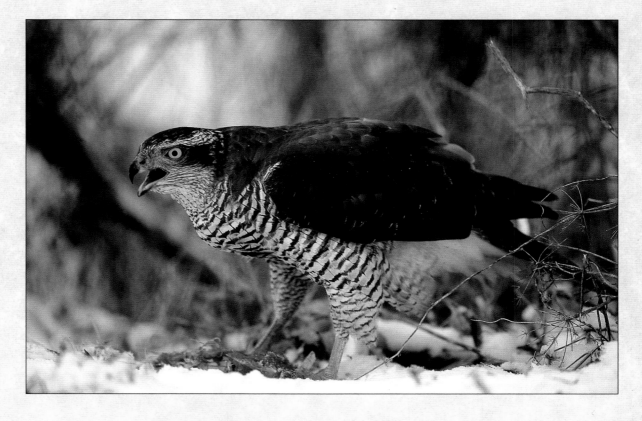

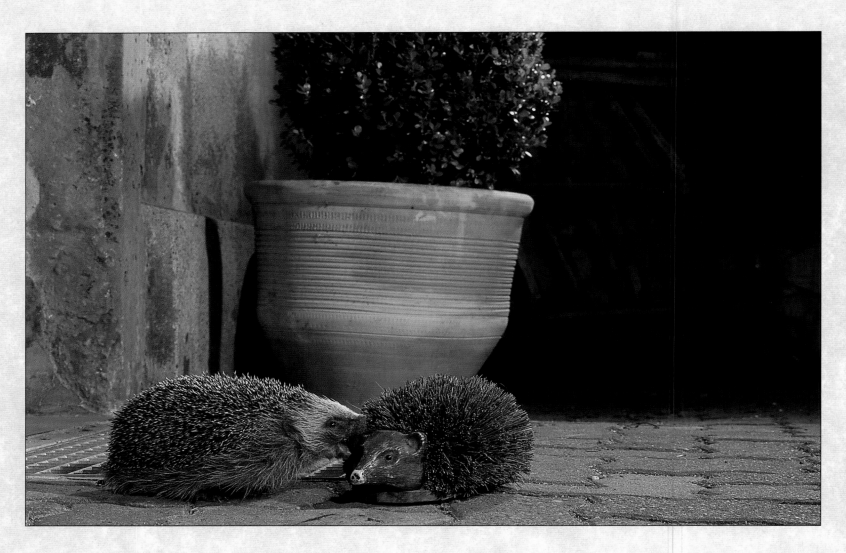

Anne Meyer
France
WINNER
YOC AWARD - CLOSE TO HOME

Hedgehog with shoe-scraper

*"We often found our hedgehog shoe-scraper
mysteriously moved from its normal place.
One evening, we caught the apparent 'culprit' —
one of our resident hedgehogs, Hoggy, standing
nose-to-nose with the dummy hedgehog.
Given how notoriously bad a hedgehog's sight is,
it struck me as odd behaviour that he should
seemingly be trying to drive the 'intruder' away.
I succeeded, though, in photographing
the drama by lying quietly nearby."*

Nikon F90x with 80-200mm lens; 1/125 sec at f11;
Fujichrome Sensia II

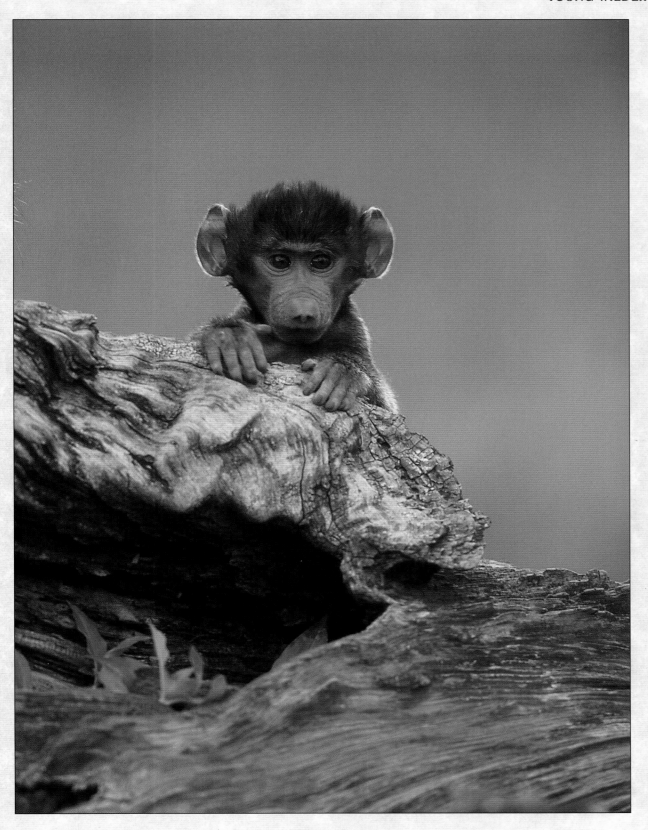

David Scott
United Kingdom
WINNER
meg@ AWARD - YOUNG AND WILD

Young olive baboon

"I spent several hours watching a group of young baboons playing and chasing one another among the trees at the edge of a forest in the Maasai Mara National Reserve, Kenya. I took lots of photographs, trying to catch the action. At one point, this tiny baboon popped his head above a stump to see what his playmates were up to."

Canon EOS I with 35-350mm lens; 1/125 at f8; Fujichrome Sensia 100; beanbag

FROM DUSK TO DAWN

Wildlife captured on film in the hours between sunset and sunrise
(the sun may be on but not above the horizon).

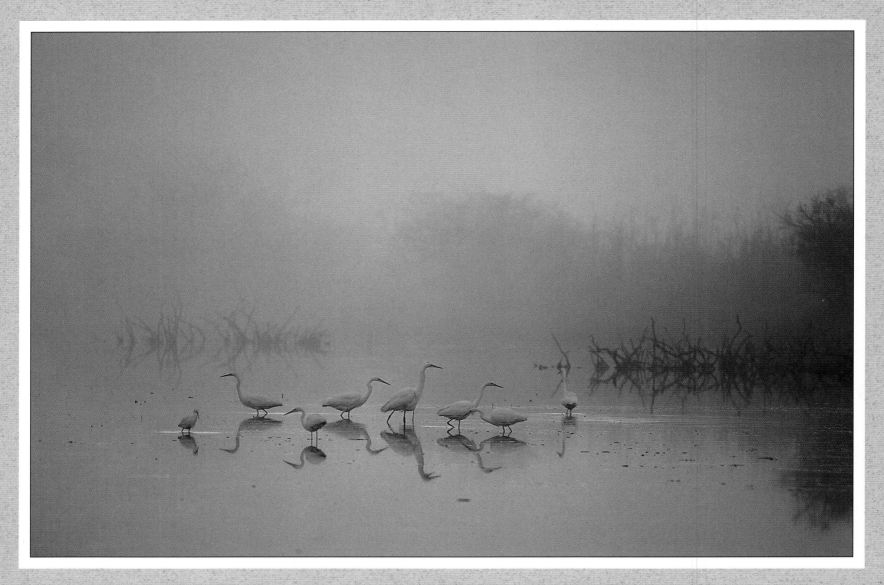

Andrea Bonetti
Switzerland
WINNER

Great white egrets in morning mist

"Up to 300 of these elegant birds gather to feed in winter at Gialova Lagoon, Pylos, Greece. But often they have to wait for the dawn mists to clear before they can begin. These foggy mornings rapidly change from a cold, white-blue to an intense, yellow-orange light when the sun emerges from the mountains. Only then do the mists clear and the day's fishing can begin."

Nikon F4 with 500mm lens; 1/250 sec at f4;
Fujichrome Sensia 100

Chris Packham
United Kingdom
HIGHLY COMMENDED

Lesser flamingos feeding at dusk

"I had been trying to photograph a secretary bird's nest near Lake Elmenteita in Kenya's Rift Valley, but the light faded too fast. I climbed instead to the top of a cliff with views across the lake where a scattered group of flamingos was feeding. What drew me to these birds was their speck-like quality. Normally so ostentatious in their pink finery, it was a relief to see them reduced to little more than a mote on the spectacular lake."

Canon EOS 1 with 400mm lens and x1.4 teleconverter;
Kodachrome 64

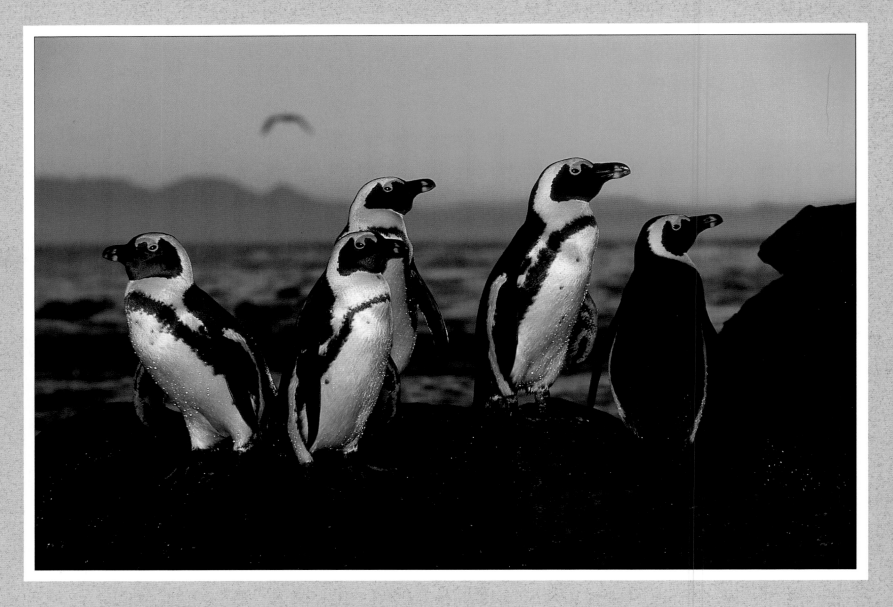

Peter Chadwick
South Africa
HIGHLY COMMENDED

African penguins at dawn

"These penguins had spent the night at their usual roost on Bouldres Beach, Simonstown, South Africa. At dawn, they made their way back to the sea, pausing to preen on the shoreline.
They then set off for their feeding ground in False Bay. This endangered species is Africa's only resident penguin and at the time were in the middle of their breeding season."

Nikon F90x with 70-210mm lens; 1/60 sec at f4; Fujichrome Astia

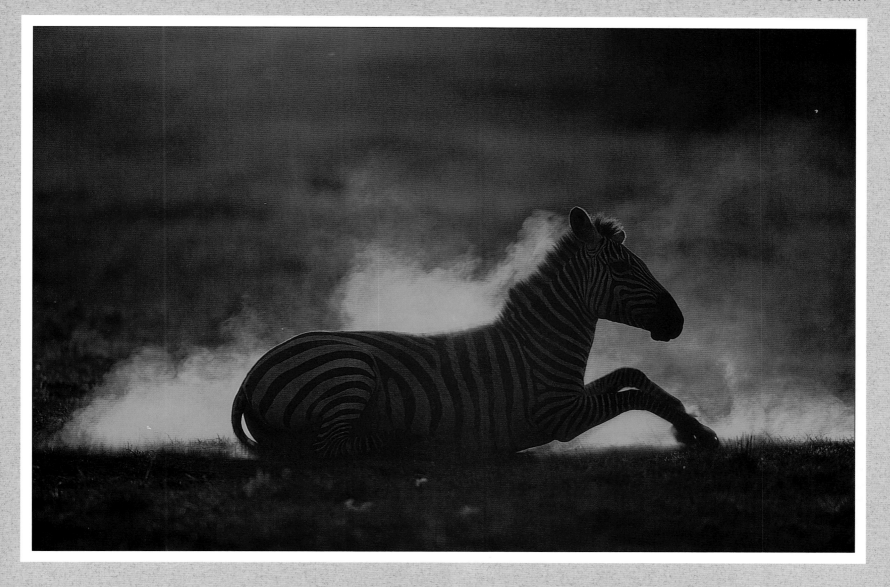

Mike Hill
United Kingdom
HIGHLY COMMENDED

Burchell's zebra dust-bathing

"On a January trip to the Maasai Mara National Reserve, Kenya, I tried to concentrate on photographing animals against the light. I noticed that the zebra tended to follow the same path in the evenings and that they stopped to dust-bathe at certain spots. As an added bonus, I was treated to a splendid sunset almost every evening, and so I was able to get a series of shots of these animals dust-bathing surrounded by a golden glow."

Nikon F5 with 500mm lens; Fujichrome Sensia 100; beanbag

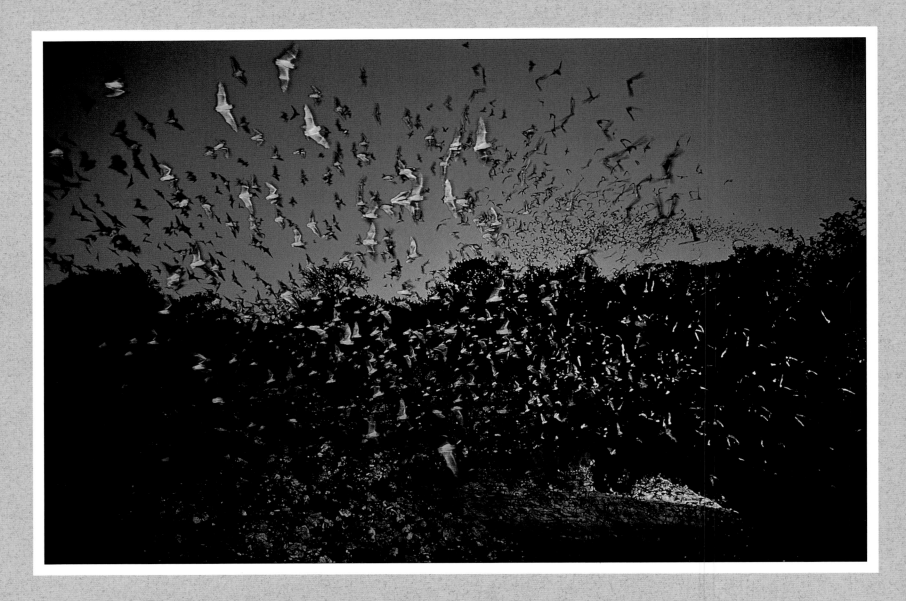

Stephen J Krasemann
Canada
HIGHLY COMMENDED

Mexican free-tailed bats
emerging from cave

"These bats leaving their daytime roost in Texas,
USA, must constitute one of the largest biomasses
anywhere on Earth. In fact, the eight-kilometre-
long string of bats shows up on the San Antonio
airport radar. As the photographer, I had to contend
with intense summer heat, biting fire ants,
and toxic fumes from the cave to take the shot."

Nikon F4 with 28mm lens; Kodachrome 64; multiple flash units

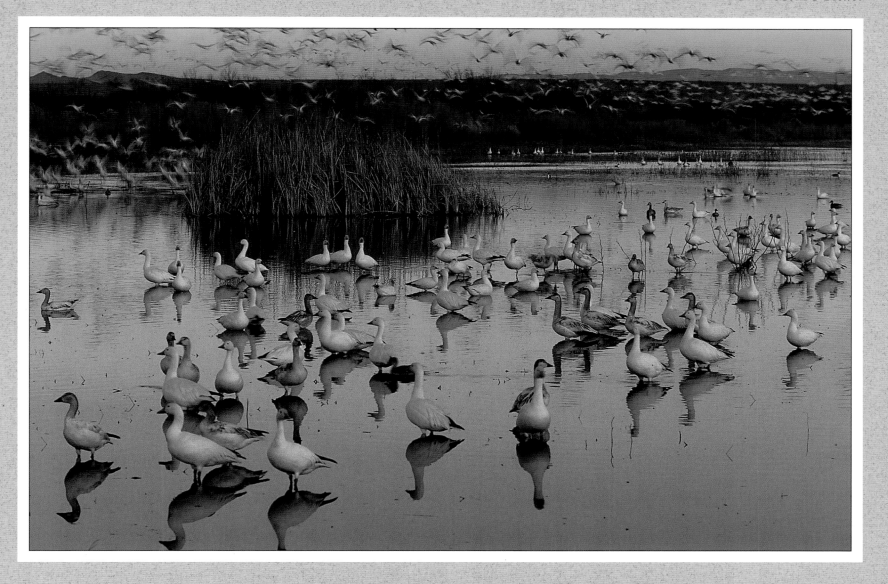

**Wendy Shattil
& Bob Rozinski**
United States of America
HIGHLY COMMENDED

Snow geese gathering to roost

*"This lake at Bosque del Apache National Wildlife
Refuge in New Mexico, USA, is a night roost for
snow geese. We were fascinated how the geese
continued to stream in a good half an hour after
sunset. To be able to photograph both the geese in
the water and the ones flying in, we used a slow
shutter speed, giving the scene a sense of motion."*

Canon EOS 1N with 70-200mm lens; 1/8 sec at f16;
Fujichrome Velvia

149

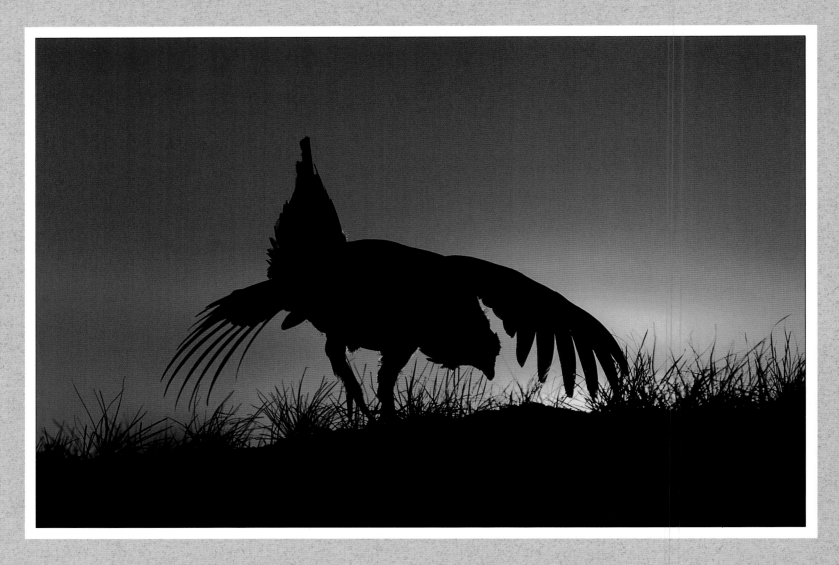

Stephen J Gettle
United States of America
HIGHLY COMMENDED

Sharp-tailed grouse dancing at dawn

*"This lekking male was dancing his heart out long
before the sun rose, trying to impress a mate.
The spring sunrise backdrop highlighted his poise
and elegance. There were about 30 males at this
lek in Michigan, USA. The most aggressive,
dominant individuals were in the centre of
the lek, and they seemed to win the most
attention from the females."*

Nikon N90s with 600mm lens; 1/500 sec at f8;
Fujichrome Velvia; tripod

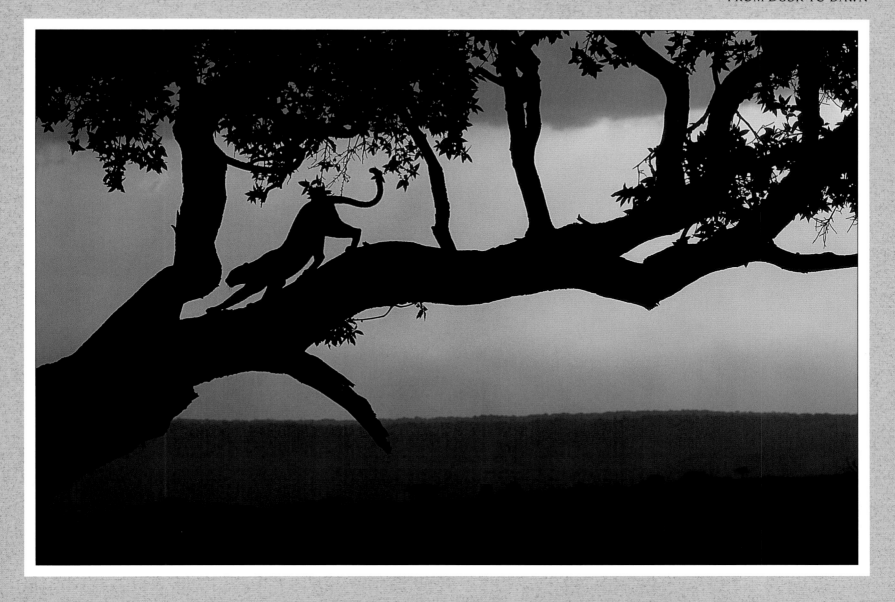

Jonathan Scott
United Kingdom
HIGHLY COMMENDED

Leopard stretching

"This ancient fig tree is located at Leopard Gorge
in the Maasai Mara National Reserve, Kenya, and
is one of my favourite landmarks. Zawadi, one of
the stars of the BBC's 'Big Cat Diary', often rested
in this tree, giving me the perfect opportunity to
photograph her when she yawned and stretched
before descending for her evening hunt."

Canon EOS 1N with 500mm lens; 1/125 sec at f8;
Fujichrome Sensia; beanbag

THE ART OF CLOSE-UP PHOTOGRAPHY
Joseph Meehan
ISBN 0 86343 356 1

THE ART OF WILDLIFE PHOTOGRAPHY
Fritz Pölking
ISBN 0 86343 322 7

THE ART & TECHNIQUE OF UNDERWATER PHOTOGRAPHY
Mark Webster
ISBN 0 86343 352 9

THE ART OF LANDSCAPE PHOTOGRAPHY
Chris Coe
ISBN 0 86343 337 5

THE REPRODUCTION OF COLOUR
Dr RW Hunt
Fifth Edition
ISBN 0 86343 381 2

MEASURING COLOUR
Dr RW Hunt
Third Edition
ISBN 0 86343 387 1

PHOTOGRAPHY YEARBOOK 2000
ISBN 0 86343 333 2

Also available
PHOTOGRAPHY YEARBOOK 1999
PHOTOGRAPHY YEARBOOK 1998
PHOTOGRAPHY YEARBOOK 1997

**BEYOND MONOCHROME
A Fine Art Printing Workshop**
ISBN 0 86343 313 8

**THE NIKON FIELD GUIDE
A Photographer's Portable Reference**
Thom Hogan
ISBN 1 883403 44 8

**WILDERNESS PHOTOGRAPHY
A Photographic and Spiritual Journey through the Landscape**
Rob Beighton
ISBN 0 86343 372 3

SILVER GELATIN
Martin Reed & Sarah Jones
ISBN 0 924346 1 X

Larry Bartlett's
Black & White
Photographic Printing
Workshop
ISBN 0 86343 366 9

**THE NUDE
Creative Photography Workshop**
Bruce Pinkard
ISBN 0 86343 392 8

**THE DIGITAL DARKROOM
Black & White Techniques Using Photoshop**
George Schaub
ISBN 1 883403 51 0

IDENTIFYING LEICA LENSES
Ghester Sartorius
ISBN 88 900059 8 X

IDENTIFYING LEICA CAMERAS
Ghester Sartorius
ISBN 88 900059 3 9

PHOTOGRAPHIC HINTS AND TIPS

PHOTOGRAPHIC HINTS AND TIPS

Photographing BUTTERFLIES AND OTHER INSECTS
Paul Hicks
ISBN 0 86343 332 4

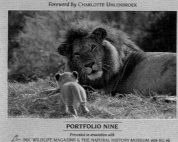

WILDLIFE PHOTOGRAPHER OF THE YEAR PORTFOLIO NINE
ISBN 0 86343 383 3
PORTFOLIOS ONE TO EIGHT still available

IMAGES OF WILDLIFE The Best of International Wildlife Photography Volume One
ISBN 0 86343 367 7

Photographing BIRDS IN THE WILD
Paul Hicks
ISBN 0 86343 357 X

A TIGER'S TALE The Indian Tiger's Struggle for Survival in the Wild
Anup & Manoj Shah
ISBN 0 86343 391 X

Photographing ANIMALS IN THE WILD
Andy Rouse
ISBN 0 86343 362 6

FASCINATING NATURE The Most Spectacular Landscapes in the World
Gogol Lobmayr
ISBN 3 924044 35 X

Photographing PLANTS AND GARDENS
John Doornkamp
ISBN 0 86343 363 4

Jonathan Scott's SAFARI GUIDE TO EAST AFRICAN BIRDS
Revised and updated by Angela Scott
ISBN 0 86343 318 9

FASCINATING NATURE

Jonathan Scott's SAFARI GUIDE TO EAST AFRICAN ANIMALS
ISBN 0 86343 323 5

THE ILLUSTRATED HISTORY OF COLOUR PHOTOGRAPHY
Jack H Coote
ISBN 0 86343 380 4

POLAR DANCE Born of the North Wind
Thomas D Mangelsen
Story by Fred Bruemmer
ISBN 0 9633080 8 4

NATURE PHOTOGRAPHY Through Four Seasons
Arnold Wilson
ISBN 0 86343 312 X

THE COMPLETE PHOTOGRAPHER A Complete Practical Guide to Every Aspect of Photography
Ron Spillman
Revised and updated edition
ISBN 0 86343 341 3

FOUNTAIN PRESS
Publishers and Distributors of Quality Illustrated Books

Fountain House, 2 Gladstone Rd, Kingston-upon-Thames, Surrey KT1 3HD.
Telephone +44 (0)20 8541 4050 Fax +44 (0)20 8547 3022
e-mail fountprs@dircon.co.uk

THE NATURAL HISTORY MUSEUM

The Natural History Museum
South Kensington, London

The Natural History Museum is internationally renowned as one of the UK's top visitor attractions and a world leader in scientific research.

The Museum welcomes some 1.9 million visitors each year to see dynamic exhibitions and participate in a range of exciting events, while maintaining its role as a leading scientific research centre. There are over 350 research scientists at the South Kensington site, some of the world's leading experts working on internationally significant scientific projects in the areas of biodiversity, human health and environmental quality.

Housing some of the world's finest collections, the Museum has over 68 million plant, animal, fossil, rock and mineral specimens. This vast resource is utilised by scientists world-wide to promote understanding, appreciation and responsible use of the natural world.

The Museum is an outstanding venue for high profile events and arts performances. To engage a wider audience, and to profile its own extensive collection of natural history art on paper, the Museum, in conjunction with the Jerwood Foundation, has established a gallery specifically dedicated to displaying art led temporary exhibitions. Appropriately, the first exhibition in the new Jerwood Gallery is the 1999 BG Wildlife Photographer of the Year.

Join today and enjoy an extra three months free!

Become a member of The Natural History Museum and you can enjoy an extra three months annual membership free if you pay by direct debit.

Being a member entitles you to a host of free benefits including special events, behind the scenes tours of the Museum and a quarterly magazine. In becoming a member you are also making a special contribution to the vital work of the Museum.

To take advantage of this special offer, contact the membership office on Tel: +44 (0) 207 942 5792 quoting "BG" for an application form.

This offer is available until 31 March 2000.

Terms and conditions

1. This offer is open to new members to The Natural History Museum only.
2. This offer is only available if payment is made by direct debit.
3. There is no cash alternative.
4. Responses received after the 31 March 2000 will not be eligible for the three months free annual membership

Membership – Your commitment to the natural world

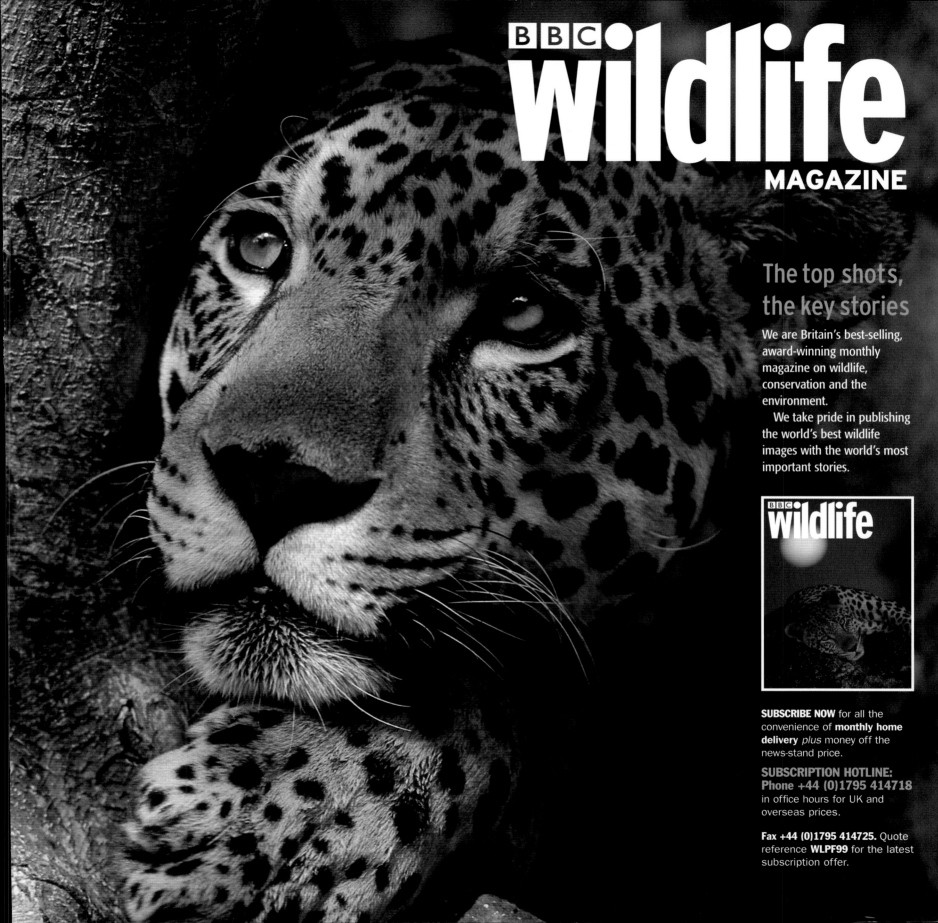

BBC● wildlife
MAGAZINE

The top shots, the key stories

We are Britain's best-selling, award-winning monthly magazine on wildlife, conservation and the environment.

We take pride in publishing the world's best wildlife images with the world's most important stories.

Index of Photographers

The numbers after the photographers' names indicate the pages on which their work can be found.

Telephone numbers are listed with international dialling codes from the UK in brackets - these should be replaced when dialling from other countries.

OVERALL WINNERS 1984-1998

Cherry Alexander
(Overall Winner 1995) 5

Higher Cottage, Manston,
Sturminster Newton, Dorset, DT10 1EZ
UK

Tel: 01258 473006
Fax: 01258 473333
Email: arcticfoto@aol.com

André Bärtschi
(Overall Winner 1992) 4

Bannholzstrasse 10, 9490 Vaduz
LIECHTENSTEIN

Tel: (004175) 232 0338
Fax: (004175) 232 0339
Email: 106224.2041@compuserve.com

Rajesh Bedi
(Overall Winner 1986)

Bedi Films,
E-19 Rajouri Gardens, New Delhi
INDIA 110 027

Jim Brandenburg
(Overall Winner 1988)

Agent:
Minden Pictures,
783 Rio del Mar Blvd 9-11, Aptos,
CA 95003
USA

Tel: (001) 831 685 1911
Fax: (001) 831 685 1913

Martyn Colbeck
(Overall Winner 1993) 4

c/o 33 High View, Hempstead,
Gloucester GL2 5LN
UK

Tel: 01452 526470

Agent:
Oxford Scientific Films Ltd,
Lower Road, Long Hanborough,
Witney, Oxfordshire, OX8 8LL
UK

Tel: 01993 881881
Fax: 01993 882808

Manfred Danegger
(Overall Winner 1998) 5

Hasenbühlweg 9, 88696 Billafingen
GERMANY

Tel: (0049) 7557 8765
Fax: (0049) 7557 8970

Richard & Julia Kemp
(Overall Winner 1984)

Valley Farmhouse, Whitwell, Norwich,
Norfolk, NR10 4SQ
UK

Tel: 01603 872498

Frans Lanting
(Overall Winner 1991) 4

1985 Smith Grade,
Santa Cruz, California 95060
USA

Tel: (001) 831 429 1331
Fax: (001) 831 423 8324
Email: Info@lanting.com

Thomas D Mangelsen
(Overall Winner 1994) 4/5

Images of Nature
PO Box 2935, 2nd Level, Gaslight Alley,
Jackson, Wyoming 83001
USA

Tel: (001) 307 733 6179
Fax: (001) 307 733 6184
Email: stockphoto@mangelsen.com

Tapani Räsänen
(Overall Winner 1997) 5

Tasalantie 27, Fin-54100 Joutseno
FINLAND

Tel & Fax: (00358) 54 534929

Jouni Ruuskanen
(Overall Winner 1989)

Ratakatu 31 As 14, 87100 Kajaani
FINLAND

Tel: (00358) 86 133026

Jonathan Scott
(Overall Winner 1987)

PO Box 24499, Nairobi
KENYA

Tel & Fax: (00254) 2 891162
Email: jpscott@swiftkenya.com

Agent:
Planet Earth Pictures,
The Innovation Centre,
225 Marsh Wall, London, E14 9FX
UK

Tel: 0207 293 2999
Fax: 0207 293 2998

Wendy Shattil
(Overall Winner 1990) 4

8325 E Princeton Ave,
Denver, Colorado 80237
USA

Tel: (001) 303 721 1991
Fax: (001) 303 721 1116
Email: wshattil@compuserve.com

Charles G Summers Jnr
(Overall Winner 1985)

Wild Images,
6746 N Yucca Trail, Parker, CO 80138
USA

Tel: (001) 303 840 3355
Fax: (001) 303 840 3366

Jason Venus
(Overall Winner 1996) 7

24 Central Acre, Yeovil,
Somerset, BA20 1NU
UK

Tel & Fax: 01935 706834

PORTFOLIO NINE

Paul Allen 36
13 White Lodge, 8 Castlebar Park,
Ealing, London, W5 1BX
UK

Tel: 0208 810 5282
Email: paulallen@wildstyles.freeserve.co.uk

Theo Allofs 100/101
Box 5473, Haines Junction YT, Y0B 1L0
CANADA

Tel: (001) 867 634 3823
Fax: (001) 867 634 2207
Email: allofsphoto@yknet.yk.ca

Karl Ammann 128, 131
c/o Mt Kenya Game Ranch
PO Box 437, Nanyuki
KENYA

Tel: (00254) 176 22448
Fax: (00254) 176 32407
Email: kamman@form-net.com

Terry Andrewartha 73
The Old Rectory, Cockley Cley, Swaffham,
Norfolk, PE37 8AN
UK

Tel: 01760 725740
Fax: 01366 328120

Pete Atkinson 18
c/o Windy Ridge, Hyams Lane, Holbrook,
Ipswich, Suffolk, IP9 2QF
UK

Tel: 01473 328349
Email: yachtvigia@hotmail.com

Agent:
Planet Earth Pictures,
The Innovation Centre, 225 Marsh Wall,
London, E14 9FX
UK

Tel: 0207 293 2999
Fax: 0207 293 2998

Steve Austin 34
*17 Burn Brae, Westhill, Inverness,
IV2 5RH
UK*

Tel: 01463 790533

*Agent:
Woodfall Wild Images, 17 Bull Lane,
Denbigh, Denbighshire, LL16 3SN
UK*

*Tel: 01745 815903
Fax: 01745 814581*

Adrian Bailey 39
*PO Box 1846, Houghton, 2041
SOUTH AFRICA*

*Tel & Fax: (0027) 11 465 9704
Email: aebailey@icon.co.za*

*Agent:
Oxford Scientific Films Ltd,
Lower Road, Long Hanborough, Witney,
Oxfordshire, OX8 8LL
UK*

*Tel: 01993 881881
Fax: 01993 882808*

Adam P Bloom 135
*Middlefield House, Olantigh Road, Wye,
Ashford, Kent, TN25 5EP
UK*

*Tel: 01233 813777
Fax: 01233 813887
Email: adam@stevebloom.com*

Steve Bloom 126/127
*Middlefield House, Olantigh Road, Wye,
Ashford, Kent, TN25 5EP
UK*

*Tel: 01233 813777
Fax: 01233 813887
Email: info@stevebloom.com*

Andrea Bonetti 144
*c/o Farmacy Tsarpalas, 24001 Pylos,
GREECE*

*Tel: (0030) 944 683996
Fax: (0030) 723 23429
Email: jobogi@aea-otenet.gr*

Dan Bool 33
*Jalan Raya Kerobokan 100X, Kuta,
Bali 80361
INDONESIA*

*Tel: (0062) 361 733280
Fax: (0062) 361 733281
Email: eastimages@hotmail.com*

Pascal Bourguignon 29
*77 rue de l'école Militaire, F-10500
Brienne le Chateau, FRANCE*

*Tel: (0033) 3 25 92 86 88
Fax: (0033) 3 25 92 74 98*

Olaf Broders 80/81
*Georg-Staber-Ring 2, 83022 Rosenheim
GERMANY*

*Tel: (0049) 8031 81265
Email: ole134@hotmail.com*

Charles Brown 49
*Riverside, Victoria Street, Yoxall,
Burton-on-Trent, DE13 8NG
UK*

*Tel: 01543 472280
Fax: 01543 473659*

Rupert Büchele 54/55
*Waldstr 12, 88486 Kirchberg
GERMANY*

*Tel: (0049) 7354 699
Fax: (0049) 7354 8411*

Laurie Campbell 85
*Hestia, Paxton, Berwick-upon-Tweed,
TD15 1TE
UK*

*Tel & Fax: 01289 386736
Email: l.campbell@starbank.demon.co.uk*

*Agent:
NHPA, 57 High Street, Ardingly,
West Sussex, RH17 6TB
UK*

*Tel: 01444 892514
Fax: 01444 892168*

John Cancalosi 28
*1532 Maplewood Drive, Slidell,
Louisiana 70458, USA*

*Tel & Fax: (001) 504 641 3870
Email: Cancalosi@compuserve.com*

Becky L Chadd 136/137
*67 Park Barn Drive, Guildford, Surrey,
GU2 6ER
UK*

Tel: 01483 578 402

Peter Chadwick 146
*12 Churchill Avenue, Seaforth,
Simonstown 7995
SOUTH AFRICA*

*Tel: (0027) 82 373 4190
Fax: (0027) 33 702 0831
Email: rinav@pmb.lia.net*

Ed Collacott 122/123
*1 Hillside, The Hollow, Dunkerton, Bath,
BA2 8BQ
UK*

Tel & Fax: 01761 436377

Claudio Contreras 106
*Av Iman 704, Ed 18A-402,
Pedregal del Maurel,
04720 Ciudad de México DF
MEXICO*

*Tel & Fax: (0052) 5 666 0072
Email: asalazar@miranda.ecologia.unam.mx*

Sylvain Cordier 63
*65 rue de Selestat, 67210 Obernai
FRANCE*

*Tel: (0033) 3 88 95 51 42
Fax: (0033) 3 88 95 63 61
Email: sylcordier@aol.com*

Manfred Danegger 44
*Hasenbühlweg 9, 88696 Billafingen
GERMANY*

*Tel: (0049) 7557 8765
Fax: (0049) 7557 8970*

Elio Della Ferrera 22, 111
*Via Signorie 3, 23030 Chiuro (SO)
ITALY*

*Tel & Fax: (0039) 0342 213254
Email: eliodellaferrera@iname.com*

*Agent:
Planet Earth Pictures,
The Innovation Centre, 225 Marsh Wall,
London, E14 9FX
UK*

*Tel: 0207 293 2999
Fax: 0207 293 2998*

David Denis 136
*1 Bis Rue des Fermes,
76310 Sainte Adresse
FRANCE*

*Tel: (0033) 2 35 46 29 70
Fax: (0033) 2 35 48 04 30*

Michel Denis-Huot 38
*1 Bis Rue des Fermes,
76310 Sainte Adresse
FRANCE*

*Tel: (0033) 2 35 46 29 70
Fax: (0033) 2 35 48 04 30
Email: DenisHuot@aol.com*

Thomas Dressler 46, 112
*Edf Marbella 2000, Apt 701,
Paseo Marítimo, E-29600 Marbella
SPAIN*

Tel & Fax: (0034) 952 860 260

Geoff du Feu 74/75
*Robins Dyke, Stubb Road, Hickling,
Norfolk, NR12 0YR
UK*

Tel & Fax: 01692 598215

David Element 77
*8 North Gardens, Collier's Wood,
London, SW19 2NR
UK*

Tel: 0208 540 7060

Gerry Ellis 114
*ENP Images, 1332 NW Kearney Street,
Portland, Oregon 97209
USA*

*Tel: (001) 503 916 0234
Fax: (001) 503 916 8849
Email: info@enpimages.com*

Thomas Endlein 64
*Topplerweg 24, 91541 Rothenburg
GERMANY*

*Tel: (0049) 9861 4501
Email:
thomas.endlein@stud-mail.uni-wuerzburg.de*

Dr Dorit Engl 116
*c/o UBTUW, Resselgasse 4, A-1040 Wien
AUSTRIA*

*Tel: (0043) 1 58801 44054
Fax: (0043) 1 58801 44099
Email: dorit.engl@tuwien.ac.at*

Yossi Eshbol 52
*27 Hagidonim Street, Zichron
Ya'acov 30900
ISRAEL*

*Tel: (00972) 6 639 8733
Fax: (00972) 6 629 0183*

*Agent:
Frank Lane Picture Agency Ltd,
Pages Green House, Wetheringsett,
Stowmarket, Suffolk, IP14 5QA
UK*

*Tel: 01728 860789
Fax: 01728 860222*

Berndt Fischer 61, 71
*Reuthstrasse 3b, D-91099 Poxdorf
GERMANY*

Tel & Fax: (0049) 9133 602616

Fabian Fischer 140, 141
*Reuthstrasse 3b, D-91099 Poxdorf
GERMANY*

*Tel: (0049) 9133 4960
Fax: (0049) 9133 602616*

Jeff Foott 54
PO Box 2167, 545 S Willow, Jackson,
WY 83001
USA

Tel & Fax: (001) 307 739 9383
Email: jfoott@blissnet.com

Jürgen Freund 68/69
Karolingerstr 26, 82205 Gilching
GERMANY

Tel & Fax: (0049) 8105 390460
Email: scubayogi@compuserve.com

Agent:
BBC Natural History Unit Picture
Library, Broadcasting House,
Whiteladies Road, Bristol, BS8 2LR
UK

Tel: 0117 974 6720
Fax: 0117 923 8166
Email: nhu.picture.library@bbc.co.uk

Stephen J Gettle 30, 150
8877 River Valley Court, Brighton,
MI 48116
USA

Tel: (001) 810 231 8118
Fax: (001) 810 231 8119

Edwin Giesbers 66/67
Groene Weide 44, 6833 BE Arnhem
NETHERLANDS

Tel: (0031) 26 321 7746

Lorne Gill 86, 130
Yew Tree Cottage, Wolfhill, Perthshire,
PH2 6DA
UK

Tel: 01821 650455
Fax: 01738 827411
Email: lorne@redgore.demon.co.uk

Chris Gomersall
 78/79, 102/103
14 Judith Gardens, Potton, Beds,
SG19 2RJ
UK

Tel: 01767 260769
Email: chris@c-gomersall.demon.co.uk

Agent:
Bruce Coleman Ltd,
16 Chiltern Business Village, Arundel
Road, Uxbridge, Middlesex, UB8 2SN
UK

Tel: 01895 257094
Fax: 01895 272357

Jose L Gonzalez 67
c/Tui 13 3°A, 36209 Vigo
SPAIN

Tel: (0034) 986 201162

Jonathan R Green 31
PO Box 17-22-20288, Quito
ECUADOR

Tel & Fax: (00593) 2 371 055
Email: macarena@uio.satnet.net

Mark Hamblin 31
63 Waller Road, Walkley Bank, Sheffield,
S6 5DP
UK

Tel & Fax: 0114 233 3910

Paavo Hamunen 87
Pesosenkaarre 15, 93600 Kuusamo
FINLAND

Tel & Fax: (00358) 8 852 3136
Email: paavo.hamunen@koillismaa.fi

Martin Harvey 25
PO Box 8945, Centurion 0046, Pretoria
SOUTH AFRICA

Tel & Fax: (0027) 12 664 2241
Email: mharvey@icon.co.za

Mike Hill 45, 147
c/o 273 Barkham Road, Wokingham,
Berkshire, RG41 4BY
UK

Tel & Fax: 01189 785009
Email: mikehill75@hotmail.com

Chalk-Seng Hong 32/33
5 Cannon Street, 10200 Penang
MALAYSIA

Tel & Fax: (0060) 4 261 3028
Email: hooigin@pd.jaring.my

Gayle Jamison 90/91
257 Ohayo Mountain Road, Woodstock,
New York 12498
USA

Tel: (001) 914 679 6138
Fax: (001) 914 679 4085
Email: jamihall@ulster.net

T A Jayakumar 24
4/3 East Street, Shanthi Nagar,
Bangalore
INDIA 560 027

Tel: (0091) 80 227 2556
Email: jay_bharat@hotmail.com

Heikki Ketola 115
Lämsänkyläntie 54, 93999 Kuusamo
FINLAND

Tel: (00358) 8 855275

David Kjaer 104
38 Gipsy Lane, Warminster, Wiltshire,
BA12 9LR
UK

Tel: 01985 216630

Stephen J Krasemann 148
PO Box 4490, Whitehorse,
Yukon, Y1A 2R8
CANADA

Tel: (001) 867 393 3335

Peter Ladell 92
22 Moreton Road, Luton, LU2 0TL
UK

Tel & Fax: 01582 419603

Jan-Peter Lahall 108/109,
113, 118
Box 402, 701 48 Örebro
SWEDEN

Tel: (0046) 19 121312
Fax: (0046) 19 187500
Email: info@jp-lahall.com

Jim Leachman 107
6432 Old Goose Creek Road, Middleburg,
Virginia 20117
USA

Tel: (001) 540 687 6911
Fax: (001) 540 687 8801
Email: jimleachman@hotmail.com

Antti Leinonen 23
Koirisärkäntie 4 C 10, 88900 Kuhmo
FINLAND

Tel: (00358) 8 6551775

Günter Lenz 124
LaTerra Magica, Ortlindestrasse 9,
81927 München
GERMANY

Tel: (0049) 89 914002
Fax: (0049) 89 917234
Email: LaTerraMagica@t-online.de

Torbjörn Lilja 89
Patrongatan 43, 93047 Byske
SWEDEN

Tel: (0046) 912 10882

Gil Lopez-Espina 42
Essentia Images, 104 Division Avenue,
Belleville, NJ 07109
USA

Tel: (001) 973 751 5641
Fax: (001) 973 751 4959
Email: glespina@essentiaimages.com

Conny Lundström 26
Hemstigen 11, 93156 Skellefteå
SWEDEN

Tel: (0046) 910 39278

Stephen G Maka 110
PO Box 305, Sherborn, MA 01770
USA

Tel: (001) 508 653 6774
Fax: (001) 508 653 4770
Email: smaka@mediaone.net

Ryo Maki 97
4-13-6 Ankoji-cho, Takatsuki-city, Osaka
JAPAN

Tel & Fax: (0081) 726 89 3957

Agent:
Japan Professionals, 32 Thomasson Street,
North Rockhampton, Qld 4701
AUSTRALIA

Tel: (0061) 7 4926 6839
Fax: (0061) 7 4926 6849
Email: mcswiny@ibm.net

Setsuko Maki 94/95
4-13-6 Ankoji-cho, Takatsuki-city, Osaka
JAPAN

Tel & Fax: (0081) 726 89 3957

Agent:
Japan Professionals, 32 Thomasson Street,
North Rockhampton, Qld 4701
AUSTRALIA

Tel: (0061) 7 4926 6839
Fax: (0061) 7 4926 6849
Email: mcswiny@ibm.net

Neil McIntyre 77
Ballinluig Cottage, Kinrara, Aviemore,
Inverness-shire, PH22 1QB
UK

Tel & Fax: 01479 810545

Agent:
Planet Earth Pictures,
The Innovation Centre, 225 Marsh Wall,
London, E14 9FX
UK

Tel: 0207 293 2999
Fax: 0207 293 2998

Anne Meyer 142
21 rue d'Altorf, F-67200 Strasbourg
FRANCE

Tel: (0033) 3 88 30 37 56
Fax: (0033) 3 88 41 39 86
Email: cmeyer@tpgnet.net

Agent:
BIOS, 31 rue Chanzy, 75011 Paris
FRANCE

Tel: (0033) 1 43 56 63 63
Fax: (0033) 1 43 56 65 17

Anup Shah
16/17, 42/43

29 Cornfield Road, Bushey, Herts,
WD2 3TB
UK

Tel & Fax: 0208 950 8705

Manoj Shah **21, 41, 57,**
70/71
PO Box 44219, Nairobi,
KENYA

Tel: (00254) 2 743962
Fax: (00254) 2 751692

Wendy Shattil
& Bob Rozinski **46, 149**
8325 E Princeton Avenue, Denver,
Colorado 80237
USA

Tel: (001) 303 721 1991
Fax: (001) 303 721 1116
Email: wshattil@compuserve.com

Raoul Slater **120**
PO Box 32, Kenmore, Qld 4069
AUSTRALIA

Tel: (0061) 7 3202 6583
Fax: (0061) 7 3202 7009
Email: p.slater@gplus.com.au

Agent:
Woodfall Wild Images, 17 Bull Lane,
Denbigh, Denbighshire, LL16 3SN
UK

Tel: 01745 815903
Fax: 01745 814581

Robert & Virginia Small
65
Agent:
Rick Poley Photography Inc,
267 Charlemagne Blvd, Key Largo,
FL 33037
USA

Tel: (001) 305 451 1255
Fax: (001) 305 451 1134
Email: rkpphoto@aol.com

Juan Tébar Carrera **23**
Apartado 469, 11100 San Fernando,
Cádiz
SPAIN

Tel: (0034) 617 845049

Jamie Thom **8/9, 10-15**
PO Mala Mala, 1353
SOUTH AFRICA

Tel: (0027) 13 735 5661
Fax: (0027) 13 735 5686
Email: maincamp@iafrica.com

David Tipling **58**
Windrush Photos, 99 Noah's Ark,
Kemsing, Sevenoaks, Kent, TN15 6PD
UK

Tel: 01732 763486
Fax: 01732 763285

Darryl Torckler **82, 96**
Mahurangi West Road, RD3, Warkworth
NEW ZEALAND

Tel: (0064) 9 422 0555
Fax: (0064) 9 422 0575
Email: darryl.dtcp@xtra.co.nz

Björn Ullhagen **88**
Kyrkbyn Tuvavägen 4, SE-81591 Tierp
SWEDEN

Tel: (0046) 293 50409
Email: ullhagen@telia.com

Agent:
Bildbyrån i Göteborg AB, Box 5243,
SE-402 24 Göteborg,
SWEDEN

Tel: (0046) 31 711 6200

Duncan Usher **105**
Mühlenbreite 9,
34346 Hann Münden (Bursfelde)
GERMANY

Tel: (0049) 5544 1050
Fax: (0049) 5544 912020

Colin Varndell **88**
The Happy Return, Whitecross,
Netherbury, Bridport, Dorset, DT6 5NH
UK

Tel: 01308 488341

Francesco Velletta **56**
Res Filare 143, 20080 Basiglio (MI),
ITALY

Tel: (0039) 02 9078 5195
Fax: (0039) 03 3143 3308
Email: vefrancesco@tiscalinet.it

Jan Vermeer **37, 84/85**
Planetenlaan 10, 7314 KA Apeldoorn
NETHERLANDS

Tel: (0031) 55 3555 803
Fax: (0031) 55 3557 268

Uwe Walz **50/51**
Pommernweg 11, D-21521 Wohltorf
GERMANY

Tel: (0049) 4104 3122
Fax: (0049) 4104 80412
Email: walz-naturfoto@t-online.de

James Warwick **40**
4 Elder Close, Portslade, Brighton,
East Sussex, BN41 2ER
UK

Tel: 01273 772441
Fax: 01273 706030

Agent:
Amana Images,
T-33 2-2-43 Higashi-Shinagawa,
Shinagawa-ku, Tokyo 140-0002
JAPAN

Tel: (0081) 3 3740 4322
Fax: (0081) 3 3740 4315

Luidger Weyers **131**
An Der Rossmühle 3, D-47839 Krefeld
GERMANY

Tel: (0049) 2151 733511
Fax: (0049) 2151 615820

Loretta Williams **83**
1523 Poplar, Royal Oak, MI 48073
USA

Tel: (001) 248 288 5881
Fax: (001) 248 548 9087

Nick Wilton **132/133**
51 4th Street, Houghton 2198,
Johannesburg
SOUTH AFRICA

Tel: (0027) 11 728 4402
Fax: (0027) 11 477 1069
Email: bwilton@smartnet.co.za

Winfried Wisniewski
48/49
Nordring 159, 45731 Waltrop
GERMANY

Tel: (0049) 2309 77116
Fax: (0049) 2309 77117
Email: W.Wisniewski@t-online.de

Stephen Wong **93**
5A Everwell Garden,
1 Sheung Hong Street, Homantin,
Kowloon
HONG KONG

Tel: (00852) 9494 0686
Fax: (00852) 2314 3429
Email: saiwong@hongkong.com

Jeremy Woodhouse
122/123
4304 Standridge Drive, The Colony,
TX 75056
USA

Tel: (001) 972 625 1595
Fax: (001) 972 624 1946
Email: jeremyw@onramp.net

Konrad Wothe **20, 125**
Maenherstrasse 27a, 81375 München
GERMANY

Tel: (0049) 89 717 453
Fax: (0049) 89 714 7141

Agent:
Minden Pictures,
783 Rio del Mar Blvd 9-11, Aptos,
CA 95003
USA

Tel: (001) 831 685 1911
Fax: (001) 831 685 1913

Norbert Wu **102**
1065 Sinex Avenue, Pacific Grove,
CA 93950
USA

Tel: (001) 831 375 4448
Fax: (001) 831 375 4319
Email: NorbertWu@ibm.net